The Complete Idiot's Reference Card

tear here

Your Learning-to-Draw Cheat Sheet

We thought it might be helpful to have a cheat sheet, with all the "rules" in one place. You might want to paste this list inside the cover of your sketchbook or tack it up on the wall near your drawing table, so you can refer to it as you work.

1. Take yourself and your work seriously. Make yourself a place to work that is just for you.

2. Set a time to work. Make a date with yourself.

3. Look around for some first subjects as ideas.

4. Arrange yourself comfortably so you can see your subject and your paper easily.

5. Select your objects or your view.

6. Arrange your objects, still life composition, or move the furniture you'll be drawing to suit you.

7. Look at things flat or at angles to see how they vanish—that is, become smaller—as they recede. Ellipses get smaller or flatter as the object is turned away. Look at the main angles in your view.

8. Decide on your viewpoint and eye level.

9. Adjust the lighting if necessary.

10. Establish a format and size of drawing.

11. Decide on your medium and paper.

12. Use the viewfinder frame to see your choice.

13. Make a box on your paper that is proportionally equal to your viewfinder frame at your chosen size.

14. Remember the diagonals; keep the box and frame in proportion.

15. Use your plastic picture plane or your viewfinder frame to see the arrangement or view in space.

16. Site what you see on your page.

17. Start with light planning lines for the simple shapes, lines, angles, and the general outline.

18. Check your initial light drawing for accuracy.

19. Check the shapes and the spaces. Look at the negative spaces, how things overlap, which way the angles are. See the basic geometric shapes in space.

20. Look to see objects as if they were transparent. See their space. Imagine a dotted line at the back of where they are to ensure there is enough space for the object to really be there in space.

21. Use your viewfinder frame to gauge any angle relative to horizontal or vertical and the grid marks on the edge of the frame. Use your pencil to do the same. Hold it horizontal or vertical next to an angle and see the difference.

22. Use your carpenter's angle measure to see an angle and transfer it to your drawing.

23. If you have a problem, use the plastic picture plane and transfer what you see to your drawing.

24. Draw a box for something that is hard to draw. Put the box in space, then draw the thing in the box.

25. See relationally. As you are sure of one shape, relate the others to it. Keep checking and adjusting until you are happy with your drawing.

alpha books

Your Learning-to-Draw Cheat Sheet ... continued

When you work on form, you can add tone, try to define the form with line, or you can leave it as a contour line drawing.

1. If you choose to add form, adjust your lighting if necessary.

2. Make a tonal chart for the values in your arrangement.

3. Squint to see the extremes of value in your arrangement and to subdue the detail and mid-tones.

4. Pick out the lightest spots and the darkest.

5. Add some tone to the middle shades, from the lighter ones to the darker ones.

6. Try to see tones as having shapes on your subjects.

7. Look at shadows next to things, under things, and on other things.

8. You can work toward a very tonal drawing or you can merely suggest volume, perhaps just with shadows.

9. Add detail and texture after you see the shapes and the form.

10. Use those naturalist's eyes of yours for a clear seeing of detail.

11. Rendering texture requires a mark that is appropriate for describing the texture. Experiment by drawing different marks—crosshatches, straight and wavy lines, and such—on a separate piece of paper.

12. Detail and texture may also require a lot of planning and measuring if there is a pattern on china, a fabric print, or fine detail on seashells.

13. Get up and look at your work from a distance. Look with fresh eyes. Don't hesitate to go back and fix something.

14. Work patiently—it is *your* drawing.

15. As you work, see the lines, tones, textures, and detail begin to work together.

16. Check to see if your work is taking on all one tone with little contrast. You can change your tonal range by lightening the lights or darkening the darks or darkening the main lines in the contour line, or by erasing out part of the texture or tone so that you merely suggest it.

Drawing

by Lauren Jarrett and Lisa Lenard

alpha books

Macmillan USA, Inc.
201 West 103rd Street
Indianapolis, IN 46290

A Pearson Education Company

International Standard Book Number: 0-02-863936-7
Library of Congress Catalog Card Number: Available upon request.

02 01 00 8 7 6 5 4 3 2 1

Interpretation of the printing code: The rightmost number of the first series of numbers is the year of the book's printing; the rightmost number of the second series of numbers is the number of the book's printing. For example, a printing code of 00-1 shows that the first printing occurred in 2000.

Printed in the United States of America

Publisher
Marie Butler-Knight

Product Manager
Phil Kitchel

Managing Editor
Cari Luna

Acquisitions Editors
Mike Sanders
Susan Zingraf

Book Producer
Lee Ann Chearney/Amaranth

Development Editor
Amy Gordon

Production Editor
Billy Fields

Copy Editor
Amy Borrelli

Illustrator
Lauren Jarrett

Cartoonist
Jody P. Schaeffer

Cover Designers
Mike Freeland
Kevin Spear

Book Designers
Scott Cook and Amy Adams of DesignLab

Indexer
Greg Pearson
Eric Schroeder

Layout/Proofreading
Angela Calvert
Mary Hunt

Contents at a Glance

Contents

Foreword

When did you stop drawing?

As a professional artist I am often asked: When did I begin to draw? Or in other words, how long have I been drawing. I have tried to answer this question, but the truth is that I'm not exactly sure. I do know that I have drawn as long as I can remember. Most children enjoy drawing as one of their games. I guess I just never stopped.

I had the great fortune to be born into a family sensitive to the visual arts: My mother was a professional ceramist before marrying my father. My father had an advertising agency and his best friend (and his agency's principal illustrator) was the acclaimed painter Ezequiel Lopez. It seems perfectly natural to me that in addition to myself, two of my four siblings are professional artists.

Growing up in Spain, I remember my mother always encouraging our artistic and cultural interests, taking us to visit museums and galleries and keeping us well stocked with art supplies. You see, when she was a little girl, Spain was going through the period in its history known as "post-guerra," the decade which followed the Spanish Civil War. Art supplies were a luxury at that time. My mother remembers wanting to draw as a little girl and, having no pencil or paper, scratching the white stucco walls of her house with coins to create gray marks, crating a kind of rustic silver-point graffiti that understandably drove my grandparents nuts. So as a parent, my mother made certain that her children always had arts and crafts materials available for play.

When I was about ten years old, my mother took up painting as a hobby. She armed herself with all the proper tools for making art, including an encyclopedia on how-to-draw-and-paint. I remember the first time I set eyes on the black cloth hardbound cover of its first volume. Printed across its austere cover in bold white letters was "Drawing is Easy" ("Dibujar es fácil"). I opened the book and discovered step by step methods for creating images that, until that moment, had seemed impossible to put down on paper: portraits, landscapes, figures, and animals. I was amazed! From that point on, I devoured the information in that encyclopedia, completing most of the assignments that the books proposed just for my own enjoyment. As the years passed, I received extensive training in art: As a teenager I enrolled in a private academy that taught traditional drawing and painting. Later, I attended the University of Madrid, the Maryland Institute College of Art and Towson University. I have been teaching college courses in art for the past fifteen years. Thirty years later, the lessons I learned in that encyclopedia are still present in my mind. I use them in my own work as well as my instruction of others.

Which brings me to *The Complete Idiot's Guide to Drawing*. Don't let the funny title fool you. This book is a serious and practical introduction for those interested in learning the basic aspects of drawing. Its tone is casual and friendly. It assumes that you don't know anything about art, but are serious and willing to learn. Its contents are approximately those of a basic comprehensive course in studio drawing at a first rate art college. In other words, it is light years beyond my beloved "Drawing is Easy," which, since it was printed in 1968, is by now quite limited and dated. *The Complete Idiot's Guide to Drawing,* on the other hand, incorporates all the current ideas on how to learn to draw. Despite the humorous name, this is not a book full of "tricks" that would show you how to draw flashy pictures if you can do certain effects. You won't find a single recipe inside on how to draw a "happy cloud," like you would in those misleading "learn to paint" television programs. This is the real thing. What you get from this book are the basic concepts for serious art making. You will learn to see like an artist, to choose a subject, to compose a picture, and to bring it to completion. And of course, you'll learn how much fun this all can be.

Drawing is the basis for all forms of visual fine arts. Painting, printmaking, sculpture, illustration, photography, mixed media, graphic design, fibers and digital art all rely on ideas that are generally explored by first learning to draw. Whatever you will eventually do artistically, whatever medium or style, you will benefit greatly from being exposed to *The Complete Idiot's Guide to Drawing*. So don't waste another precious minute—let's get started! What are you waiting for?

José Villarrubia, MFA, is a painter, photographer and digital artist, born in Madrid, Spain, but residing in Baltimore for the past twenty years. Since 1986, he has been included in over ninety international solo and group exhibitions in the United States, Europe, and Latin America. His work is in the permanent collections of the Baltimore museum of Art and the Inter-American Development Bank. He is a full time faculty member at the Maryland Institute College of Art, where he has been teaching drawing and digital art for the past four years. He taught for twelve years in the art department of Towson University, and has taught at the Walters Art Gallery and for the Bright Starts Program. His numerous lectures include those at the Johns Hopkins University and the College Art Association. Entertainment Weekly has called his work "Groundbreaking, a treat for the eyes!"

Since 1992 Mr. Villarrubia has been the art reviewer for the literary magazine Lambda Book Report. He is currently writing Koan, a book about the paintings of Jon J. Muth and Kent Williams to be published later this year by Allen Spiegel Fine Arts.

Introduction

If you've got draw-o-phobia, you're not alone. Millions of Americans (including, until this book, one of its coauthors) are afraid to pick up a pencil to try to represent an image on a page. You drew as a child—we all did—but maybe you were laughed at by your peers or siblings early on, or maybe a " well-meaning" art teacher discouraged your earliest efforts. Suddenly, you felt critical of your drawings, unhappy with your attempts, worried that you would fail, and unwilling or afraid to try.

Drawing is thought of as magic by some, and an inherited trait by others, but neither of those ideas is true. The good news is it's never too late to learn to draw or learn to draw more confidently and sensitively. The first step, in fact, is as simple as picking up a pencil and some paper and just drawing a simple image on the page.

Pick a single flower, leaf, or branch, and sit and see it for the first time, then make a simple line drawing.

Give yourself a little time to draw. Try it now, here:

How did you feel while you were drawing? Did you relax and enjoy it? Did you feel nervous about how you would do? Working through the exercises in this book will help you get past those fears and the tendency to be too critical. You will have fun drawing and experience your own creativity. See? It won't be so hard. The rest of learning to draw will be a breeze, too.

How to Use This Book

Drawing is a basic skill, like writing, or riding a bicycle—it must be learned and practiced, but is within your grasp. We've arranged this book so that you start off with easy stuff, like seeing, and then slowly move through exercises that will take you further and further along in your drawing skills.

This book is divided into seven parts:

Part 1, "Drawing and Seeing, Seeing and Drawing," introduces you to the pleasures of drawing and seeing, including discovering the difference between your critical left brain and your creative right brain. Tapping your own creativity may be the most exciting thing you have ever done. Plus, right off the bat, we'll be providing exercises to help you loosen up and exercise your drawing hand, entice your creative right brain, and banish the left side, "Old Lefty," out to left field, where he belongs. Learning to just "see," and to draw what you see, is fun and the beginning of an adventure in drawing that can take you almost anywhere. A contour line drawing of an object is the place to start.

In Part 2, "Now You Are Ready to Draw," you'll meet some of the tools of the trade, including the viewfinder frame and the plastic picture plane. We'll show you how to make your own viewfinder frame and plastic picture plane to take with you wherever you go, and how to use both of these tools to help with your drawings. Then you'll experiment with negative space, the spaces in and around an object or objects. Seeing the negative space can greatly help your composition and drawings.

Part 3, "Starting Out: Learning You Can See and Draw," has a lot of work to do. First, you need some materials and a place to work, because you need to take yourself and your work seriously. We'll begin with simple groups of objects in a drawing and then move on to the full still life, exploring why artists throughout the ages just love those fruits and veggies. We'll also help you begin to choose what to draw, what to draw it with, and how to make your way from a contour line to a consideration of form and weight. Then we will look at those all-important details.

By **Part 4, "Developing Drawing Skills,"** you'll be feeling much more confident about your drawing skills. We'll discuss some new materials and how to acquaint yourself with them. Journals and sketchbooks are next, a way for you to practice drawing every day. We'll peer into some working artists' studios to see what's behind those light-filled windows and we'll look at their views on drawing, their studios, and their feelings about their work. Then, we'll work on your portable drawing kit to take on the road, and poke around your house and garden (and ours) to find some good subjects for your sketchbook.

In **Part 5, "Out and About with Your Sketchbook,"** we'll get you out of the house. We'll look at perspective, that all-important way of seeing three-dimensional space that all artists use, and then we'll get you outside to use your newfound knowledge. We will look at the land itself, elements in the landscape, and then houses and other structures, so you will feel confident to tackle any and all the drawing challenges in your neighborhood or anywhere in the world.

Part 6, "Drawing Animals and People," looks at animals, humans, and the human figure as drawing subjects. Action, gesture, proportion, shape, and form are the buzzwords here, for animals and the human animal. We'll explore why the nude has always been the object of artists' affections—and why it may turn out to be yours as well. We'll also look at gesture and movement—and how to render them on the page.

Part 7, "Enjoying the Artist's Life!" will put it all together, helping you express yourself in your drawings. We'll discuss how to frame and care for your work and how to expand your skills into new media, projects, or into cyberspace. We'll also go to the museum with you, and help you learn how you can learn more about yourself by finding what art you're drawn to.

Last, in the back of this book, you'll find three appendixes, including a list of materials you may want to purchase, a list of books for further reading, and a glossary, chock-full of art-y words.

And, in the front of the book, you'll find a tear-out reference card to take with you wherever you draw.

Extras

In addition to helping you learn how to draw, we've provided additional information to help you along. These include sidebars like the following:

Artist's Sketchbook

These margin notes introduce you to the language of drawing, so you'll understand the terminology as well as the how-to's.

Back to the Drawing Board

These margin notes can help you avoid making drawing mistakes—as well as learn from the ones you do make.

Try Your Hand

Everyone could use an extra tip here and there, and this margin note is where you'll find them.

The Art of Drawing

This is the place you'll find those extra tidbits of information that you may not have known about learning to draw.

Acknowledgments

We both thank Lee Ann Chearney at Amaranth, for guiding this book through its assorted hoops.

Lauren thanks the long list of friends, students, and family members who have agreed to the use of their work as examples in this book. She especially thanks Stan, her grandfather, her mentor as an artist and her source of inspiration, and Virginia, her mother, and a fine artist herself, who has always encouraged her in anything she tried, including the writing of this book. And Lauren thanks Lisa for months of inspiringly apt and funny e-mails and help writing this drawing book.

Lisa thanks her sister in laughter, Lauren Jarrett, for making this book a particularly easy and fun-filled journey. Not only do we share warped senses of humor, Lauren can outdraw the best of 'em.

Special Thanks to the Technical Reviewer

The Complete Idiot's Guide to Drawing was reviewed by an expert who double-checked the accuracy of what you'll learn here, to help us ensure that this book gives you everything you need to know about drawing. Special thanks are extended to Dan Welden.

Dan Welden took time from his own busy schedule of printing, teaching, and writing a book about his own special solar etching techniques. He is unfailingly helpful and encouraging to all who ask his help and expertise.

Dan Welden is a printmaker and painter who has had more than 50 international solo exhibitions in Australia, New Zealand, Belgium, Switzerland, Germany, and the United States. His teaching experience includes 10 years of full-time teaching at the State University of New York at Stony Brook and Central Connecticut State University, as well as many years as an adjunct professor at Suffolk Community College and Long Island University.

As a Master Printmaker, Dan Welden has collaborated with or printed for many prominent artists including Willem and Elaine de Kooning, Esteban Vicente, Ibram Lassaw, Eric Fischl, Louisa Chase, Robert Rauschenberg, Jasper Johns, Dan Flavin, Jim Dine, Robert Motherwell, and Kurt Vonnegut.

Dan Welden is director of Hampton Editions, Ltd., and resides in Sag Harbor, New York.

Trademarks

All terms mentioned in this book that are known to be or are suspected of being trademarks or service marks have been appropriately capitalized. Alpha Books and Macmillan USA, Inc. cannot attest to the accuracy of this information. Use of a term in this book should not be regarded as affecting the validity of any trademark or service mark.

Part 1

Drawing and Seeing, Seeing and Drawing

Learning to draw is learning a skill, and, like other skills that require practice, you can do it if you try. Getting past your fears and the thought that "you can't draw" is the first step. It will help to discover the difference between your critical left brain and your creative right brain—and then learn how to banish "Old Lefty" out to left field, where he belongs. He is no help when learning to see and draw, and learning to "just see" will send him packing.

In this section, we provide exercises to help you loosen up and warm up your drawing hand, as well as help you begin to see as an artist does.

The Pleasures of Seeing and Drawing

In This Chapter

➤ Realizing the magic of drawing

➤ Learning that drawing *is* seeing

➤ Looking through the barriers

➤ Understanding the two sides to every brain

When the artist is alive in any person, whatever his kind of work may be, he becomes an inventive, searching, daring, self-expressive creature. He becomes interesting to other people. He disturbs, upsets, enlightens, and opens ways for a better understanding. Where those who are not artists are trying to close the book, he opens it and shows there are still more pages possible.

—*Robert Henri,* The Art Spirit *(1923)*

You may think of drawing as something magical, maybe even as something beyond your grasp or understanding. But drawing is really an elemental skill, one that you can learn with no more effort than learning to walk, ride a bike—or even tie your shoes!

Quite simply, drawing is a way of showing others what and how you see. Even at its most basic stage, drawing is about seeing the miracle of all things, of admiring the essential poetry in things. Viewed this way, drawing isn't any more magical than anything else— it's simply part of the larger magic that is life itself.

What Is Drawing?

A way of using lines to convey meaning, *drawing* is one of the most basic ways to communicate. Today, we know that drawing preceded the written word—and it may have preceded spoken language as well. For early humans, drawing was as essential a response to life as

knowing which roots were good to eat and which were good to rub on wounds. In prehistoric times, drawings were used to

➤ Exchange ideas and information.

➤ Celebrate and record the details of life.

➤ Solve mysteries.

➤ Revere and give thanks.

➤ Wish and dream.

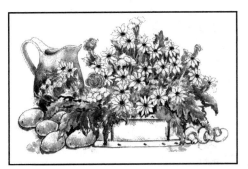 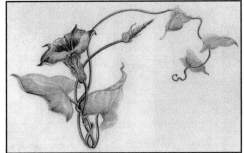

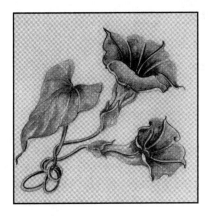

There's no magic to drawing—it's as simple as recording what you see.

Artist's Sketchbook

Drawing is a way of representing what we see by placing lines onto a surface.

Although these drawings were, according to scientists, very utilitarian in nature, they are considered works of art by the artistic community, in that the works were done with "heart"; no two drawings are identical—some demonstrate more expression than others.

Drawing is ...

While you may believe that drawing is only for artists, it's really a basic skill like talking, reading, or walking. Once you've learned to draw, in fact, it becomes automatic, although—as with any basic skill—the more you practice, the more you'll be able to improve on it.

As this sketch of ancient petroglyphs shows, humans have been using drawings to communicate for millennia.

The secret of drawing is no secret at all: It's all about seeing, and then representing what you see onto the page. In *Drawing on the Right Side of the Brain* (New York: Jeremy P. Tarcher/Putnam, 1999), artist/writer Betty Edwards considers learning to see and draw a collection of five skills:

1. The perception of edges
2. The perception of spaces
3. The perception of relationships, or *sighting*
4. The perception of light and shadow, or *form*
5. The perception of the whole, or the *gestalt*

The Artist's Answer

We believe that drawing makes life richer, every single day. Drawing is a skill that opens up the world, and so it can put you in touch with the balances and beauties of nature. Drawing and seeing allow, if not demand, that you live in the moment, see the now, stop the chatter, and simply *look*. In the silence while you look, there is a peace and centering that can transform your life.

Try Your Hand

Beyond these basic skills are memory and imagination, which are used by artists to create new works and move beyond the beginning skills necessary to learn to draw. The more you draw, the more you will progress from seeing and drawing line to space, shape, form, value, weight, light, shadow, texture, and detail.

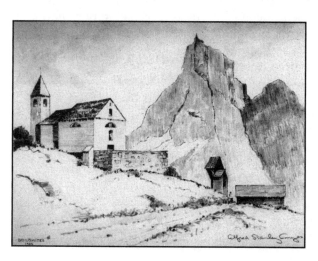

This is a travel drawing by Lauren's grandfather, who was a fine draftsman and painter of landscapes.

The Art of Drawing

We like to think of drawing as a door to the world that many, for one reason or another, don't use. This same door opens to the miracle of life and the myriad of rich detail that you can experience, and is a way into your (and others') thoughts and emotions. This door is also a window to the soul—maybe, for the soul—and so it's a way beyond the cares and preoccupations of daily existence to an altered state that is at once a challenge and a rest.

Express Yourself

Learning to draw is about learning to see things in a new way. Let's start by taking apart your brain. Well, not literally. For now, we'll just separate it in two.

Scientists now accept that the brain has two hemispheres. You have a rational, logical, verbal, analytical, and sequential way of thinking or processing information, which is on the left side of your brain, and an intuitive, visual, perceptive, simultaneous, and holistic way, which is on the right side of your brain. Your *left brain* processes parts of things and words, tries to identify and organize, and works to make sense of things. Your *right brain* processes the whole, in pictures and relationships between things.

Artist's Sketchbook

The brain is comprised of two hemispheres, the analytical and logical **left brain** and the more intuitive and holistic **right brain.** While Westerners tend to use their left brains far more, drawing is largely a function of the right brain.

Drawing is a skill that uses right-brain perceptions, which many people—especially those in the western world—have difficulty accessing. But there are ways of encouraging the right side of the brain to take over the more dominant left side. These exercises can actually change the way you see. You can move from being largely verbal and analytical to being visual and intuitive. And, learning to use your right brain is the first step in learning to draw.

In the logic-centered western world, you spend most of your life working on the left side of your brain—a banker, for example. You're taught to think cognitively, rationally, and logically. This is fine for many tasks, but for the more creative and, we think, more rewarding pursuits in life, you need to cultivate the right side.

The Left Brain	The Right Brain
processing is:	processing is:
rational	*intuitive*
verbal	*visual*
analytical	*perceptive*
sequential	*simultaneous*
looks at:	looks at:
the parts	*the whole*

The Art of Drawing

In order to help children learn to develop both sides of their brain rather than just the left, educator David Galin suggests three tasks for teachers.

1. Teach to both the left- and right-sided functions: the verbal, symbolic, logical left, and the visual, relational, holistic right.

2. Teach the ability to use the style of thought best suited to a particular task.

3. Teach the ability to integrate both systems to maximize potential.

Why You Draw, and Why Sometimes You Stop Drawing

You learn most of your basic skills when you're young, so you're largely unaware of the time you put in to learn and practice those skills. Some of you may remember learning to read, especially if it was difficult for you, but most people don't remember the learning itself, once a skill is acquired.

On the other hand, you might remember the learning involved for skills you learned later, such as learning to ride a bike or learning to write, or you may remember when you learned to drive a car. If you ever learned to ski or play the piano, you probably remember some of those lessons (and may have some pretty funny stories to tell, too—we know we do!). What all of these later skills have in common is that you accepted the necessity of practice and learning in stages.

For some reason, many seem to think that the skills needed to draw are more difficult to acquire, especially when they take into consideration our need as adults to accomplish things quickly. Maybe the fact that we desire such immediate gratification is precisely the reason we think we can't learn to draw. But it's really no more difficult than any new skill, and it's certainly easier—and safer—than learning to drive a car!

Creativity research suggests that the reason adults are so afraid of their creativity is that they're literally afraid of "making a mess." By the time you've reached adulthood, you're carrying many more voices in your head than merely your own; you've got your parents, your teachers, your friends, and possibly even your bosses, all telling you what you've done wrong. No wonder you censor yourself before you even try! In this book, we're going to help you go out and play again without those voices telling you there's a right and wrong way to do so.

Back to the Drawing Board

Children are more immersed in the moment, or the now, than adults, and so it's easy for them to draw. Children are less concerned with judgmental responses to their efforts, a concern that seems to develop as we try for greater accuracy and specificity as we mature. In fact, the more we develop our largely analytical skills, the more trouble we have drawing. We lose the spontaneity and joy that simply making a mess can bring.

Anyone can draw! This simple line drawing was done by a 7-year-old boy who managed to really look and draw the contours and shapes of a sleeping dog very accurately, because he was following what he could see.

Try Your Hand

The ability to draw is really the ability to see something and then transfer it to paper. It's as simple as that!

Looking Through the Barriers

The ability to draw is really the ability to see—to see what's really there, and transfer it to paper. The key is to see as an artist sees.

Artists process visual information differently from the way most Westerners do. Most are taught a means of processing that's more suited to other tasks, so to learn to process (or see) as an artist takes some practice. Most people get discouraged before they've tried very long, and soon feel they'll never get there. They then say, "I'll never learn to draw," forgetting that all skills (and drawing, remember, is a skill) take practice.

Learning How to Look

Learning to draw is really a matter of learning to see—to see correctly—and that means a good deal more than merely looking with the eyes.

—*Kimon Nicolaides,* The Natural Way to Draw *(Boston: Houghton Mifflin Co., 1990)*

Back to the Drawing Board

Because of our analytical approach to thinking, a common belief among Westerners is that creativity is limited to artistic endeavors such as drawing, creative writing, or musical performance. Nothing could be further from the truth! Creativity takes many forms. You may be someone whose talents lie in putting others at ease, or you may take a creative approach to getting from point A to point B. What's important is to let your right brain do the work; it's got a lot to offer, and it's just waiting for a cue.

In the chapters that follow, we will be encouraging the right side of your brain to do the work. To help you, we'll be providing exercises that will show you how to see what's before your eyes, without thinking much, and to draw what you see. As you practice, it will become easier and easier for you to do this; you'll soon be able to switch consciously from left brain to right for the specific purpose of drawing, or to access your intuitive side just to relax and enjoy it!

Changing from the verbal perception of ideas to the visual perception of intuition is of tremendous value for more than just drawing. Within our increasingly high-tech, high-speed, 24/7 world, you'll discover great pleasure in just the accomplishment of learning to use your right brain. At the same time, as you learn to use the right side of your brain to see and draw, your own innate creativity will become more readily available to you.

To tap your inventive and creative energy is a great power. You may feel tremendously energized by the process, whether you draw or

choose another expression, such as writing or music. Even conventional problem solving is enhanced by creative growth.

Drawing is first about seeing, and a few basic skills and supplies are needed to get started. Then curiosity, energy, and personal interest take the process to its next stage. At the very least, drawing will enhance your life. At the most, who knows? As your right brain will be the first to tell you, the possibilities are endless!

Open Up Your Eyes

> *It is the unexplainable thing in nature that makes me feel the world is big far beyond my understanding—to understand maybe by trying to put it into form. To find the feeling of infinity on the horizon or just over the next hill.*
>
> —Georgia O'Keeffe, 1976

Artist's Sketchbook

Filter is the word we use to describe the process of noticing only what we need to in any given scene. A **frame** is a similar sensory device, where we ignore what's outside of what we want to look at.

So just how do you learn to open up your eyes and see what's around you? Let's start by talking about filters and frames, two imaginary sensory devices that you use every minute you're awake.

When you look at any given scene, you filter out all that isn't important to what you're looking at. You don't read every word on every billboard as you're driving down the highway, for example; this would pull your attention away from the task at hand—driving. At the same time, you pay little attention to the traffic on the other side of the highway median. This is framing what you see, and ignoring everything that's outside the frame.

In Chapter 5, "Finding the View," we'll be introducing you to the viewfinder frame, a device that artists use to do just this. What's important to remember now is that filtering and framing are already parts of the way you see every day, so you've already taken the first step to learning to draw.

Drawings can be scenes from every part of your everyday life.

The Gallery of Life

In Appendix A of this book, you'll find a list of materials you'll probably want to have on hand as you read this book. But to begin, even if you have none of the other materials, at the very least we'd like you to have some blank, unlined paper and a pencil. In fact, go find those now. Are you back? Congratulations—you've just taken the second step in learning to draw!

Chances are that, right now, you're sitting in a room in your house, reading this book. Look up from the book. What do you see? Use your paper and pencil to sketch that image. Don't worry that you know nothing about learning to draw—just do the best you can. (Note: We realized that making a list was very left-brained, so replaced this with a more right-brained endeavor.)

What did you see? You probably noticed the furnishings in the room, the pictures on the walls, maybe the titles of some books in a bookcase, or some houseplants that you know by name. That's good; you're seeing what's in the room you're in. But now, look again, ignoring all of the things you just drew above. That's right—look beyond the books and plants. What do you see now?

What did you see this time? Did you notice a place that needs some touch-up paint on the wall? Did you see the pattern of your rug or carpet, which you haven't really noticed since you first bought it? Maybe you saw a face in the wallpaper that isn't really there, or your own face, reflected in the television screen. When you start seeing these details, you're beginning to see like an artist. Pretty exciting, isn't it?

Seeing Your Way to Drawing

When you draw, you live in the present. You are always entertained, and you always have something to do. Your delight in each day and the detail of the world will show you the power of small things. Drawing makes you see the relationships between things, as well as the relationship between yourself and the world. You will experience the deep pleasure of self-expression: *I am me. I did this.* In addition, you'll reconnect with your inner child's joy.

Your drawings will range from learning opportunities to appreciating the wealth of detail in the world, and from a feeling of connection to the relationships between things to a personal meditation and response to your own inner being.

Your drawings will be as diverse—and as particular—as your world.

The Art of Drawing

We'd like to share some thoughts for you to take along as you begin your journey toward learning to draw.

➤ The uniqueness of you—your eyes and mind and soul—is a gift. Use it!

➤ Being an artist is like being an athlete. Stay in shape—draw every day.

➤ Individuality comes through practice and ongoing observation of detail.

➤ God *is* in the details.

Techniques as Tools of Expression

Beginning in the next chapter, we provide you with exercises that will help you exercise your "right" to draw. These exercises will show you how to keep your perception in the intuitive mode, by not letting the left, or logical, side take over. For example:

➤ We'll show you how to stop the left side from "doing all the thinking," which makes it difficult to just see.

➤ We'll teach you to concentrate on shape and form (right brain), rather than content (left brain).

➤ You'll learn how to "just look."

➤ You'll learn to concentrate on shape rather than content—to look at the "big picture."

➤ You'll experiment with negative space drawing.

You'll learn how to draw a variety of things as you go through the exercises in this book.

In addition, we'll be providing warm-up exercises to limber up your hand for the job of transferring what you see to the paper, and to help in the development of your own personal style and set of preferred marks, from simple lines to crosshatches.

Lastly, throughout this book, you'll find a series of exercises, ideas, explanations, and tips to help you try increasingly challenging subjects and develop your own personal method of drawing. The last page of each chapter will feature "Your Sketchbook Page," a place where you can practice what you've learned, right on the spot, if you'd like.

Developing a Way of Seeing and Drawing

Among the many pleasures of drawing is a somewhat altered state of consciousness that is familiar to artists, writers, and musicians—or anyone deeply immersed in a compelling project. In this altered state, time just seems to fly by, hours can disappear, and you feel happy and relaxed, though very concentrated on what you are doing. Some report that this state feels rather like floating, or an "out-of-body" experience, while others call it being "involved in the moment" or "the now."

No matter what you choose to call it, certain activities have been found to make it easier to achieve this state. Music, meditation, walking, skiing, jogging, and driving are just some of the activities that can induce an altered state of consciousness.

Drawing not only puts you into this lovely place, it requires being there. When the right side of your brain does the processing, you can truly see, without the analytical side of your brain telling you what to think. Then, you can see what's really there: see to draw.

The rest is up to you!

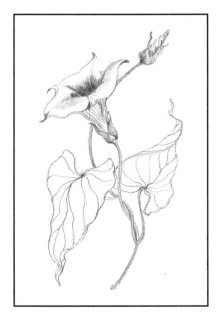 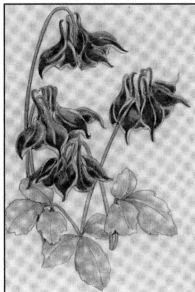

Being in an altered state of consciousness helps you see and draw what's really there.

The Least You Need to Know

➤ You don't have to be a magician to learn how to draw.

➤ Drawing is a way of showing others what and how you see.

➤ Logical thinking and analysis are left-brain activities.

➤ Drawing is largely a right-brain activity.

➤ You can learn to use your right brain more often and more effectively for other things in life.

Toward Seeing for Drawing

In This Chapter

➤ Seeing as a child

➤ Beginning to draw

➤ Copying a complicated drawing

➤ Exercises to get you started

To see itself is a creative operation, requiring an effort. Everything that we see in our daily life is more or less distorted by acquired habits. The effort needed to see things without distortion takes something very like courage.

—Henri Matisse

Young children live in a wonderful world of direct experience and response, where they "see" the world without a lot of the logic and analysis that we develop as adults. Instead, children see as artists do, using the right side of their brains, where pictures are more important than language.

In this chapter, you'll return to your childhood. You'll rediscover the child's way of seeing that you lost as you grew older—and you'll rediscover the joy of making pictures that come straight from the right side of your brain.

Free Your Mind, Your Eyes Will Follow

Maybe you've always wanted to draw. Or maybe you drew a lot as a child without thinking, and then grew frustrated as you got older (and more judgmental) and gave it up. The fact is, when you were a child you were unworried about your drawing—you just did it. Having everything "correct" didn't bother you much; you had your own ideas about what you wanted to draw and that was enough.

Children draw what they find interesting, without worrying about why or how they're drawing it.

Soon, though, education and experience add the powerful left brain to the mix. Somewhere between the ages of 10 and 12 years old, all that lovely right-brainedness starts to change. As children learn the necessary skills of language, reading, and mathematics, the analytical left brain takes over, and they see the world differently. Drawing, which was so easy when they saw with children's eyes, becomes a problem, a quandary, and a frustration as they work with the exacting, judgmental left side of their brains. They struggle for correctness—and often give up because the joy of drawing has gone.

The Wonders of the Human Brain

Few people realize what an astonishing achievement it is to be able to see at all When one reflects on the number of computations that must have to be carried out before one can recognize even such an everyday scene as another person crossing the street, one is left with a feeling of amazement that such an extraordinary series of detailed operations can be accomplished so effortlessly in such a short space of time.

—F.H.C. Crick, winner of the 1962 Nobel Prize for physiology or medicine for discovering the structure of DNA.

The human brain is an amazing thing, as celebrated in those wonderful words from British molecular biologist, Francis Crick. It is capable of lightning-fast, complicated computations, connections, responses, and reactions simultaneously—allowing for amazing feats like walking and chewing gum, or, more seriously, seeing and drawing.

Just how the brain works and how humans are evolved beyond other species fascinated early scientists, still does, and probably always will. We know that the brain has two halves and that the two sides have different functions. For the last 200 years or more, scientists and surgeons have known that functions that control speech, language, and cognitive thought are on the left side, and that visual functions are the work of the right side.

As language, speech, and logical thinking are so crucial to the human race and our sense of dominance, the left side of the brain has long been considered the stronger, more important, dominant side. The right side has been thought to be weaker, less important, maybe even dispensable.

It has also been long known that the two sides of the brain control physical operations on the opposite sides of the body. Damage or injury to one side of the brain is reflected in loss of function on the other side of the body. Damage or injury to one side of the brain is also reflected in loss of function specific to the skills managed by that side.

16

Are You a Lefty or a Righty?

The main theme to emerge ... is that there appear to be two modes of thinking, verbal and nonverbal, represented rather separately in left and right hemispheres respectively, and that our educational system, as well as science in general, tends to neglect the nonverbal form of intellect. What it comes down to is that modern society discriminates against the right hemisphere.

—Roger W. Sperry, 1981 Nobel Prize winner for research that separated and identified functions of the left and right hemispheres of the brain.

It would seem that the notion of the relative dominance of the left side of the brain has been around for a long, long time. Our language and the way we refer to things are responses to how we think or feel about them. Language is full of negative references to anything "left," which means left hand and therefore right brain. Right is right, meaning right hand and the dominant left brain. There is such prejudice against left-handedness and the left generally—socially, politically, morally, and culturally—and early conceptions and language reflected that prejudice. This prejudice still goes on today; the right, the right hand, and the logical left brain overpower the undervalued left, the left hand, and the more intuitive right brain.

The fact is that the two sides of the brain each have their own jobs, strengths, and skills. The verbal left side is often dominant, while the right, nonverbal side responds to feelings and processes infor-mation differently. While the two sides can work independently or together for well-rounded response, the left side often takes over—even for tasks it's not suited for, like drawing. So when it comes to drawing, facilitating the "switch" from left to right is the idea, no matter which hand holds the pencil.

There does seem to be a difference between left- and right-handed people. Brain function is usually less lateralized in left-handed people than in right-handed people. Left-handed people tend to process information on both sides, bilaterally, while right-handed people tend to process information on one side. Bilateral, left-handed people can be more likely to have confusion in some areas, such as reading, but they are often highly creative people, excelling in art and music. Among the left-handed, for example, were the brilliant Italian Renaissance artists, Leonardo da Vinci, Raphael, and Michelangelo.

Up until very recently, being left-handed was so much discouraged that many left-handed children were forced to become right-handed when they were very young. Not surprisingly, in addition to confusing their hand dominance, this also confused the bilateral organization of their left- and right-brain functions. If you suspect your hands were "switched at birth," you may want to try the exercises in this chapter with each hand.

Back to the Drawing Board

The longstanding bias against the left has been behind the practice of insisting that children who are naturally left-handed learn to use their right hands. This is a real mistake. Brain function and left- or right-handedness are connected and exist from birth. Insisting on switching a child's hand can cause real problems in learning, reading, and cognitive processes. Don't do it!

Artist's Sketchbook

Lateralization is the way specific functions or tasks are handled by the brain, whether by one side or the other or both.

The Art of Drawing

Lauren's mother did her graduate work in dyslexia, and, as part of her studies, tested each of her four children for handedness. They came up as one solid righty, an ambidextrous righty, an ambidextrous lefty, and a solid lefty—a perfect sample range for her study! As the solid righty, having a seemingly laterally organized brain, Lauren nonetheless finds her typing filled with letter inversions, one sign of a bilaterally organized brain, common in creative people. She thinks that she's a bilateral, right-handed, right-brainer in a left-brained world. Not a pretty sight. At least her co-author, Lisa, presents a similar picture!

Whichever hand you use, you'll want to learn to "switch" between your left brain and right brain as you learn to draw. This becomes easier and easier the more you practice, and drawing practice is one of the best exercises to improve your switching function.

From "Logical Left" to "Relational Right"

Pooh looked at his two paws. He knew that one of them was the right, and he knew that when you had decided which one of them was the right, that the other one was the left, but he could never remember how to begin.

"Well," he said slowly

—A.A. Milne

Pooh was probably a bilateral type; "a bear of very little brain," he was a creative thinker, especially about honey jars and how to get into them. So all you need is a little painless re-arrangement of your brain function and all will be well. The following exercises are designed to show you, first, the frustration of trying to draw while your mind is seeing with the "logical left," and second, the surprising difference that seeing with the "relational right" will make in your drawing.

Right-Left-Right: Your Brain Learns to Follow Orders

Even in the early exercises, you may notice a change in your state of consciousness—a relaxed, focused peace—though you're trying something very new. Time will pass quickly while you're working, and the rest of the world may fade into the background. The right side, after all, is not a timekeeper.

As a first step toward learning to shift your brain from left to right, let's begin by exploring how you drew when you were a child.

18

The Art of Drawing

Why are artists different? The artist's way of seeing involves the ability to consciously make a mental shift from the left brain, in which we mostly function, to the reflective right side when they work. They are used to the more expansive state of consciousness, a somewhat floaty sensation, outside of time, focused and attentive, but also a peaceful state. This is the way artists see and work.

The Art of the Child

Has your mother kept those boxes of your childhood drawings all these years? Or maybe, when you moved into your own home, she insisted you put them in your own attic. If you can find any of your childhood drawings at all, we'd like you to take a look at them now. So either climb up to your attic, call your mom, or head over to that storage locker and dig them out.

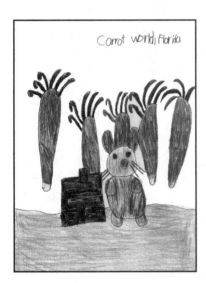
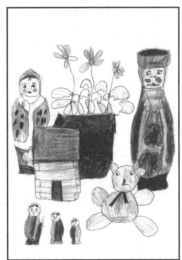

Spread your childhood artwork out and take a look at how your own drawing developed. Can you see where you moved from not worrying about what was correct to a more judgmental approach? What difference did it make in your work?

Okay, ready? Spread your drawings out and consider the following:

➤ Can you see where, as a young child, you drew without particular regard for "correctness," and instead drew to tell a story or as a response to life?

➤ Did you draw your family?

➤ Can you pick out yourself in the drawings? In Lauren's, she always has long blonde hair, an interesting psychological point as she's always had brown hair—long, but definitely brown! Lisa always made her eyes very large, and it turns out they're not particularly big at all. So wishful thinking probably plays a part as well.

➤ Did you find drawings dating from when you were an older child? If so, can you see evidence of mounting frustration as you tried to draw complicated things or things in space or perspective? Can you see where you began to struggle for correctness to please the exacting left side of your brain?

If your mother wasn't a pack rat, try looking at the drawings of any child. What you'll notice is how the process of development is almost always the same. As the child grows older, his or her purely visual response to things is hampered by the ongoing demands of the left

brain as language, identification, and exactness take over and pass judgment on the more intuitive right-brain responses, particularly drawing.

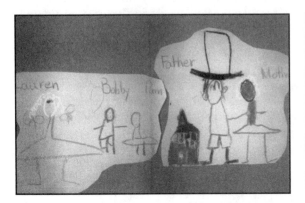

Here are two of Lauren's childhood drawings of her family.

Simple Materials to Begin

While your first exercises require only pencil, paper, and some time, we will add more and more materials as your drawing skills improve. For now, we'd like to introduce you to the simple materials that will get you started. Think that paper is just paper and a pencil's just a pencil? Think again!

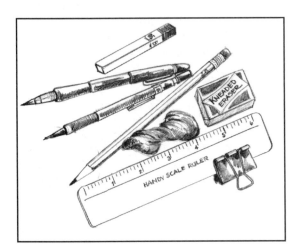

Paper, pencils, eraser, and a place to keep it all—and you're on your way!

Paper

A pad of drawing or sketching paper (9" × 12" or 11" × 14") is nice to start, but you can also begin with some sheets of typing, computer, or fax paper. No excuses accepted here; begin on the backs of envelopes, if you have to. Eventually, you'll want to explore what the shelves of your local art supply store have to offer in the way of paper—you'll be amazed at the variety!

Pencils

Any #2 pencil will work, but if you're going out for a pad of paper anyway, do yourself a favor and get some mechanical pencils. In the past, these were used mostly for drafting, but they're readily available and are great for drawing. They make a clean, consistent line that can be varied with pressure. Plus, they never need sharpening!

Look for a pencil with a smooth barrel that feels good in your hand. Mechanical pencil leads come with different thicknesses and hardnesses; a good choice is a variety of 0.5 leads in a range of hardnesses. For starters, HB and B will do; they are less smudgy than a standard #2 pencil, although a B is more smudgy than an HB.

Mechanical pencil leads are labeled as to thickness and hardness on their little storage boxes. Check to make sure that the pencil barrel and thickness of lead correspond. It is handy to have a pencil for each hardness that you want to use. You can also buy the pencils in a variety of colors to color code the hardnesses you are using so you know which is which.

Try Your Hand

If you live in an area where there's a paper specialty store, you'll want to stop by at some point. Take the time to feel the paper, to note its grain and texture. There's more to paper than meets the eye!

Artist's Sketchbook

Pencil **hardnesses** range from the very hard Hs, which you can use to make a faint line, to the very soft Bs, which are smudgier, ranging from 6H all the way to 6B. Regular pencils are numbered as to hardness on the point.

Eraser

A kneaded eraser is best. You may remember this type of eraser from grammar school days. Like kneaded bread dough, it can be stretched and pinched into shapes to get at whatever you want to change—even the smallest line—and should be considered as much of a tool as your pencils and paper. Don't settle for less than a good quality kneaded eraser. It's the cleanest way to erase—and you'll be doing lots of erasing!

Drawing Board

A simple piece of plywood ($^1/_4$" – $^3/_8$" thick) with sanded edges and that fits comfortably on your lap is fine as a drawing board. You can also buy masonite boards at any art supply store, a place you'll begin to frequent more and more. The important thing is to have a strong, flat, hard, smooth surface on which you can work without worrying about bumps and bruises.

A Few Other Things

Here are a few other art supplies you may want to consider buying now. They're not absolutely necessary this early on, but you may find them helpful.

➤ While you're up and about, you may want to buy some masking or artist's tape. Artist's tape does less damage to paper than masking tape, but the latter will work if you're picking up a few quick supplies along with the groceries and it's all you can find.

➤ A ruler will often prove helpful. If you haven't got a ruler, anything that offers a straight edge will come in handy sooner or later.

➤ A few strong clips to hold your work to the board are an alternative to taping and are handy to have. More on these later.

Exercises to Get You on the Right Side (of the Brain)

So you've got your pencil, paper, eraser, and drawing board or hard surface. It's time to get over to the right side—of the brain, that is. We're going to provide you with two exercises that will help you begin to see the difference between how the two sides of your brain see, the classic Profile/Vase-Vase/Profile exercise, and a copying exercise.

Profile/Vase-Vase/Profile

This drawing exercise is used by Betty Edwards and many other art educators to demonstrate the difficulty of drawing while the brain is functioning on its left side. The "logical left" is not helpful when it comes to visual tasks best given to the "relational right," as you'll discover when you take a stab at the exercise and experience your left brain trying to perform a right-brain task.

1. First, draw a simple profile, either the example here or an imaginary one.

2. As you draw, think about each part of the profile, naming them to yourself as you draw: forehead, eyes, nose, upper lip, mouth, lower lip, and chin.

Try Your Hand

If you go to an art store to purchase your first materials, let yourself look around and enjoy the place. Poke into the piles and boxes. Get acquainted with all the toys (they are toys, and you will like playing with them!). Don't be afraid to ask questions. Learning to explore this new territory is an important aspect of learning to draw—and it's fun as well!

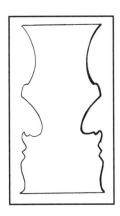

Here's an example of a profile/vase-vase/profile drawing. Yours may or may not resemble this one.

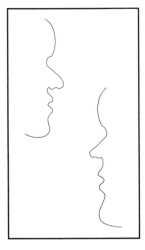

3. For this exercise to be most effective, right-handed people should work on a left-facing profile, and left-handed people should work on a right-facing profile.

4. When you've finished drawing the profile, draw a horizontal line at the top and bottom of your profile, moving out from the profile itself.

Draw a horizontal line at the top and bottom of your profile.

5. Now, retrace your profile, thinking again about each feature and naming it to yourself as you draw.

6. Last, switch sides and try to draw the mirror image profile that will make a symmetrical contour drawing of a vase.

Draw a mirror image of the profile.

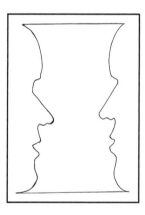

Reviewing the Exercise

Did you find this exercise difficult? It may surprise you to learn that most people do. That's because the naming of the parts of the profile while drawing gets us thinking on the logical left, the side of the brain that likes to name and organize everything. It thinks it has it all figured out: The forehead, eyes, nose, lips, and chin make a profile.

Repeating the names after you drew the horizontal lines on the top and bottom of the profile reinforces the left brain: Yes, that was it—forehead, eyes, nose, lips, and chin, a profile, all right—even with the lines!

Next, the quick switch to drawing the opposite, mirror-image profile is a problem. The logical left is confused by the task of repeating the profile backwards. This is a task that requires sensitivity to shapes and relationships, something the logical left is simply not good at. The profile is not the same as the other side; in fact, you may have found it difficult to draw it

at all. Plus, the vase isn't even symmetrical—something that strikes horror into the heart of the left brain (if it had a heart!).

You may have tried a tactic or two to complete the profile and make the vase symmetrical. If that's the case, how did you do it? Were you confused? Did you settle for a profile that was different? That would be letting the left side stay in charge of the profile, but the vase would end up asymmetrical.

Did you ignore the names for the parts and concentrate on the shapes? Did you concentrate on the vase and try to make the line symmetrical with the first side? Did you measure or mark the curves or relationships between the curves? Did you start in the middle or at the bottom and work backwards? Any of these solutions would have been right-brain approaches to the problem, paying attention to the visual and not what you thought you knew.

All right, we admit it: Your first drawing was a set-up, purposely a "left brainer," full of identification and names. To match it on the other, right side required a switch to the visual, to see the shapes instead of the names. Drawing is easiest when you think the least, and just see the shapes, without naming them.

The first profile is conceptual and imaginary, drawn from memory, but naming the parts makes it a left-brain activity. To really draw as you see, you must be able to make a perceptual or relational drawing, a right-brain activity. In order to match the shapes, relationships, and curves on the second side and make the vase symmetrical, you must focus your eyes and mind on the first profile in order to draw the second—and chances are, your left brain wouldn't let you do that.

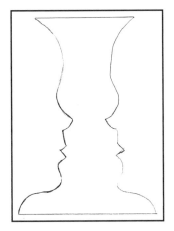

Try Your Hand

What this exercise asked you to do was make a shift mentally from your normal cognitive function—the left side—that named all the pieces, to the visual side—the right side—that cares about the shapes and the relationship between them. That's because the nonverbal right is better suited for the business of seeing than the linguistic left.

The left profile, the first one drawn, corresponds to the left side of the brain; the right profile, the one copied, draws on the right side of the brain.

The ability to switch modes of brain function is the ability to see differently. Once you master this switching, you'll find that it's very handy for all sorts of problem solving in your daily existence!

Student samples of the exercise drawn right-handed and left-handed.

The numbers indicate the order in which each profile was drawn.

Right-handed ————

Left-handed ————

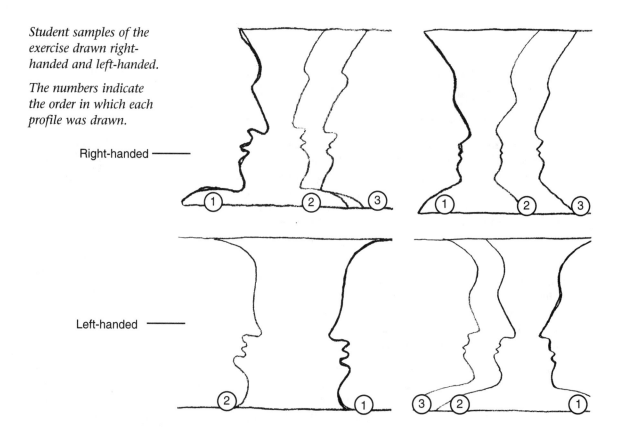

When the Familiar Gets Unfamiliar

Now that you're aware of the difficulty of doing a right-brain task while you're operating on the left, let's try an exercise that helps get you over the fence onto the right side.

We recognize and identify things in our world based on our familiarity with them. We see, identify, name, categorize, and remember, so we think we "know." That's fine for facts: names, dates, numbers, concepts, and ideas. For seeing and drawing, though, a more flexible, responsive way of observing is better, because things are not always as they seem.

Mostly, we're used to seeing things one way, right side up. Our left brain easily identifies an object and names it for us, and then we know what it is and feel confident and secure.

But the familiar becomes instantly unfamiliar when it's upside down or backwards. We expect to see it right side up and are confused when it's not. Upside-down shapes and relationships are strange to us because they're different from the memory we've stored from past experience. Our brain doesn't like them.

Right Side Up/Upside Down

Here are two exercises to help you see how you feel when the familiar is somehow changed.

Write your name (this is something you're used to).

➤ Now look at it in a mirror—is it hard to read?

➤ Look at it upside down. For some, this is even harder to read than a mirror image.

➤ Try looking at your signature upside down and backwards. Does it appear to be hieroglyphics or a foreign language—or no language at all?

Normal signature——— *Lauren Jarrett*

Try looking at your signature upside down and backwards. Here's Lauren's.

Upside down ———

Backwards ——— (in mirror)

Upside down and ——— backwards

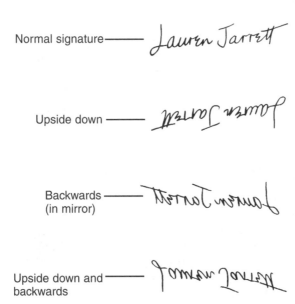

Now, look at yourself in the mirror. This, too, is what you're used to.

➤ Look at a photo of yourself; it will look slightly different because we are all a little asymmetrical, and the mirror image is the one we're most familiar with.

➤ Look at the photo of yourself upside down. Does this look a little odd to you?

➤ Now look at it upside down and in the mirror. This looks even stranger, doesn't it?

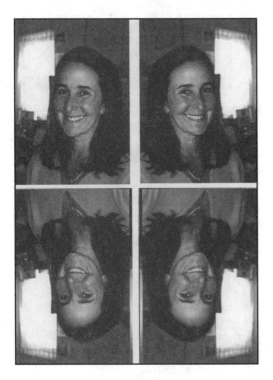

Photos of Lauren, right side up and upside down.

We know our world—or think that we do—because we can identify and remember. Upside down or backwards, things look a little odd or even unsettling, particularly faces and handwriting, because they're asymmetrical. Our logical left brain is easily confused when our memory is different from reality, and visual tricks or problems are frustrating. The organized memory is of no use here and often gives up or over to the relative right. For us, that's good news—it's just what we want to happen!

Copy a Complicated Drawing

When it comes to a complicated drawing with detail, proportion, and foreshortening, it can be much easier to copy the image upside down as forgers do, concentrating on the shapes and relationships rather than on the drawing itself, which can seem intimidatingly difficult. A complicated drawing can throw the logical left into complete revolt and send it packing. That's the idea behind this exercise—to see with the relational right.

Use these images to practice copying a drawing right side up and upside down.

1. Select one of the previous images above and copy it right side up.

2. Now, turn the same example image upside down.

3. Begin a new drawing of the upside-down image.

Here are some tips to try as you work on the upside-down image:

➤ Concentrate on the shapes, not the image.

➤ Don't try to draw the whole thing first and fill in the detail.

➤ Start where you can see a shape and draw it.

➤ Think about lines. Which way do they go? Do they curve or stay straight? Where do they connect to other lines?

➤ Where are the horizontals, the verticals? Which way do they go?

➤ Compare shapes rather than identify them. How do they relate to others?

➤ Work on one area at a time. You can cover most of the example drawing and only look at the part you are drawing.

➤ Resist the temptation to see how you are doing or even think about it.

➤ Try not to think at all. Just look and draw what you see.

Keep Up the Good Work

Your second, upside-down drawing should be a significant improvement over the first, right-side-up one. Problems like scale, proportion, likeness, and detail that were very difficult right side up are merely shapes and relationships when viewed upside down, and so they can be observed and drawn easily, one by one.

You may have just done the first drawing that you liked in years by concentrating on shapes and relationships with the relational right and sending the logical left off to sleep. Fascinating, isn't it? Amazing, even—and that's just the beginning. When you can send the logical left on vacation at will and concentrate on seeing what's there rather than what you thought you knew, you'll find the door to drawing swing open!

Exercising Your Right(s)

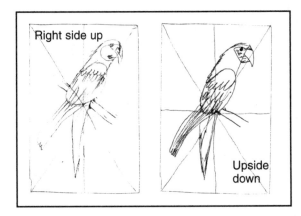
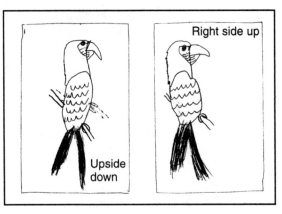

Right side up

Upside down

Upside down Right side up

Right side up Upside down

Right side up

Upside down

No two right-side-up/upside-down drawings are alike, as these children's student samples show. If yours doesn't look like any of these, in fact, that's great!

Now that you've begun to draw on the relational right, next comes a chapter of contour drawings, to do first without looking and then while looking. These drawings will help you further your newfound ability to see as an artist sees, using shape, space, and relationships.

Your Sketchbook Page

Try your hand at practicing the exercises you've learned in this chapter.

The Least You Need to Know

➤ In daily life we're taught to function on the analytical, verbal, left side of our brain.

➤ An artist, while working, makes a conscious shift in cognitive function from "logical left" to "relational right."

➤ Learning to draw is really learning to see as an artist does, on the right side of the brain.

➤ Creative thinking and problem solving can be useful in other areas of work and life, too.

Loosen Up

In This Chapter

➤ Warm-ups for the eyes and hand

➤ Drawing without looking

➤ Drawing while looking

➤ Farewell, left brain!

Drawing is a language without words.

—Harvey Weiss

Now that you've practiced switching from your left brain to your right, it's time to warm up your relational right for the exercises that follow in the rest of the book. Learning to draw is like any other skill; it's about practice, practice, practice—but it's a fun kind of practice.

To begin your practice, get out your paper and pencils, as well as your artist's board. In this chapter, we're going to doodle the night (or day) away, and bid Old Lefty farewell.

Now You See It

Remember when you were learning to write and the long practice sessions you put in before you mastered that skill? Your drawing hand also needs practice to make attractive and sensitive marks in reaction to your new awareness and observation. Calligraphers warm up before they work, to get their hand back into the swing of beautiful writing, and probably our friends the forgers do, too. So should you.

When practicing Palmer Method writing, try reproducing your signature upside down. Lauren uses blocks that spell the letters of her name, L A U R E N, which is fairly simple to copy. If you have any blocks around, whether in the attic or belonging to your children, you can try this, too. Arrange them upside down and copy the letters—as well as the pictures on them.

The Art of Drawing

Are you old enough to remember the Palmer Method? It was once the preferred method of teaching and practicing penmanship, based on observation of shapes and the practice of letter shapes, rather like practicing scales when you are learning to play the piano. Generations of schoolchildren (and the adults they became) can be identified by their careful o's and w's—not to mention their p's and q's.

Warm-Up for the Eyes and Hand

Just as you may have practiced your penmanship by forming a's or s's over and over again, why not try a page of marks before you start drawing? Practice circles and ovals and ellipses (a long, skinny oval, often a difficult shape to master). It is good for your hand to do a series of these, or of graduated sizes, chains of circles, concentric circles, spirals, eggs, bullets, and even some calculated squiggles.

Warm up your hand with a page of circles, ovals, spirals, ellipses, and similar curving lines.

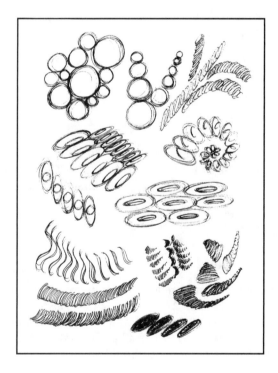

Next, try practicing other marks or kinds of lines you might find useful to make drawings:

➤ Straight

➤ Curved

➤ Parallel

➤ Crisscrossing or cross-hatching

➤ Overlapping

or

➤ Single

➤ Smooth

➤ Scratchy

➤ Wiggly

The separate lists are meant as two possible options of one's choice of marks. When you make smooth lines, you don't pick up the pencil from the page, but make a continuous smooth line, as opposed to scratchy lines, which require repeated lifting of the pencil.

Try them all—build up a vocabulary of lines and marks!

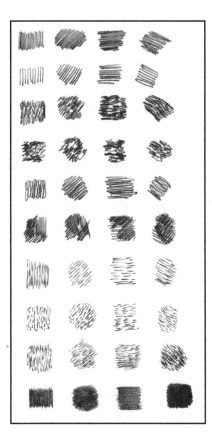

Doodle a page of marks and lines to warm up your hand as well.

Entering the Flow

If a certain kind of activity, such as painting, becomes the habitual mode of expression, it may follow that taking up the painting materials and beginning to work with them will act suggestively and so presently evoke a flight into the higher state.

—Robert Henri

One of the wonderful things about drawing is the tendency to move into a different, higher state of consciousness while working. The attentive, observant right brain focuses on what you are really seeing, rather than on what your left brain tells you, leaving you open to this lovely state and place.

Time seems to fade into the distance, and you can experience a rare floating feeling as you work, removed from the moment-to-moment world. Even music in the background can virtually disappear. Of course, almost any intrusion can swing you to left-brain reality; the phone ringing is the worst offender, but you can swing yourself back, too, just by seeing instead of thinking.

The Art of Drawing

When practicing marks, try to get your whole arm involved, not just your hand. Develop a sense of your hand, almost suspended above your paper, with just a light touch for stability. Let your arm move your hand as it works to make the marks. You will find that your line is smoother and can reach out further in any direction to follow an edge or make a shape without becoming fragmented and scratchy.

Drawing is a meditation, a way to get in touch with some of your innermost feelings and insights, and a rest from the concerns of our high-pressure lives.

To Begin

Before you begin drawing, you'll want to get yourself in a drawing state of mind. These steps can help you get yourself there. Because steps are a left-brained arrangement, you may want to record yourself saying these steps slowly and then play the recording when you want to arrive in this state.

1. Arrange yourself and your hand or subject.
2. Close your eyes and meditate for a few moments. Try to clear your mind of clutter.
3. Sit comfortably, and arrange your paper and board.
4. Relax for a moment. Try to forget about the rest of the world and the other things you need to do today.
5. Close your eyes for a moment. Breathe slowly and try to let all that you normally think about pass out of your mind.
6. Concentrate on the moment. Sit comfortably. Open your eyes.
7. Look closely at your subject. Try to see it as if you were looking at it for the first time.
8. Let your eyes travel around the outside of your object.
9. Try to see all the detail inside the outside shape.
10. Now, focus on a line. See how it curves. Which way? How long? Which line does it meet? Does it go over or under that line?
11. Try to see all the lines as special to the whole. Then place your pencil on the page and begin to draw.

Artist's Sketchbook

A **contour drawing** is any drawing in which the lines represent the edge of a form, shape, or space; the edge between two forms, shapes, or spaces; or the shared edge between groups of forms, shapes, or spaces.

The Next Set—Send Off the Logical Left

Here is a drawing exercise to buy an express ticket to send that persistent "logical left" packing. Your left brain will want to leave town, and not even call or write. Let it go; it is a nuisance.

You are going to try a *contour drawing* of your hand (not the drawing hand, "the other one," as Pooh would say). You are going to do this drawing without looking at your paper, not even once!

This exercise is one developed by Kimon Nicolaides in his book, *The Natural Way to Draw* (Boston: Houghton Mifflin, 1990). It is a way to completely concentrate on what you see, without looking to check, analyze, and judge your work. In other words, "just do it." Plan on about 10 minutes for each part that you try.

Contour Drawing of Your Hand—Without Looking

If you would like to really see what a difference it can make to concentrate on just seeing and drawing what you see, you can make a drawing of your hand before you start these exercises. Just do it, to the best of your ability, and set it aside. Then you can compare it to the second drawing that you do, when you can look again.

1. Start by setting up your area to draw. Your pad of sketch paper on your board and a pencil will do.

2. Seat yourself in a comfortable chair, angled away from your drawing board.

3. Take a good look at your other hand. Make a bit of a fist so that there are a lot of wrinkles in your palm.

4. Decide on a place to start on your hand, one of the lines on your palm, for example.

5. Put your pencil down on your paper. Consider that spot the same as the spot or line you picked on your hand. Once you've placed your pencil, don't look at the page again.

6. Look very carefully at the line that goes off from your starting spot.

 ➤ Which way does it go?
 ➤ For how far?
 ➤ Does it curve?
 ➤ How much?
 ➤ Is there another line that it meets?

7. Move your pencil, slowly, in response to what you see. Remember—don't look at the page!

8. Look at the lines in your hand one by one as they touch each other and try to draw exactly those lines that you are looking at.

9. Keep at it. Don't look!

Try Your Hand

One way you can gauge your absorption and higher state of consciousness is to set a timer while you are working on these exercises. Set it for 5 or 10 minutes to start. If the timer goes off unexpectedly, then, my friend, you have been off in the void!

Remain observant and sensitive to the wealth of linear texture, shape, and proportion in your hand, and try to put it into your drawing.

Keep working until you have drawn all the lines and shapes in the palm of your hand.

That it won't look like a hand doesn't matter. Your absorption in a purely visual task is what counts. Has your left brain left yet?

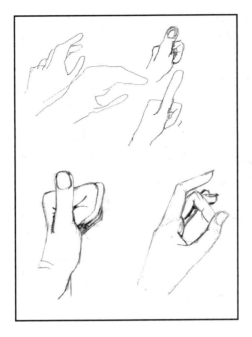

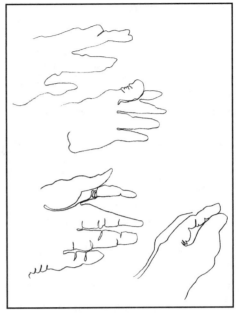

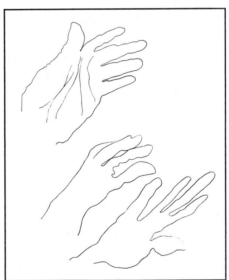

Here are some examples of students' contour drawings without looking.

Contour Drawing of Your Hand—While Looking

Now, take a stab at that drawing while looking. Hands as a drawing subject are usually avoided, but you can actually get a decent drawing if you do just as much looking and relating of one line to another as you did in the first exercise.

1. Change your seated position so you can rest your other hand on the table.

2. Take another good look at your hand and the lines in your palm.

3. Pick a place and a line on your hand to start with.

4. Pick a place on your paper to place your pencil and begin your drawing.

5. Make the same careful observations about your hand as before.

 ➤ How far does the first line go?

 ➤ In what direction?

 ➤ Does it curve?

 ➤ Which way?

 ➤ When does it meet another line?

 ➤ Then what happens?

6. Draw what you see, not what you think you see.

7. Work slowly and carefully until you have gone all around your hand and recorded all the lines that you can see.

Your drawing should have all the sensitivity that you put into the making of it. If you did a drawing of your hand before you began these exercises, take it out and compare the two. Your experience drawing without looking (and sending Old Lefty off again) should have helped with the second drawing of your hand while looking. The more you practice really seeing and drawing what you see rather than what you think you see, the better your drawings will be.

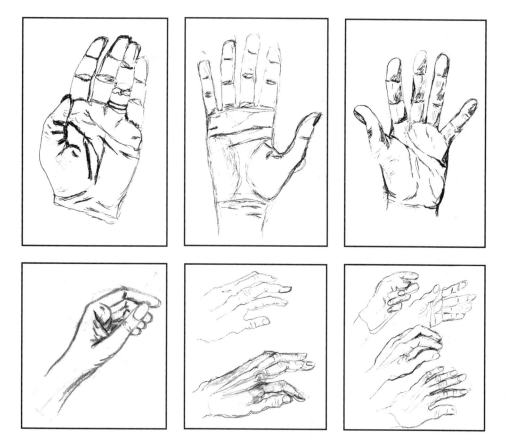

Here are some student contour drawings, done while looking, for you to ponder.

Another Set to Keep It Gone

The "it," of course, is that left brain of yours, just waiting for a chance to come back in and tell you what it thinks about all this drawing stuff. Keep it out of your life for a while. Try the same exercise, but with a household object, like a corkscrew or a pair of scissors. Pick an object with a complicated shape that will require the same careful looking and relating to shapes.

As you see and draw, your own innate creativity will be accessible to you. The specialness of your eyes and mind is a gift. Use it! You'll find that the pleasure of simple accomplishment in a high-tech world is a personal triumph.

Contour Drawing of an Object—Without Looking

If you would like to really see what a difference it can make to concentrate on just seeing and drawing what you see, you can make a drawing of your object before you start these exercises. Just do it, to the best of your ability, and set it aside. Then you can compare it to the second drawing that you do, when you can look again.

1. Start by setting up your area to draw. Your pad of sketch paper on your board and a pencil will do.

2. Seat yourself in a comfortable chair, angled away from your drawing board.

3. Take a good look at the object that you have chosen. Make sure that you cannot see the drawing itself as you draw.

4. Decide on a place to start on your object. One of the lines that makes the shape is a good beginning point.

5. Put your pencil down on your paper and consider that spot the same as the spot or line you picked on your object. Once you've placed your pencil, don't look at the page again.

6. Look very carefully at the line that goes off from your starting spot.

 ➤ Which way does it go?

 ➤ For how far?

 ➤ Does it curve?

 ➤ How much?

 ➤ Is there another line that it meets?

7. Move your pencil, slowly, in response to what you see. Remember—don't look at the page!

8. Look at the lines in your object, one by one as they touch each other, and try to draw exactly those lines that you are looking at.

9. Keep at it. Don't look!

10. Remain observant and sensitive to the wealth of linear texture, shape, and proportion in your object, and try to put it into your drawing.

11. Keep working until you have drawn all the lines and shapes in your object.

That it won't look like the object you chose doesn't matter; your absorption in another purely visual task is what counts. Has your left brain called home?

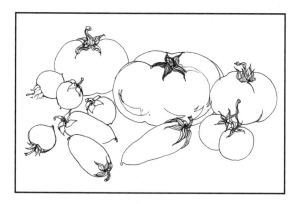
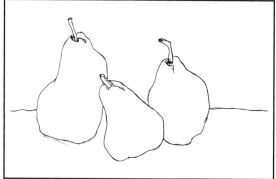

Here are some contour drawings of objects done without looking.

Contour Drawing of an Object—While Looking

Now, we'd like you try the same drawing, only this time, while looking. Even if it is a complicated object, you can get a decent drawing if you do just as much looking and relating of one line to another as you did in the other exercises.

The contour drawing while looking should be done with the same focus on seeing the lines, but you get to follow your drawing hand by looking. Stay focused on what you see.

1. Change your seated position so you can look at the object you are drawing.

2. Take another good look at your object.

3. Pick a place and a line on your object to start with.

4. Pick a place on your paper to place and begin your drawing.

5. Make the same careful observations about your object as before.

 ➤ How far does the first line go?
 ➤ In what direction?
 ➤ Does it curve?
 ➤ Which way?
 ➤ When does it meet another line?
 ➤ Then what happens?

6. Draw what you see, not what you think you see.

7. Work slowly and carefully until you have gone all around your object and recorded all the lines that you can see.

Back to the Drawing Board

Looking while you're doing the "blind" contour drawing is just the chance Old Lefty needs to come back in and try to tell you what you're doing wrong. The point here is to do a drawing that has nothing to do with anything—except seeing the lines.

As with your first set of drawings, you'll find that the more you practice really seeing and drawing what you see rather than what you think you see, the better your drawings will be. To tap into your creative energy and realize your potential is a great power, one you can use for more than just drawing.

You may feel tremendously energized by the process. You can use this creativity to solve problems of all kinds, by looking at all sides of a problem rather than seeing things in the usual ordered way. You'll be able to see the big picture, moving beyond the concepts to the relationships.

We've provided a set of sample contour drawings of objects done while looking.

Farewell, Old Lefty

These exercises should have made Old Lefty head for the hills for good. They also should also have shown you some beginning practice at seeing and relating shapes and lines, whether you were looking at your subject or not.

In the next chapter, we'll be taking a look at using the plastic picture frame, a surprisingly simple method of projecting an image onto paper.

Your Sketchbook Page

Try your hand at practicing the exercises you've learned in this chapter.

The Least You Need to Know

➤ A warm-up for your eyes and hand is a good way for beginning artists to start a drawing session.

➤ Drawing brings you into a higher state of consciousness.

➤ Contour drawing focuses your attention and observation, while switching your cognitive brain function from the "logical left" to the "relational right."

➤ Looking carefully at the detail in any drawing subject will keep you working on the right side.

➤ You can see as an artist does and keep the left side out of the mix.

Part 2
Now You Are Ready to Draw

It's time to meet some of the tools of the trade, including the view finder frame and the plastic picture plane. We'll show you how to make your own view finder frame and plastic picture plane to take with you wherever you go, and how to use both of these tools to help with your drawings.

Your first drawings will concentrate on learning to see an object in space, using a contour line to describe the shapes, and looking at the negative spaces in and around those objects.

If you've come this far, you've already developed some real drawing skills. Now it's time to start thinking about your studio and some more materials for your new work.

The P
Plane

In This Chapter

➤ What is a picture plane?

➤ Building a picture plane

➤ Using a picture plane

➤ Transferring your drawing to paper

What the eye can see, the hand can draw.

—*Michelangelo*

If Michelangelo said it, it is so. If you can learn to really see, you can draw. It's that simple.

In Chapter 3, "Loosen Up," drawing the lines that are on your palm was an experience in learning to really see, by taking the time to see each line in your hand. Drawing is about detail and relation, represented on paper as a direct response to what you see—nothing else—just what you see. Drawing your hand should have become easier after all that concentrated seeing!

It may surprise you to learn that artists don't always draw freehand. There's even evidence that, as early as the fifteenth century, artists such as da Vinci may have been using picture plane-like devices to project images onto paper.

In the next two chapters, we'll be showing you how to make and use similar devices of your own. In this chapter, we'll be discussing the plastic picture plane, and in the next chapter, the viewfinder frame.

at Is a Picture Plane?

Instead of beginning with a definition, we will explore the *picture plane* and how to use it to see even more clearly and easily.

You will need:

➤ A piece of Plexiglas 8" × 12". You can get a few pieces. A larger piece can be handy because you can rest it in your lap and work on the top half. Try a few sizes. Later in this chapter you may find the larger piece works better for you.

➤ A fine-point permanent marker, like a Sharpy or fine laundry marker.

➤ A fine-point washable marker that will hold a line on the plastic.

How to Use a Picture Plane

For a dramatic example, we will begin with that hand of yours. Hands are good models; you don't have to pay them much and they are always available.

1. Place your hand comfortably on a table (keep the Plexiglas and the washable marker at reach). Scrunch, ball, twist, or turn your hand into the hardest position you can imagine (or not imagine) drawing. Find a position with a lot of *foreshortening*—your fingers coming straight out at you—and imagine trying to get it to look right. You can add a prop, if you'd like, something difficult to draw, like scissors or a corkscrew.

2. Uncap the washable marker.

3. Put the piece of Plexiglas on your posing hand, with or without a prop, and balance everything as best you can.

4. Stay motionless except for your drawing hand.

5. Look through the plastic at your hand. Then look at your hand *as you see it on the plastic.*

6. Close one eye and carefully draw exactly what you see directly on the plastic. Take your time. Draw each line that you can see of your hand and whatever you are holding.

7. Draw only what you can see on the plastic.

8. Keep going until you have drawn every line you can see.

Shake out that poor modeling hand and take a look at your drawing. A difficult, foreshortened, even contorted, position of your hand and whatever you were holding should be clearly visible on the plastic. You have drawn your hand in drastic foreshortening because *you drew only what you could see on the plastic*—the picture plane between you and your hand.

Artist's Sketchbook

A **picture plane** is the imaginary visual plane out in front of your eyes, turning as you do to look at the world, as if through a window. Leone Battista Alberti, a Renaissance artist, found that he could easily draw the scene outside his window by drawing directly on the glass. He called it "a window separating the viewer from the picture itself." And German Renaissance artist Albrecht Dürer was inspired by the writings of Leonardo da Vinci and designed himself a picture-plane device.

Back to the Drawing Board

Try out all these items in the art store where you get the Plexiglas. Say we told you to do it! They may think you're crazy, but you don't really care and you can consider it the beginning of building your reputation locally as an artist. We are all a bit crazy; it's part of the fun.

A hand drawn on a picture plane.

If you did it once, you can do it again. Try another. Each one will be easier. Fill your piece of Plexiglas with drawings of your hand, or start a new piece. Keep the best one or two, and compare them to the first hand drawings that you did, the drawings of your palm, and the drawing of your hand after you drew your palm. You should see a change!

Hand drawings done on Plexiglas can be placed on a copy machine or scanner for duplication.

Historical Uses of Drawing Devices

From the High Renaissance's Albrecht Dürer to the Impressionist's Vincent van Gogh, the old masters made good use of various drawing aids and devices. Mind you, they were still great draftsmen, but they had their tools, not unlike what we are using.

In reality, the picture plane is a visual concept, an imaginary, clear surface that is there in front of your face, turning with you wherever you look. What you see, you see on that surface, but in reality the view extends backwards, from there into the distance.

When you "see" on the picture plane, you visually flatten the distance between you and what you see. Quite a trick? Not really. It's like a photograph, a *3-D* view on a *2-D* surface. You see the 3-D image (in space) as you look into the distance, but you see the 2-D (flat) image of it on the picture plane. You can draw what you see directly on the plastic picture plane, then eventually on paper.

Easy, huh?

Artist's Sketchbook

Foreshortening is the illusion of spatial depth. It is a way to portray a three-dimensional object on a two-dimensional plane (like piece of paper). The object appears to project beyond or recede behind the picture plane by visual distortion.

The Art of Drawing

The development of photography grew out of early experiments with the picture plane and lenses which were used to project an image down on to a piece of paper, something like a projector does today. It is now thought that the old masters used projector-like devices to help capture likeness, complicated perspective, or elaborate detail in their very realistic paintings. After the development of the camera, artist interest began to move away from perfectly represented realism to more expressive ways of seeing and painting.

Try Your Hand

If you want to keep one of your picture plane drawings as a record, you can try putting it on a copy machine or a scanner. Or, you can place a piece of tracing paper on the plastic and make a careful tracing of your drawing.

Artist's Sketchbook

2-D is an abbreviation for two-dimensional, having the dimensions of height and width, such as a flat surface like a piece of paper. **3-D** is an abbreviation for three-dimensional, having the dimensions of height, width, and depth, an object in space.

What you see on the picture plane is magically "flattened." This is because the distance between you and what you see and the distances or space within the subject are foreshortened.

How a Picture Plane Works

To get a general idea of how a picture plane works, grab a new piece of Plexiglas or clean off the one used for the previous exercise if it's the only one you have.

1. Hold the piece of Plexiglas evenly in front of your face.
2. Look around the room, at a corner, at a window, at a doorway to another room. Look at a table from the corner, across or down the length of it. Look out into the backyard or go look down the street or up the hill.

All that you can see on the plastic picture plane is drawable, first on the plastic, and then, when you've got the hang of it, directly on paper.

So, we will start with a few additions to your piece of plastic and set up for drawing.

Preparing a Plexiglas Picture Plane for Drawing

For this exercise, you will need

➤ An 8" × 12" piece of Plexiglas.
➤ A fine-point *permanent* marker.
➤ A fine-point *washable* marker that will hold a line on plastic.
➤ A ruler.

To make a grid on your picture plane:

1. Draw diagonal lines from corner to corner on the piece of plastic with the permanent marker.

First, draw a set of diagonal lines.

2. Measure and draw center lines vertically and horizontally in the center of the plastic.

Add horizontal and vertical lines to the diagonals.

3. Measure and draw lines dividing each of the four boxes you now have on the plastic. The boxes will be 2" × 3" vertical.

Divide each grid into boxes.

Back to the Drawing Board

To draw on the plastic picture plane, you must keep it as motionless as possible—and you mustn't move either. You'll be looking at a single view, and the hardest thing will be to keep still enough for that single view to remain static. You can try propping the picture plane on a pillow or books if it's a small piece. If it's a larger one, simply set it on your lap.

Make sure your picture plane is even with your eyes and that it's resting straight up and down at a level you can see your subject through. Prop it up on a book or two if you need to. This is where a longer piece of glass might be handy.

Your drawing will be done on the plastic picture plane with the washable marker. The permanent grid is there to help you see relationally—that is, how one shape relates to another. It will help you transfer the drawing to paper when you are finished. Right now, the grid will get you used to seeing where things are in an image or a drawing, and eventually you won't even need it.

Isolate a Subject with the Picture Plane

Now you are ready to try one of the drawing devices favored by the old masters. This is an exercise that will help you get the idea of the picture plane in your mind's eye—or is it your eye's mind?

1. Look around the room and decide on a first subject. Don't get too ambitious at first. A corner of a room might be too much; try a table or a chair, or a window at an angle.

2. It is absolutely necessary that you're able to keep the plastic picture plane at your eye level and that it be still. Rest it on a table, or hold it straight up and down at a level that you can see through and draw on at the same time.

3. Once you have situated yourself and your subject, close one eye and take a good long look through your picture plane, particularly at the parts that would seem hard to draw, either because of angles, complicated shapes, distortion, detail, or perspective. Try to get back to just seeing, but really seeing, and just what you can see, not what you think.

4. See the image through the lines that you put on the picture plane, but try to note where things are relative to the lines:

 ➤ What part of the image is in the middle?

 ➤ What part is near the diagonal?

➤ What part is halfway across?

➤ On which side of each grid is each part?

➤ Does a particular line go from top to bottom or across?

➤ Does a curve start in one box and travel to another before it disappears?

➤ And then what?

5. Uncap your marker and decide where to start. It should be a shape that you are quite sure of, one you can use to go to the next shape, one you can see your way from to where it connects with another. See where it is relative to your grid of lines.

6. Start to draw your subject, line by line. See how one line goes into another, over or under, curved or straight. The marker line will be somewhat thicker than a pencil and a little wobbly because you are working vertically, but no matter, just draw what you see.

7. Keep going at it at a nice easy pace, concentrating but not rushed. You should be having fun now. Are you?

When you have put in all that you see in your object, take a moment and observe the accuracy with which you have drawn a complicated drawing. Try to see where the plastic picture plane made it easy for you to draw a difficult part, like a table in perspective, or the scale of two objects, or the detail on the side of a box, or the pattern of a fabric that was in folds.

These potential problems are no longer problems, once you really see and really draw what you see.

Do you like your drawing? Would you like to keep it? How about transferring it to a piece of paper?

Back to the Drawing Board

If all this holding still and seeing through seems like a lot of requirements, think about those poor old masters lugging a much more cumbersome glass version of a picture-plane drawing device out into the fields. Then you will be happy that you have a nice table to work at—and presumably a nice cup of hot coffee, thought by many to be an essential.

Here are some sample drawings done on Plexiglas picture planes.

Transfer the Drawing to Paper

To transfer your picture plane drawing to paper, you will need

➤ A piece of paper, preferably 11" × 14".

➤ One of those new mechanical pencils, with HB or B lead in it.

➤ A kneaded eraser.

➤ A ruler.

1. Measure and draw the center vertical and horizontal lines on your paper. A piece of 11" × 14" paper would have a vertical center line at 5$\frac{1}{2}$" and a horizontal at 7".

2. Measure and draw a box that is 8" × 12," centered, or you can put your piece of plastic directly onto the paper, line up the center vertical and horizontal lines, and trace the outside edge of the plastic for your box.

3. Draw the diagonals in your box. Then measure and draw the secondary lines to divide the four boxes, just like the grid. Are you getting the idea of what we are doing?

4. Put your drawing on the plastic up in front of you, as vertically as possible.

5. Start copying your drawing onto paper, using the grid to see the relations between things and lines that you drew on the plastic.

6. Don't let your mind (Old Lefty!) trick you into drawing anything differently because you're not on plastic anymore. Don't think—just see and draw. Work lightly, and if you get lost, go back to the grid to see where you should be. It's fine to erase when necessary. Keep drawing the lines from the plastic.

7. When you have drawn as much on your paper as you had on the plastic, take a moment to assess your work.

 ➤ Can you see how the grid helped you to transfer your drawing from the plastic to the paper?

 ➤ Could you begin to relate one line or shape to another or to the lines on the grid?

 ➤ Did it help to have the grid to establish distance or relation between things as you copied your drawing?

8. If you are happy with the pencil drawing, you can add more to it by looking back at your subject, but make sure that you draw relative to things that you see—no fudging or filling in just to fill in. If you can see something to add, fine, otherwise leave it.

The Art of Drawing

Another exercise to try is drawing an object or a person through a plate glass door—right on the door! You'll be amazed how easy it is to draw on the glass (don't use permanent marker, though). The subject on the other side will come out very small unless you and it are quite close to one another on either side of the glass. You can adjust yourself and your subject as you like, of course. And you can make a tracing on tracing paper after you've gotten the main lines on glass.

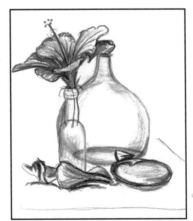
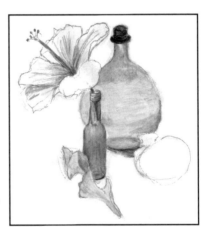

Here are three drawings by three different students transferred from Plexiglas to paper.

When you're finished, put your drawing aside to compare later. These exercises can be repeated as often as you like; you will only get better at seeing and drawing.

In the next chapter, we will add a viewfinder, another handy item for helping you to see what is there and to draw it.

Your Sketchbook Page

Try your hand at practicing the exercises you've learned in this chapter.

The Least You Need to Know

➤ A picture plane is the imaginary visual plane out in front of your eyes, turning as you do to look at the world, as if through a window.

➤ When you see through a Plexiglas picture plane, 3-D space is condensed into a drawable 2-D image.

➤ Drawing on a plastic picture plane is a step to seeing the space and shapes and relationships in the drawing.

➤ You can transfer your picture plane drawing to paper, if you like.

Finding the View

In This Chapter

➤ What is a viewfinder frame?

➤ Materials to get you started

➤ How to use a viewfinder frame

➤ Drawing what you see in the viewfinder frame

Drawing should suggest and stimulate observation.

Bernice Oehler Figure Sketching, *(Pelham NY: Bridgman Publishers, 1926).*

Working with the plastic picture plane has shown you 3-D space condensed into a drawable 2-D image on the surface. But it's also shown you the beginnings of another concept that's important to drawing—looking through a frame to see your subject.

In this chapter, we'll be exploring the concept of a viewfinder frame. Using a viewfinder isn't cheating. As artists have known for centuries, it's a way to help you see spatial relations and make your drawing more accurate.

A Viewfinder Frame

A *viewfinder frame* is a simple device that will help you decide on a subject to draw and then focus on it. As we discussed in Chapter 1, "The Pleasures of Seeing and Drawing," framing an image makes it easier to see, and the graduated marks on the edges of the viewfinder frame give you reference points for relations between lines and shapes, rather like the grid on the plastic of the picture plane, but requiring more clear seeing on your part.

Seen through a viewfinder frame, the main points of an image can be drawn on paper using the graduated marks. The important thing is to have the viewfinder frame and your paper or the box that you draw on it in the same *proportion,* so that the relative positions and placement do not change.

Making a Viewfinder Frame

A viewfinder can be as simple as your two hands held up to make a frame. Through your hands, you see only what is framed by them.

You can make a simple viewfinder using only your hands.

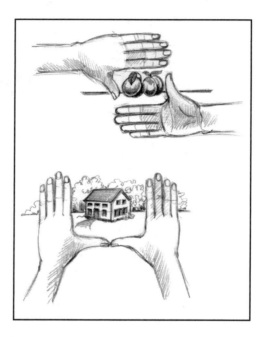

If you want to use more than just your hands, but don't feel like leaving home to buy anything, you can make a simple viewfinder frame with two L-shaped pieces of mat board, shirt cardboard, or even from the sides of a cardboard box.

To make any viewfinder frame, you will need

➤ Cardboard or mat board.

➤ A ruler, preferably metal that you can cut against.

➤ A mat knife or utility knife. You can use scissors but you will get a better edge with a knife and you will use it constantly as time goes on.

Got your materials? Okay. Just follow these simple steps to make your viewfinder frame:

1. Cut pieces of mat board or cardboard into a few sizes for different sized windows (10" × 13" for a 6" × 9" window, 12" × 14" for an 8" × 10" window, 13" × 16" for a 9" × 12" window, etc). These are standard proportions, but you can also cut a longer one (8" × 14" for a 4" × 10" window, or 10" × 16" for a 6" × 12" window, for example), if you'd like.

2. Measure and draw the diagonals and the center lines as you did on the plastic picture planes.

Artist's Sketchbook

A **viewfinder frame** is a "window" through which you see an image and can relate the angles, lines, shapes, and parts to the measuring marks on the frame and to each other. It is as simple as using your two hands to frame a view or making a cardboard frame.

Here are diagonals and center lines drawn on a rectangular board.

3. Measure and cut framing windows in the cardboard, leaving 2" on all sides.

Now we've cut a window in our board.

4. You can choose which proportion frame to use for each drawing. What you see through the frame will vary according to how close or far away you are from the object/view.

 Keeping your viewfinder frame and your work in proportion is easy. Diagonals drawn across a rectangle will extend in proportion out to larger but proportionally equal rectangles.

Here's a rectangle with a diagonal that extends out into larger rectangles.

5. Measure and then lightly draw the center lines on your piece of paper (for 11" × 14", they will be at $5^{1}/_{2}$" and 7").

6. Line up the center lines of your viewfinder frame with the center line of your piece of paper.

7. Use a long ruler to extend the diagonal lines of the viewfinder frame out onto your paper.

Diagonal lines from the viewfinder frame extended out onto the piece of paper.

Artist's Sketchbook

Proportion is the comparative relation between things; in a rectangle, for example, it's the comparative ratio between the height and width. Rectangles of different sizes that are in proportion share the same ratio in their height and width.

8. Starting from any corner, anywhere along the diagonal, you can now draw a rectangle that is larger than the viewfinder frame but in proportion to it, whatever the proportion of the paper. Just make sure that all your lines are *square*.

Another way to create diagonals is to put the viewfinder frame in the corner of a piece of paper and draw one diagonal out from that corner. Rectangles drawn from that diagonal will be in proportion to the original (the viewfinder frame). You can use this method to decide on the best-sized piece of paper you want to use for a particular drawing after you have selected the viewfinder frame.

Eventually, you won't need to draw a box unless you find that you like to draw in them.

Extending the diagonal from your viewfinder frame will show you whether the viewfinder frame and the piece of paper are in proportion or not. Understanding proportion is worth the time.

The Art of Drawing

You can fasten the pieces of cardboard of your viewfinder frame together with paper clips or brass fasteners in any size or proportion and turn the frame horizontally or vertically. That way, it will break down and pack easily for outings, which will be handy later. Having a few viewfinder frames on hand allows you to see the relative differences in proportion and helps in deciding which works best for a particular image or for a particular paper format.

A simple viewfinder frame can be made by fastening two L-shaped sections of cardboard together with paper clips.

Using the Viewfinder Frame

Now that you've done all that and made a viewfinder of your own, let's try to use the viewfinder frame to make a drawing.

1. Decide on an object; a wooden chair would be a good choice for this exercise.

2. Position yourself, your drawing materials in front of you and the chair out in front of you at an angle (45 degrees) so that you can see the whole chair.

3. Pick a viewfinder frame that surrounds the chair quite closely on all sides.

4. Draw a proportionally equal rectangle on your paper.

5. Reposition the viewfinder frame until the chair is nicely framed within the window and spend some time really seeing the chair through it.

6. Close one eye and do the following:

 ➤ Observe the diagonals and center marks on the viewfinder frame.

 ➤ See where the chair fits against the sides of the frame.

 ➤ See where each of the legs touch the floor relative to the marks on the frame.

 ➤ Where is the top of the chair?

 ➤ Look at the angle of the top of the chair compared to the top edge of the frame.

7. Begin to draw the chair on your paper in the same place as you see it in the frame. Use the frame to know where a particular piece of the chair belongs. Draw what you can see in the frame—that's all.

Try Your Hand

By retaining the proportion, a drawing can be much larger than the image in the viewfinder frame—in fact, any size you would like it to be.

Artist's Sketchbook

Square is 90 degrees, at right angles, as in the sides of a rectangle. Measuring carefully off the center lines helps keep your rectangle square.

Back to the Drawing Board

Work carefully. Each line is dependent on the accurate seeing and drawing of the line before it. If you need to correct something, do it—don't leave it to haunt you later. Try to see each part in relation to the frame and all the other parts.

8. Draw imaginary lines between the feet of the chair and measure those angles against the sides of the frame. Look at the legs of the chair and make sure they are vertical.

9. Carefully note the following:
 ➤ Where is the seat?
 ➤ How far from the center horizontal line is it?
 ➤ And the back of the seat? Draw the angle of the sides relative to the marks on the frame.

10. Add each part of the chair relative to the frame and the rest of the drawing itself.

11. Add details, like the rungs across the legs, as you can really see them and relate them to what you have drawn. *Take your time.*

When you've finished, you should have a more accurate drawing of that chair than you expected. It should be sitting on the floor convincingly with the legs vertical and the seat looking comfortably level.

Here are some chairs and a ladder drawn by students using view-finder frames for the first time.

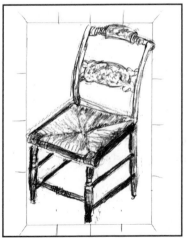

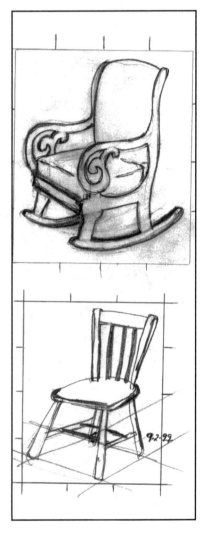

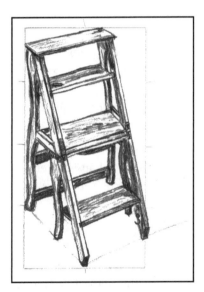

Draw What You See in the Viewfinder

You may want to try a wooden armchair, rocking chair, small stepladder, a picnic table, or even a gateleg table for a little more challenge. Pick a differently proportioned frame to see how you do. Experiment a little—it's easy.

Next, an excursion into space ... or at least your perception of it.

Your Sketchbook Page

Try your hand at practicing the exercises you've learned in this chapter.

The Least You Need to Know

➤ A viewfinder frame helps you single out an image—an object, a collection of objects, or a more complicated view.

➤ The proportion of the viewfinder frame and the box for your drawing must be the same.

➤ You can see, measure, and draw the parts of an object relative to the marks on the viewfinder frame and the marks on your paper.

➤ The viewfinder frame keeps you seeing the parts and lines in relation to each other.

Negative Space as a Positive Tool

I have learned that what I have not drawn, I have never really seen, and that when I start drawing an ordinary thing, I realize how extraordinary it is, a sheer miracle.

—Frederick Frank, The Zen of Seeing, *(New York: Vintage/Random House, 1973)*

Let's be positive about this. In space, "negative" is not a bad thing. This chapter is about shape and space. Really seeing both of them is a great step in learning to draw. In fact, from a drawing perspective, you should think of shape and space as interchangeable:

Positive Shape = Negative Space

Positive Space = Negative Shape

Find Your Space

Your brain speaks to you constantly, reminding you of what you know about everything. That's fine for tasks that require verbal skills and linear, logical thinking. But seeing and drawing are visual skills, requiring relational, visual processing of information. And seeing a concept like *negative space* is definitely a job for the right side of the brain.

In Chapter 4, "The Picture Plane," you tried drawing a complicated object in a foreshortened view (fingers pointing at you) on the plastic picture plane. On the surface of the plastic, the 3-D shapes and space of your hand were condensed into two dimensions, and were

easier to see and draw. In Chapter 5, "Finding the View," you drew a chair inside the viewfinder frame and used the marks on the frame to help you establish where all the lines and shapes were, and how they all related to one another. Both exercises have helped you to see and draw what you saw, rather than what you thought.

Artist's Sketchbook

Negative space is the area around an object or objects that share edges with those objects or shapes.

The Virtues of Negative Space

We all have minds full of preconceived ideas about how things are. We often deal in symbols and abbreviations for things—as long as we can identify them and they suit our needs.

For seeing and drawing, though, what we *think we know* is not a help, but a hindrance. It is Old Lefty butting in to tell what he knows. And what does he know? Sure, he has the chair in his head—the size of the seat, the length of the legs (all equal), and the arrangement of all the other shapes. But when seen at an angle in space, everything is different. The seat of a chair is a *parallelogram,* not a square. The imaginary line between the four feet is also not a square, but another parallelogram. The shapes and spaces are not equal—you saw that as you drew your chair with the viewfinder frame. So, as usual, it is best to get Old Lefty out of the process of seeing and drawing.

Parallelograms.

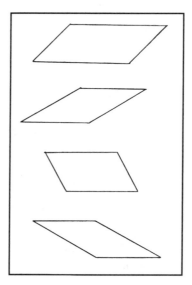

Learning How to Use Negative Space

Drawing the negative space around an object is a great way to send Old Lefty off again. Why? Because you, and particularly Old Lefty, don't know anything about those spaces. Certainly you have no memory or preconceived notions of them; you have probably never even looked at them. But they are there all right, and they can be mighty handy as guides to seeing and drawing.

For now, those spaces will confuse Old Lefty, and that's what we want. And because you will get no help from Old Lefty, you are free to see—really see—and then, to draw what you see. Once you try it, you will realize that there is something strangely liberating about drawing what isn't there instead of what is. You'll be wondering what is and what isn't, and that's not a bad thing.

The Art of Drawing

As drawing becomes easier for you, the negative space in a more complicated composition is even more important. Compelling arrangement of shapes in great paintings is as much the arrangement of space as shape. The more you see negative space in composition, the better the composition will be.

Select an Object to Draw: They're Everywhere!

So, let's start with another chair. Pick a rocking chair, or an armchair with curves, or a stool, or a canvas beach chair, or a table with crossbars underneath, or a stepladder—something with spaces within it. Objects like this are everywhere, so you shouldn't have any trouble finding one to draw.

Remember to position yourself properly—materials near at hand, your subject out where you can see it, and your paper in front of you. Rather than looking over your working hand, righties should look to the left and back to your paper, and lefties should look to the right and back to your paper. All set?

A View Through the Viewfinder

Pick a frame that is close to the proportion of your chosen object (a tall, thin one for a stepladder or a more square one for a wide rocker with arms). Adjust yourself so the chair (or whatever) almost fills the frame.

1. Measure and draw (lightly) the center lines and the proportionally equal box from your frame, using the diagonals extended out from the frame to establish the diagonals on the paper.
2. Then draw the box, any size along the diagonal that you want, which will be in proportion with the frame.
3. Your plastic picture plane can come in handy here. Make sure that the grid matches the proportions of the viewfinder frame, or draw a new grid to the same proportions. You can use the plastic picture plane to check yourself as you work.

Back to the Drawing Board

It is our concepts and memories of things—our habits and our modes of perception (basically the realm of the left side of our brains)—that make seeing and drawing seem difficult.

Artist's Sketchbook

A **parallelogram** is a geometric shape having four sides. Each pair of opposite sides is parallel and equidistant to each other.

Draw the spaces between your chair and the edges of the frame and all the spaces within the chair itself—a study in relativity. You'll see.

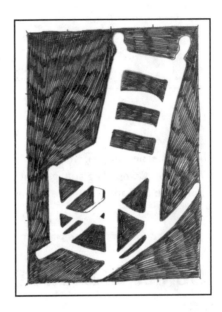

Where to Start—Location, Location, Location

Basically, you start with a spot and a shape—of negative space. Perhaps we can call this a "spot of space," a basic shape that you can see, from which you can proceed to the next.

We will base our "seeing" of the negative space on this first "spot of space."

Remember that it is a "spot of space" somewhere in or around the chair.

Back to the Drawing Board

Drawing in, and being sensitive to, a format such as negative space is a common problem in beginning drawings. The concentration and focus are on the object and the background is filled in later. But this method often results in the image being poorly placed on the page. No consideration is given to the siting of the object on the page, and the negative space around the object is not part of the arrangement. Usually, it's not considered at all!

1. Hold the viewfinder frame very still and frame the chair in the window. Rearrange the chair if necessary to see it at an interesting angle. See the relative angles of the seat, the back, and the legs.

2. Try to pick a spot of space somewhere inside your chair to start, and really see it. Maybe it is the space between the rungs on the ladder, or between the slats of the back of a rocking chair. Close one eye and "see" that spot until it becomes more real than the chair. You will know when this has happened because it will pop forward as a spot of space while the chair itself will fade or recede.

3. Now see where that spot is relative to the grid lines on your viewfinder frame. You can also look at the spot through your plastic picture plane to isolate just where it is relative to the grid. If you choose, you can draw your spot on the plastic first and then transfer it to the paper after you see how it works.

 Or, you can do your "seeing" through the grid on the plastic and draw the negative spots of space on your paper; it will be a little easier to see where the spots of space are on the plastic grid.

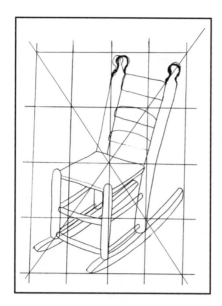

Holding the viewfinder very still, frame the chair within it so that there is an interesting angle.

4. Either way, use the grid on your paper to draw the first spot of space on the paper.

5. Think relatively and relationally. Try to see where your spot is relative to the marks on the frame, the grid on the plastic, and the light lines on the paper.

Draw the Holes, not the Thing

Check your spot of space shape and the lines that make it, the angle, whether they curve or not, which way, and how far. Check again against the frame. Even if your drawing is larger than the frame, the two are in proportion, so all the relative positions will be the same.

Now, stay focused on the space. As for the chair … forget about it! Keep one eye closed and find your next spot of space. Find the shape of that spot by seeing it relative to your grid marks. Draw the holes, not the thing.

Here are some things to consider as you draw the negative space:

➤ Try to not think about the chair itself. Think about comparing the shapes of the negative space and the edges of those shapes. Are the lines horizontal or vertical? If they aren't, try to see the angle relative to horizontal or vertical and draw what you see.

➤ Gauge any shape—its lines and angles, curves, or lengths—by seeing it relative to the horizontals, verticals, and diagonals. Begin to see new shapes of negative space relative to the ones you have already drawn.

➤ Draw each new space shape as you can see it. Work carefully, checking each new shape, and remember that they are all in relation to each other.

Try Your Hand

If you are confused, you can take a moment and look again through the plastic picture plane. You can draw the shape of the space there and then transfer it to paper. If you can see where it *is* on the plastic, draw the shape of that spot of space on your drawing.

➤ Don't think about the chair at all.

➤ If you talk to yourself while drawing, talk to yourself about the relationship between lines and shapes of negative space. Otherwise, don't talk at all. Enjoy the process of real visual thinking, just seeing and drawing shapes of negative space that you have never seen before.

Back to the Drawing Board

If you get confused or have a problem, remember to see the shape relative to the guides—the marks on the frame, the grid on the plastic, the grid on your drawing, and the parts of your drawing that you are sure of.

See the Object Through the Space Around It

As you draw more and more of the negative space shapes, it will be easier and easier to fit in the remaining ones. The spaces around your chair will be defining the chair itself!

When you have drawn all the negative spaces on your drawing, check each one in turn against the chair itself. Make small corrections to the shapes of the negative spaces as you see them. You can lightly shade the negative space shapes as you refine them, if you'd like. Your chair will take turns with the space around it; one will appear positive and the other negative, then they will flip.

When you are finished, your drawing will be a very different record of seeing. The chair will come out of the space you have drawn around it.

Here are some drawings done by Lauren and two students, concentrating on negative space rather than on the object itself.

Each negative space drawing is another chance to really see rather than think your way through a drawing. By concentrating on the negative space shapes, you can see relationships that will make drawing difficult things easier. Practice in considering negative space will steadily improve your ability to select an image, arrange an interesting composition, place it well on the page, and draw!

Getting Negative

Next, try this exercise with a complicated kitchen gadget like an eggbeater or a handheld can opener. Try a pair of glasses on a table. Try a bicycle for a real challenge. The important thing is to concentrate on the negative space rather than the object itself.

As you can see, drawing the negative space can make a difficult drawing easy, particularly when it comes to foreshortening or complicated shapes, because you can focus on the space to tell you, visually, about the shapes it surrounds. And the more you work on negative space drawings, the more you'll develop a heightened perception of negative space, which will tremendously improve your composition skills as you do more complicated compositions.

In Part 3, "Starting Out: Learning You Can See and Draw," we will look at setting up a place to work, artists' studios, and exactly how to get started with the simple compositions—the seeing, selecting, placing, and drawing.

Your Sketchbook Page

Try your hand at practicing the exercises you've learned in this chapter.

The Least You Need to Know

➤ Our memory of things—the left side of the brain at work—can actually inhibit our ability to see what is really there.

➤ The logical left side does not remember or understand negative space too well, so it's up to the visual, relational right side to step in and see more clearly.

➤ Negative space is the area around any object or objects that share edges.

➤ Negative space can make a difficult drawing easy, particularly foreshortening or complicated shapes, because we can focus on the space to tell us, visually, about the shapes it surrounds.

➤ A heightened perception of negative space will tremendously improve composition in more complicated compositions.

Part 3

Starting Out: Learning You Can See and Draw

How do artists choose what to draw and what to draw it with? How do you begin to arrange objects in a composition?

What makes a good composition? How do you learn to draw the form or volume into something? And what about all those important details you have to draw? In this part, we'll answer all of your questions.

We'll start with simple contour drawings of objects and then move on to form, volume, light, and shadow in more complicated still lifes, exploring why artists throughout the ages just love those fruits and veggies. Then, we'll look at a few new materials, as well as details, details, and more details—and how to balance them for a finished drawing that will really please you.

A Room of Your Own

In This Chapter

➤ Making your own space to draw

➤ Finding the time

➤ Tools of the trade

➤ Beginning practice

If you have an empty wall, you can think on it better. I like a space to think in.

—*Georgia O'Keeffe*

Now that you've mastered the beginning exercises that can help you to see as an artist sees, it's time to get serious, get yourself some materials and a place to work, set aside some time, and get to it.

In this chapter, we'll begin exploring the places you create and playthings you acquire that help you become an artist. No room, you say? No time? Let's take a closer look at fitting drawing into your life—and your home.

Finding Space and Time

A studio or a place to draw is almost as important as your interest in learning to draw. We live in a hectic world that's full of deadlines and responsibilities. A space of your own, however small and simple, will become a refuge from the rest of your day. You will look forward to the time you can spend there.

Time alone—to observe, learn, experience, and grow—is often disregarded in the pressure-ridden careers and lives we lead. Drawing, a visual, meditative, learning experience, can help you enjoy your time alone. You deserve a space and the time to immerse yourself in a pastime like drawing.

Setting Up Your Drawing Room or Table

Studios are magical places. They are not like other rooms in a house. While most rooms are shared spaces, your studio is just for you—even if it's just a corner of a room. Your studio will be an intensely personal place, a retreat where you can express yourself in the surroundings, as well as in what you create.

A studio can be a large, expansive space with several work areas, lots of storage, walls of books, a computer, a sound system, and great light. Or, it can be a sunny end of your kitchen, the bay window of your dining room, a spare bedroom, or any quiet corner where you like to sit. Try for good light if you can; a corner with a window and a blank wall will do nicely. A small space can still be made into a special place for you, and a drawing table, or any table, is a beginning.

Studio Beautiful 101

The next question is how to furnish your studio. Whether you recruit pieces gathering dust in your attic or buy all new ones is up to you. The list that follows includes what we consider essentials to a drawing studio, but you can easily get by with far less (at least in the beginning).

Try Your Hand

Allowing yourself a space and some time is giving yourself a great gift. It's a way of valuing yourself, thinking seriously about your interest in drawing, and making an effort to encourage yourself.

Artist's Sketchbook

Artists' **studios** range from converted closets to converted guest houses. Where you put your studio depends on where you have room, of course, but you can make it as individualized as you choose.

➤ An adjustable drawing table and a comfortable office-style chair are a great start. You can work at an angle by putting a drawing board in your lap or propping it up with books, but your own table is a great help. This can help keep you from hunching over your work. We don't want any sore backs!

➤ An extendable goosenecked architectural lamp will extend the time you can work on overcast days and into the evening.

➤ A small freestanding bookshelf will hold your materials, books, magazines, and your portfolio.

➤ Supply carts on wheels, called taborets, are a wonderful addition. They hold everything and you can move them as necessary, which is particularly helpful if you have to condense your work area when you're finished for the day.

➤ A tackboard is nice if you have a wall to use. You will enjoy putting up your work, postcards, photos, and other visual ideas.

➤ If you have a computer, it can live quite happily on a nearby table. It can be very handy, as we will discuss in Chapter 25, "Express Yourself."

➤ A box, such as a file box, big tackle box, toolbox, or photo storage box, will hold your beginning materials.

➤ A portfolio or two is a way to keep your work organized and your paper stored safely. Ideally, portfolios should be kept flat. A set of paper storage drawers can go on your wish list.

The sky is the limit with studios, but a modest space is better than no space, and working small is far better than putting off the experience of learning to see and draw because of a lack of space. Compromise where you have to; the important thing is procuring a space of your own.

The Art of Drawing

We know you may be limited by your budget, so you should consider everything in this section as suggestions. Even with a limited budget, however, a weekend at yard sales or even browsing through your local thrift shops can yield some surprising bargains that you'll treasure because you yourself found them.

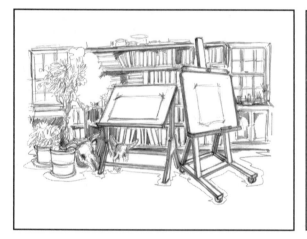 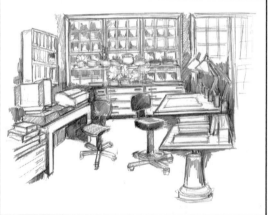

Lauren drew these pictures of her studio so you can see it as she sees it. One drawing shows the painter's side of her studio, and the other, the high-tech side!

Just for fun, compare these photos of Lauren's studio with her rendition of her high-tech studio above.

The Best Time to Draw

The best time to draw is anytime—at least anytime you can manage to escape your other responsibilities for a while. Quiet helps, as does a little soft music. As you develop your ability to focus on your work, distractions seem to vanish, but try for a quiet time. Maybe you'll have to get up an hour earlier than usual to find that quiet time, or maybe it will be the hour or so in the evening when you can pass on the sitcoms and do some drawing instead.

During the week, your lunch break at work can be a time to draw. A small sketchbook, one pencil, and an eraser that you can carry with you is all you need—you never know what will catch your attention. You can eat your lunch with one hand, can't you?

Our weekends, such as they are, are often more filled with activities and responsibilities than the workweek, but try for an hour or so of time for yourself on weekends, too. That hour before a Saturday night date night, for example, can be a great time to go off by yourself and draw.

Vacations and business trips are other great drawing opportunities. Planes, trains, and buses are filled with faces to try. Boats are filled with interesting places and shapes. If you are dining alone, you can draw the dining room, rather than just look out at it. Even a hotel room may have something to draw.

Anywhere away from home is interesting in some way. The flowers, plants, landscape, and architecture of a foreign or exotic place are always compelling. Drawing in a sketchbook or journal will remind you of your trip in a different, more personal way than photos from a camera will.

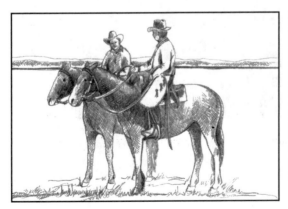

You can draw anything, anywhere, anytime, as these journal drawings show.

What About Drawing Classes?

Drawing classes, like any classes, are an additional opportunity to learn. The commitment you make to a class can help you focus your attention and prioritize your time.

Drawing classes are everywhere. High school continuing education classes, community college classes, art museum classes, and small privately organized classes with local artists are some of your options. If you develop an interest in a specific medium, a good class can help a great deal, providing special instruction or access to different materials and techniques. Investigate your options, and ask around to find out if a friend has enjoyed a particular class.

You can also organize your own group with or without a teacher. You and your friends can take turns running the group or you can work independently. You can meet and work together at someone's studio, a friend's garden, a park, a zoo, a public garden, or in a natural science or art museum. The camaraderie is fun, the commitment you make to the group helps you to make the time, you can all learn from each other, and, best of all, it is free.

Try Your Hand

The important thing is time that's all your own—no kids, no phone, no spousal interruptions. Make it clear to the others in your household that this time is yours, and they'll soon be asking for their special times as well!

Beginning Materials You'll Need

Good art materials are a tremendous pleasure, but don't feel you have to break the bank to begin. You can start out with just a few basics. No excuses here!

On Paper

Your choice of paper is somewhat dictated by your budget. Art stores and specialty paper shops offer a dazzling array of choices, but a pad or two of good *vellum surface* drawing paper is all you really need.

There are many other types of paper to choose from as well. Here are some of the plusses and minuses of each.

➤ Newsprint is thin, shiny, and not very rewarding as surfaces go.

➤ General drawing paper in pads or sketchbooks is a better surface, but not too precious. You will go through a lot of it.

➤ Bristol board in pads is a bit heavier. The vellum finish is pleasant to work on and it can stand up to an ink line, ink wash, or water-soluble pencils.

➤ Watercolor paper, in pads, blocks (pads with adhesive on all sides to keep it flat while you are working), or individual sheets, is more expensive but worth it later on for your finished work. A 90-lb. or 140-lb. hot-pressed paper is a good choice.

Paper surface varies as well.

➤ Drawing paper comes in plate (shiny) and vellum (smooth) surfaces. The vellum surface is nicer for pencil drawing.

➤ Watercolor and print paper surfaces are hot press, cold press, and rough. Think of an iron and you will remember which is which. A hot iron will press out more wrinkles, and so it is with paper. Hot press is smooth and silky, great for pencil line and tone. Cold-press papers have a texture (like wrinkles) and take drawing material differently. Experiment—it's the only way to know which you like best. Rough-surfaced paper is very bumpy and will show itself through almost any drawing media.

Artist's Sketchbook

Vellum surface drawing paper has a velvety soft finish that feels good as you draw, and it can handle a fair amount of erasing.

The Art of Drawing

Paper's thickness is labeled by its weight. Typing paper is 24 lb.; good heavyweight computer ink-jet paper is 30–36 lb.; drawing paper and printer's cover stock are about 60 lb.; good drawing, pastel, charcoal, and watercolor paper range from 70-lb. all the way to 300-lb. paper that can stand on end, with 90 to 140 lb. being the mid-range.

Drawing Instruments

Pencils are best for beginning drawings; they're both simple and correctable. As we discussed in Chapter 3, "Loosen Up," pencils come in hardnesses from very hard technical pencils in the H range, to very soft, smudgy pencils in the B range. They are labeled at the end of the pencil (4H, 3H, 2H, H, HB, B, 2B, 3B, 4B). School or regular pencils are 2HB, rather on the smudgy side.

➤ Mechanical pencils, once used only for drafting and architectural drawing, are fine tools. They maintain a consistent though variable line and never need sharpening. The leads must match the pencil in thickness, and 0.5 leads and pencils make fine lines. As the pencil barrels are not labeled, you can buy a few colors and color code

your choice of leads. They cost about $1.50 each, so make sure you like the feel of the barrel in your hand. Try to acquire at least 2H, H, HB, B, and 2B for a range of tonal color.

➤ Erasers are important tools. A kneaded eraser can be twisted and worked into small points to get at a little corner—and they can be kept clean by stretching and folding for a new surface. They erase without scratching or damaging the paper surface. Experiment with the pink, white, and gum erasers, too.

➤ Charcoal pencils, charcoal, and conte crayons all make their own tones and textures, but the medium can be preoccupying at first. Ink, inkpens, brushes, and water-soluble pencils, we will leave for later.

➤ Boards are handy, but the stiff back of a drawing pad or a sketchbook can take the place of a board, if you don't have one. Boards can help keep your work at an angle because you can put them in your lap with the paper taped at a good working height, and they are more stable than cardboard. Plywood, $3/8$-inch thick with sanded edges, is easy to find. Art stores sell masonite boards in various sizes. Buy a board somewhat bigger than your paper.

Tools of the trade: drawing boards and journals.

Storing Your Materials and Work

If you don't have that big studio with stacks of paper drawers, a few simple portfolios will do. Store your individual sheets of paper in one and your finished work in another. You can make simple portfolios out of scored and folded corrugated cardboard, or even incorporate duct tape hinges. It's not necessary to sign each piece, but if you do, make it small and neat, in the lower right-hand corner, and straight, please. A date is more useful, so you can see your progress. That pin-up board is a nice idea, too, for your own exhibit.

Beginning Techniques to Use

Practice makes perfect, but it's fun, too. Once you've got your studio space organized, you'll want to warm it up with some work as well. Let's look at some beginning techniques that will help you make your studio feel like your own.

The Marks That Can Make a Drawing

The warm-up exercises in Chapter 3 are always good to refer to for artists, calligraphers, forgers, and you. Take a moment and limber up your drawing hand with some circles,

curves, spirals, sweeps, swoops, smooth lines, and squiggles, just as you did in Chapter 3. Then, try some dots, dashes, crosses, hatches, and stripes. Find out which marks you like. Try to develop a vocabulary as you go along. Drawing is a language without words—but it does have a vocabulary we will be exploring in later chapters, including terms like *tone, texture, shape,* and *shadow.*

Practice making marks that please both your hand and your eye.

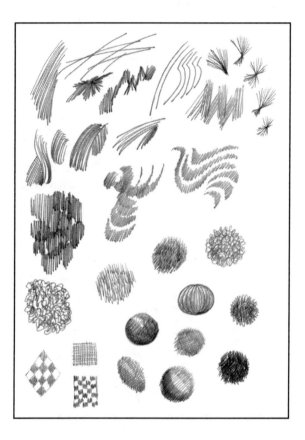

In addition, you may want to try cross-hatching in pencil. Try to practice making parallel lines to tone a part of your drawing. Then, go over them at an angle. Start with a 90-degree angle, but try others as well—45, 30—and see which you like. Or, try a mixture of angles over each other for a moiré pattern. It's less mechanical looking.

Simple Geometric Shapes to Practice

In the next chapters, you will begin to make choices, arrangements, and compositions. You will see that the world is full of geometric shapes, and that you can use the geometry to draw things more easily. The more you draw, the more you'll be trying to see objects in your drawings as being based on geometric shapes, seen flat or in space.

For now, begin to collect a few simple shapes, such as spheres, cubes, cylinders, cones, and pyramids. Household objects like cans, boxes, tins, fruit, funnels, ice cream cones (empty), or toy blocks are a few easy ones. See how the shapes look when you look at them straight on, then turn them at an angle so you see the tops and sides.

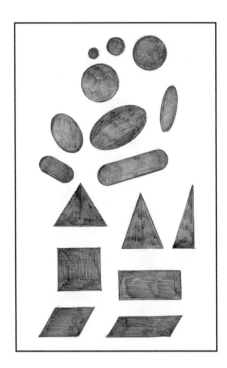

Practice looking at basic geometric shapes from a variety of angles, including straight on, in space, on a table, and in the air.

Now, try to draw the basic shapes, first flat and then in space. Draw them sitting on a table, and then hold them up and draw them as if they were floating in the air. This practice with basic shapes will help you see the geometry in the objects you'll choose to draw in the next chapter.

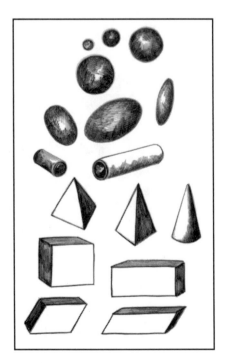

Practice drawing the shapes, too. See how the same shape looks different, depending on the angle?

Your Sketchbook Page

Try your hand at practicing the exercises you've learned in this chapter.

The Least You Need to Know

➤ A studio is a special personal refuge, whether large or small.

➤ Setting aside time for drawing is a gift to yourself.

➤ Beginning materials can be simple and easy to collect.

➤ Practicing lines and basic shapes is a good warm-up anytime.

How to Get Started

In This Chapter

➤ What to draw? What to draw?

➤ Picking your paper

➤ Making arrangements

➤ Seeing, siting, and sketching

➤ You're on your way!

In order to really see, to see ever deeper, ever more intensely, hence to be fully aware and alive, that I draw what the Chinese call "The Ten Thousand Things" around me. Drawing is the discipline by which I constantly rediscover the world.

—Frederick Frank, The Zen of Seeing, *(New York: Vintage/Random House, 1973).*

Yikes, now what? All set up and nowhere to go? No worries here, let's just pick an object or two and begin to draw. You've got to start somewhere. Look around your world and rediscover it—after all, it's where you're most likely to find things you want to draw.

What Are You Going to Draw?

Your house is full of choices, from simple to extremely challenging. You want to start simply because choosing, arranging, composing on the page, seeing, and drawing will keep you busy enough for now.

Begin with a leisurely stroll through your house. Look at it as you never have before, really seeing the things that are there. Think about how objects might look together, like that antique vase you inherited from your great aunt or that postmodern Italian clock left over from your last relationship. Sometimes the simplest objects can make the most interesting compositions.

Select Your Objects and Pick Your Subject

Pick a few objects as possibilities, and then you can select from the group. Try for interesting shapes, but ones that are basic, geometric, and manageable. Possibilities include

➤ Mugs.

➤ Cans.

➤ Boxes.

➤ Vases.

➤ A few pieces of fruit.

➤ Some veggies.

➤ Toy blocks.

Or, if you are feeling really confident, a toy animal, a toy car, or an old doll might be just the thing.

Make yourself a little collection of possibilities. Put two or three together. Then try another combination. Look for shapes that complement each other. Play around until you have made a choice.

Choose the Format and the Paper

Next, pick a piece of paper to work on, 9" × 12" or 11" × 14", and decide on a horizontal or vertical orientation. Look at the shapes of the objects you've selected. Are they tall or short? Do they seem to need a piece of paper that is vertical or horizontal in its orientation?

Back to the Drawing Board

Avoid shapeless objects or objects with cartoon or caricature detail. Realistic, accurate detail is better for learning. Save the action figures and cartoon characters for another time.

You may be familiar with the idea of vertical or horizontal paper orientation from your word processing program, where it's called portrait or landscape. A vertically oriented page is widest from top to bottom (portrait), while a horizontally oriented page is widest across (landscape).

How Will You Arrange the Objects?

There are always lots of ways to arrange things to draw, and no one way is best, but you want to make the best choice that you can. Oftentimes, it is the simplest arrangement that works best, especially if the objects have a lot of detail. Sometimes, a jumble of things creates an interesting mix of shapes. Later on, in Chapter 10, "Toward the Finish Line," we'll

pay more attention to tone and texture, but for now we will concentrate on arranging, seeing, and drawing shapes in relation to each other.

Seeing Arrangement and Composition

Arrangement and composition are the first steps in making a good drawing out of your chosen objects. As you play around and change the combination and arrangement of your chosen objects (feel free to change your mind), take time to look at your choice through one of your viewfinder frames, picking the one that best frames your composition. Turn it horizontally or vertically to match your arrangement and your paper orientation.

Make sure you have chosen your objects, arrangement, composition, paper size, paper orientation, and viewfinder frame so that they all work together. Whew, that's a lot right there, but you can do it! When you've got everything ready, follow these steps:

1. Lightly draw in the horizontal and vertical center lines on your paper.
2. Place the viewfinder frame on the paper and line up the center lines.
3. Extend the diagonals on the viewfinder frame onto the paper.
4. Draw a box that is proportionally equal to the viewfinder frame by measuring, or positioning it on the diagonals at whatever size you wish.

Now you can look at your arrangement through your viewfinder frame and begin to draw it, in the same proportion to the larger box on your paper. You can also look at your composition through a proportionally equal grid on a plastic picture plane to gauge where things are and where to start.

But the main work of positioning the objects in your drawing should be done by really *seeing* your chosen objects as a small group and then trying to imagine them sitting evenly across the center lines of your paper. You'll want to maintain a constant view, looking at the same spot from the same height. Of course, if you've got to get up, you can draw a line around an object to mark its place for later.

Look again through your viewfinder frame to see where the center lines are. See what shapes are right there in the middle. Lightly sketch the main shapes relative to the center lines.

Remember that objects need to "sit down" where they belong in your drawing. One way to accomplish this is to imagine them in the box they came in. Draw the box in space, and then fit the object into the box. This works for chairs, tables, boats—really, just about anything.

See the View and the Distance

Once you've made your arrangement, take a look at it through the viewfinder frame. Decide on the exact area you will draw. How you hold the viewfinder frame will determine what you draw and from what vantage point and distance you draw it. This will affect the space in your work and around your objects, or the *range*.

Try Your Hand

In more complicated arrangements, you may want to exclude some of the elements or some of the detail. You can "filter out," or choose to eliminate what you don't want, in order to emphasize what you do want. The choice is up to you.

Artist's Sketchbook

Range is the distance between you and your objects: close-up (objects), mid-range (still life), or far away (landscape).

Some of the ranges you may consider are:

➤ **Close-up Range:** Objects that fill the frame will look close to you, almost in your face.

Objects in close-up will fill the frame.

➤ **Still Life or Mid–Range:** Objects drawn smaller in the same frame will look somewhat farther back, as if on a table.

Objects at mid-range will be set farther back.

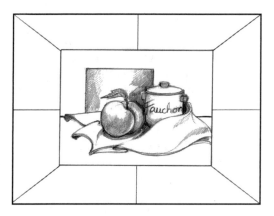

➤ **Deep or Landscape Space:** Objects drawn smaller, still in the same frame, and placed toward the top of the frame will seem far away, as if in a landscape space.

Objects in deep space will be seen in the distance.

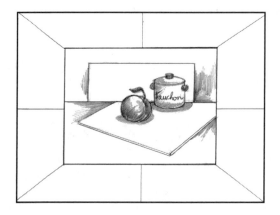

The Art of Drawing

Most arrangements and still lifes are seen and drawn looking across and slightly down at the objects, but more radical views can be more interesting. They are also more challenging. Eventually, you should try drawing at all the different vantage points that you can; you may find you are particularly fond of an unusual way of seeing things.

These different senses of space are fun to play with, but for now, let's keep to a range somewhere between close-up and still life space and leave the long views for later. Understanding, seeing, and drawing from a particular view and vantage point is a big step and can seem complicated, but it really isn't.

Whether you look across at your objects or down on them, and at what angle, will greatly affect what you see. This makes the difference between looking at the side of a box or vase or mug and looking into them.

On the Page

First, just see your arrangement from where you are, considering the following:

➤ Can you tell where eye level is?

➤ Can you tell if you are looking across at it or down at it?

➤ Can you see the tops of things?

➤ Or into things?

Probably, you can see somewhat into or over things in your arrangement. We tend to see across and down at objects on a table, for example, because we are sitting higher than the table. If we sat on a higher chair or stool we would be looking down onto the objects even more.

If you look straight across at your objects, you are looking at eye level. You will see just the sides or things, but not the tops or bottoms.

And if the objects were on a high shelf and you looked up at them, your view point would be lower than the middle. If the shelf were glass, you would see the bottoms of things as well.

Try Your Hand

To "see" means looking on the right side, without letting Old Lefty help out, to see only what is there—no thinking in ideas, only in visual, relational terms.

Artist's Sketchbook

Eye level is straight out from where you are, neither above nor below the level of your view. As you move up or down, your eye level and view change.

Next Step: Establish Eye Level

So then, for starters, let's say that the center horizontal line on your paper is *eye level*. Hold your viewfinder frame so that you are looking through the middle of it at your arrangement. Can you tell where the center horizontal line on the viewfinder frame is in your arrangement? That spot or line is at eye level from where you are seeing your arrangement.

Site the Image on the Paper Using the Center Lines

Use the lines on your viewfinder frame to decide on eye level in your view, which is called siting the image. Know whether you are looking down, and try to know how much: a little, some, more? If you are sitting in a chair, sit on a stool and see the difference, then stand up and see more of a difference. You can even stand on your chair and look down for a bird's eye view.

From a bird's-eye view to a fly on the wall, the way you look at your arrangement will determine how it looks on the page.

Making a Simple Contour Drawing

Whatever view you choose, see it through the viewfinder frame and find where the center lines are, then imagine the view as you see it, centered on the center lines of the box on your paper.

Then, of course, you just lightly draw it, as you see it. Nothing to it!

The Lightest Sketch to Begin

So do it now. Use a light pencil, HB or H, and use a light touch. Try to see the basic shapes in your objects and their relative placement, with or without the aid of the viewfinder frame or the picture plane.

Don't worry if you use either of these to check yourself or for help as you practice. You will use them less and trust yourself more the more drawings you do.

Either way, take the time to check yourself in the beginning. Don't wait. See the arrangement again through your viewfinder frame and on your drawing.

Check It Over

When you've finished, consider the following:

➤ Check that the image is centered on your paper with some help from the center lines.

➤ Check the view and the vantage point.

➤ Look for clues as to your view:

Can you see into or on top of your objects? You are looking down.

Can you see the tops or just the sides of things? You are looking across.

➤ Check that you have drawn the shapes of your objects as you see them.

Correct or change any problems you see before you go on.

Correct It Now, Render It Later

Continue to add or refine the lines you draw to say as much about the shape of your objects as you can. Look for little details in the shapes and make them part of your drawing. See as much as you can and draw as much as you can see.

When you're finished, your drawing should be a reasonable representation of the simple arrangement you chose. It should reflect the choices that you made, including ...

➤ The objects you picked.

➤ The arrangement of them.

➤ The frame and the format.

➤ The distance from you.

➤ The viewpoint and vantage point.

➤ Side view, above, below, or partway in between.

In addition, the basic shapes of your objects and their placement relative to each other should be clear. The detail in the shapes of each should be there. And let's throw in a bit of your own personality, response, or uniqueness in the way that you made the drawing.

Now you've completed your first real selection and drawing on your own. From here on, the sky is quite literally the limit. Try a few of these small, simple drawings. Try different views and ways of framing the view.

In the next chapter, we'll be taking a closer look at objects and still life composition.

Your Sketchbook Page

Try your hand at practicing the exercises you've learned in this chapter.

The Least You Need to Know

➤ You begin a drawing by selecting your subject and deciding on the exact arrangement.

➤ Your viewpoint, vantage point, and eye level all influence what you can see of your arrangement and therefore what you will draw.

➤ Centering your view with the viewfinder frame and seeing the same view on your paper gets you started correctly.

➤ Remember to see shapes and relations between your objects and to draw what you see.

Step Up to a Still Life: Composition, Composition, Composition

> **In This Chapter**
>
> ➤ All about still life
>
> ➤ Why artists love fruits and veggies
>
> ➤ Filtering and framing your still life
>
> ➤ Seeing your still life in space

Drawing seems to provide an extra measure of engagement.

—Hannah Hinchman

Artists love to draw the still life—and so will you. In this chapter, we'll be exploring exactly what a still life is, and how you can make this most popular of artistic expressions your own.

What Is a Still Life?

You began drawing your choice of a few basically shaped objects in a simple arrangement. Drawing from a *still life* arrangement is an extension of those simple pairings. The space in a still life is usually rather shallow and the *vantage point* is fairly close in, while the *viewpoint* (seeing from above, the side, or below) can vary quite a bit, for surprising results.

Picking Objects: Classic, Contemporary, and Out There

Not all of the items in a still life need be exactly dead. You can include flowers (cut or potted), fruit and vegetables, sea shells, seeds, pods, nuts, or leaves. You can include a few "classic nature mort" items like butterflies, bugs, bones, fish, seafood, skulls, and stuffed animals (real ones, not your toddler's bedmate). Human-made items (including pots and pans, antiques, china, baskets, fabric for background color, garden tools, the contents of a drawer,

your shelf of plants, your bathroom shelf, and your collection of art supplies)—basically anything with an interesting shape—is worth a look.

Artist's Sketchbook

Still life, called *nature mort* ("dead natural things" in French), is a collection and arrangement of things in a composition.

Vantage point is the place from which you view something, and just exactly what part of that whole picture, you are choosing to see and draw. It is the place from which you pick your view from the larger whole, rather like cropping a photograph. If you move, your exact vantage point changes.

Viewpoint is similar, but think of it as specifically where your eyes are, whether you are looking up, across, or down at something. Eye level is where you look straight out from that particular viewpoint. Things in your view are above, at, or below eye level. If you move, your view and eye level move, too.

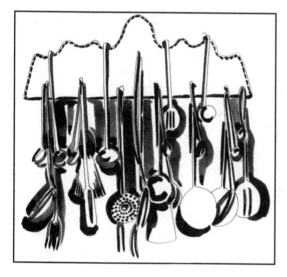

Your choice of still life objects is limited by only your imagination.

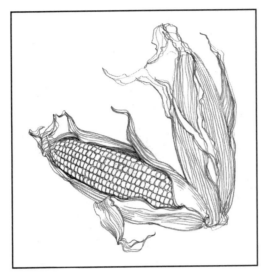 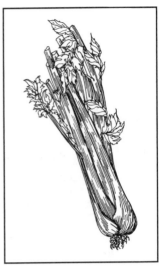

Try Your Hand

Still life items tend to be rather domestic or household in nature, but you can push the envelope and start including unusual things. Just make sure that you think they are worth your time to draw. There are as many possibilities as you have ideas.

Back to the Drawing Board

Objects with unclear shapes or un-realistic proportions are not the best choices for a still life. The idea is to learn about shape and pro-portion, so opt for realism, even if your taste is for the unusual.

You can add sentimental items, such as old lace and china, a baby's shoe, or an old hat with ribbons. Even old pictures, photographs in an-tique frames, and vintage postcards work well in still lifes. You can go wild and thematic with items from an exotic trip to the Caribbean or South America or out West. Or you can include a small Adirondack chair, a willow basket, some pinecones, oak leaves, a toy cabin, and a small carved bear. You can go high tech and make a composition of your Palm Pilot and your keyboard, or go the sports route and arrange your sneakers and your tennis racket.

You can reflect your favorite pastime; food, of course, is a great choice and has been favored by artists over the centuries for the wealth of shape, color, and texture it provides. A food still life can be classic or surprising. Fishing tackle, a gardening arrangement, books and pens, a collection of boxes—you name it, and you can draw it.

Why Artists Love to Draw Fruit and Vegetables

Objects from nature have been favorites of artists since the early Renaissance, when painters began paying more attention to their sur-roundings in their largely religious paintings. The luscious shapes, vivid colors, and textures in fruit and vegetables are good reasons for their appeal. They are also apt metaphors for life generally, and add to any domestic scene.

A Few Thoughts on Composition

Composition is the way you arrange things for a drawing, rather than accepting them just the way you find them. It includes where you posi-tion yourself, how much you decide to see, from what position you de-cide to see it, and how you decide to put the image on the page. While a lot has been written about composition, experience is still the best guide. Still, here are some of Lauren's thoughts on the subject.

Off Center Is Often Better

Arranging things slightly off center relative to your center lines can create a pleasing balance of elements. Use your viewfinder frame and the center lines on your page. Position the main objects to the side of center, rather than right in the middle. See if you enjoy the shapes and spaces this way. Remember to see the negative spaces between things as part of your composition.

Centering on Purpose

You can choose to center something for emphasis, particularly if it is also a close-up view. Other times, the symmetrical shapes of things can be striking if arranged in the center. Just make sure your choice of objects warrants that decision.

Charming Diagonals

You'll want to look for diagonals—in life, in landscapes, in other drawings, in compositions, and, of course, in your own drawings. Try to see an imaginary triangular shape or two in the relationship between things in the composition. You will like the change in your drawing.

Try Your Hand

Try to see the compositional structure when you look at a painting that you like and try the same balance in one of your drawings.

Other Shapes to See in the Shapes of Things

As well as seeing triangles in your compositions, which means you have established some strong diagonals, try to arrange some of your compositions around a strong curve or ellipse. Note which side of the paper you favor for a strong compositional line or curve. Many of us are happier with an emphasis on the left side, because many of us are right-handed and so is our written tradition. Many Eastern compositions are balanced differently.

The Art of Drawing

Euclid, a Greek mathematician from the third century, was the author of *Elements*, a treatise on early geometry and the concepts of point, line, and plane. His thoughts on design are called the "Golden Section," to establish where the central point in a composition should be. He wrote:

"So that the space divided into unequal areas be aesthetically pleasing, one must establish the same relationship between the smallest part and the largest part, as exists between the largest part and the whole."

Basically, this means that a horizontal that is a bit off center and a vertical that is a bit off center and the place where they cross that is off center, but in a pleasing amount, is what the eye seeks. Try it for yourself!

Composing a Still Life

Composition is really a way to think about your arrangement so that it is as pleasing as possible after you have gone to the trouble to draw it.

Collect more objects than you did in Chapter 8, "How to Get Started." Play around with them until you have narrowed down your options.

Decide on a horizontal or vertical format, using the viewfinder frame if you wish.

Choosing from a Group of Possibilities

Arrange and rearrange the final players until you are pleased. Don't hesitate to chuck out or change at the last minute; it's your choice here.

Filtering and Framing for the View You Want

You can decide to use a jumble of things, but you might want to eliminate or just suggest some of them. You will get the effect, say, of a drawer full of tools or toys, but call attention to only some of them.

See your composition through the viewfinder frame that best frames your arrangement.

Space in a Still Life

A good drawing reflects the single view put on paper. You need to see and establish, in your own mind's eye, the vantage point and viewpoint from which you are seeing and therefore drawing your composition.

Try Your Hand

Cubist artists departed from the idea of a single view and began the process of seeing and drawing multiple views as one image. You can, too, but only after you can see and draw that single view.

Vantage and View

Before you begin, you'll want to explore both the *vantage point* and *viewpoint*. Remember, the vantage point refers to your distance away from the subject, while the viewpoint refers to the angle at which you see the subject.

Still life space is usually shallow, so the vantage point is usually in the mid-range. As you draw more, you can alter your vantage or viewpoint as you wish. For now, though, let's stay in middle ground, and save the bird's eye views for a little later.

More Work on Eye Level

Eye level is important. Since drawing is putting that single view on paper, you need to keep a consistent vantage and viewpoint and maintain eye level as you work. Check that you can see where eye level is in your arrangement and on your paper.

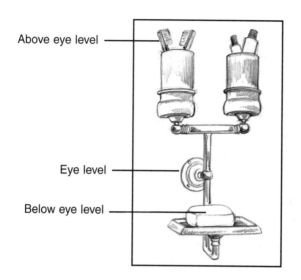

Above eye level

Eye level

Below eye level

Objects look different depending on how you look at them—from above, at, or below eye level. Examine these shapes (eye level is at center) and you'll see what we mean.

Making Things Sit Down, or Roll Over, and Stay

Your dog may sit and stay, but when it comes to drawing, you have to *make* things sit and stay sitting. Objects in a still life have a funny way of not staying quite where you want them. They seem to slant or tilt, or look crooked or asymmetrical. They fall off the table or jump out into the air where they don't belong. You can fix all that with a working knowledge of simple viewpoint and perspective. Accurately drawing objects at the view that you see them is the way to keep them sitting down.

Ellipses Are Your Friends

A lot of things that you might have chosen to draw are circular, such as cups, mugs, bowls, vases, plates, and parts of other things. Circles seen in space become *ellipses*. The relative fullness or flatness of the ellipse is a function of how high above or how much below the object you are, whether you can see into it or not, and whether you can see the bottom—or could, if the table or shelf were glass. Drawing the basic shapes you see in light circles and ellipses can establish eye level and some roundness to the object from the beginning.

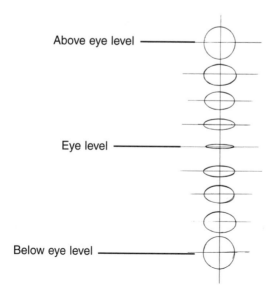

Above eye level

Eye level

Below eye level

Circles become ellipses when viewed from above or below eye levels.

107

Artist's Sketchbook

An **ellipse** is a curved geometric shape, different from a circle.

A circle has one central point, from which can be measured its radius, or all the way across for its diameter. An ellipse has two points that determine its shape and proportion, the farther away from center the two points are, the flatter the ellipse is.

A 3-D ellipse is called an ellipsoid (something to remember for advantage in Scrabble games) and is a shape to use when sketching in the fullness of things.

Your practice in warm-up drawings of basic shapes and your practice in drawing basic geometric shapes should have acquainted you with ellipses. Practice more if you need to. Note how they are flattest near eye level, whether above or below. They get fuller and fuller as they are further from eye level, so that when you are looking completely into a round object, it appears round, too.

Here are a few simple objects that Lauren has drawn above, at, and below eye level, so you can see how their appearance changes. First, in sketch form; then, as polished contour drawings.

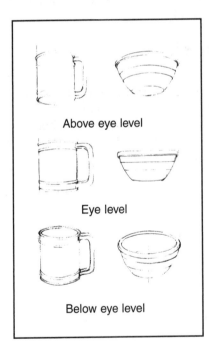

Above eye level

Eye level

Below eye level

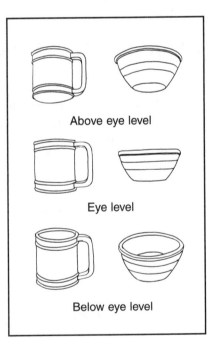

Above eye level

Eye level

Below eye level

When a Cube Is a Cube, in Space

Rectangular objects do their own thing in space. Not only are they affected by eye level (above, at, or below), but they also change as you see them from an angle other than straight on. As you see a rectangle from an angle, the face or plane that is slanting away

from you starts to diminish or vanish. So a plane in space needs to reflect that vanishing as well as its place relative to eye level.

This is not as hard as it sounds. Again, your practice in drawing basic geometric shapes should help. Draw more at angles and different eye levels to practice.

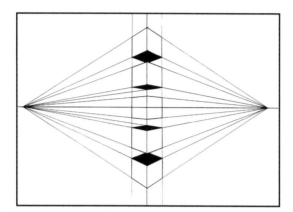

Note how this cube in space starts to diminish or vanish.

When a Cylinder Is a Rectangle, with Curves

Try seeing and drawing a cylinder as if it were a rectangle in space. Get the angle and eye level right and then adjust the shape inside. A cylinder has round ends, in space they are ellipses. You can get the right ellipse by fitting it into the end of the rectangle at the same angle and eye level.

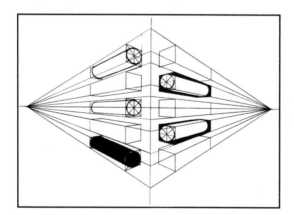

Lauren (upper) and one of her students (lower) draw a cylinder as if it were a rectangle in space.

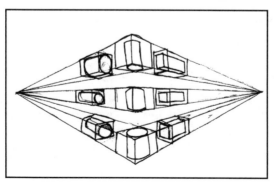

Fitting Other Shapes into the Boxes They Came In

Most things in your life came in a box. That box sat on the table or the floor before the object was taken out of it. It might take a little pushing or prodding, but that object would fit back inside. Visualize your object inside a box. You can even draw the box in lightly to make sure it is sitting at the correct angle. Then, simply draw the object inside the box and you will have it where you want it. Try it!

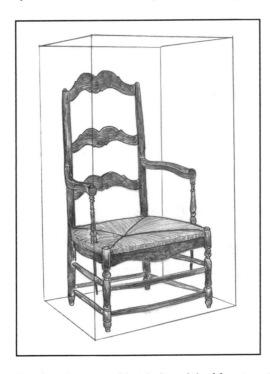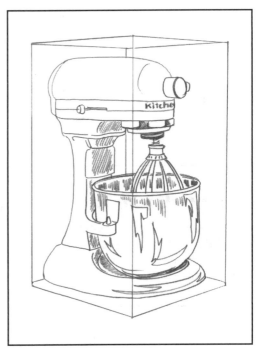

Try drawing your object in its original box to get it where you want it.

Drawing That Still Life

You already have all the tools to draw your still life, you just need to use them. This more complicated composition will take more patience, time, and clear seeing, but these are skills that you now have, right?

Try Your Hand

Patience is a virtue, especially in drawing.

See Your Still Life in Space

Sit and see your composition in space, with or without the viewfinder frame or the plastic picture plane.

Site the Arrangement on the Page

Draw the horizontal and vertical center lines on your paper. You can use the diagonals of your viewfinder frame to make a box on your paper that is proportionally equal to the frame. Site the arrangement in that box on your paper. Then pick a place to start and draw the first shape.

Start out with some planning lines in addition to the center horizontal and vertical lines. Make a light set of shapes and lines that establish placement on the page, position of objects, and amount of overlap. Try drawing a light set of lines that enclose your composition. You can use these lines to judge shapes and spaces against.

In addition, you may want to check relative heights and widths against each other. To do this, select a baseline or measurement that you can consider having a length of "1." Then, use that measurement to gauge other lengths, widths, curves, shapes, and spaces. Establish the ratio between the base and any line you measure against it, such as 1:2, 1:4, 1:5, etc.

Try Your Hand

The planning lines in your work should be light, and need not be erased later. They can add a vitality and they show the process that you have been through, too.

Start with a Light Sketch to Position

As usual, you should begin with the lightest line, your H or HB pencil, and a light touch to draw in the basic shapes and angles and relations between things. Take your time. Don't rush. A complicated arrangement takes more time. Consider the following as you begin:

➤ Start with the lightest of directional lines for each object.

➤ See how they overlap.

➤ Try to see each one in its own spot, but relative to the others.

➤ Imagine that you have x-ray vision and can see the backs of your objects, where they touch or are close to one another.

➤ Make sure you have left enough space for each.

Check Your Spacing

Don't go on until you are sure of everything and everything is in its place, and that you have a place for everything. An object with a shape and size has to have the space in your drawing that it needs to look three-dimensional. If two objects are in the same three-dimensional spot in your drawing, they will both look flat. Give them the room they need to look full.

God is in the details.

—*Buckminster Fuller (And he was right.)*

See the Detail in Each Object and Draw What You See

When you have located and drawn the shape of each object in your composition, the rest is clear seeing and drawing of the remaining detail.

Your finished drawing should reflect all the work you have done lately. An arrangement that you would have thought impossible to draw is now within your grasp. It is a great feeling.

In the next chapter, we will look at getting things to look a little more full of volume and detail. We will look at volume, weight, light, and shadow, and how to draw them by adding a bit of tone to your line drawing. Detail and still more detail will give your work the complexity that makes it special.

Your Sketchbook Page

Try your hand at practicing the exercises you've learned in this chapter.

The Least You Need to Know

➤ A still life is a composition of objects chosen and arranged for interesting shapes, spaces, and some special sense of you and your choices.

➤ Composition is based on some classic rules, but is basically working until you have a pleasant arrangement of your objects in space.

➤ Vantage point and viewpoint are important considerations in composition.

➤ Once you have decided on your composition, see what you arranged and draw what you see.

Toward the Finish Line

In This Chapter

➤ Establishing volume and tone

➤ Using light and shadow

➤ Creating a balance between line and tone

➤ Knowing when you are finished

The most obvious reason for drawing disciplines is to train the eye and the hand to instantaneous coordinated activity. Artists of the past and present have made countless drawings, not only as students, but all through their lives.

—Harry Sternberg

You've heard the phrase "It's all in the details.", and when it comes to drawing, those details include volume and tone, line and shape, and light and shadow. How do you add those finishing touches? In this chapter, you'll find out.

Line and Shape Are in the Lead, Form Follows Close Behind

For many drawings, a clear, sensitive contour line can say as much as you need to say. You may enjoy the line quality as it is, feel the shapes and spaces between shapes to be accurate, and have enough detail to feel your drawing is finished.

In other drawings, it helps to define the form or fullness of things by rendering them with tone. Light and shade come into play here, and the direction from which an object is lighted will determine the play of light upon it, the direction of the shadow it casts, and whether that shadow is on the object next to it and how much.

Light and shadow can create strong patterns that are part of your composition and can make an object seem more full of volume and weight. Detail and texture are on the surface of an object, further defining it. Sometimes they can be confusing when they don't follow the form. It is better to concentrate on shape and space first, volume and weight second, and light and shadow next, and then detail and texture can follow along later.

You'll want to make a graded chart for yourself as a guide for your range of *tones* to establish light, shadow, and volume.

1. Measure and draw a box 6" wide and 1" high.

2. Draw a horizontal center line to make two long boxes, $1/2$" high.

3. Measure and draw vertical lines at 1" intervals to make six boxes on the top row and six on the bottom row.

Artist's Sketchbook

Tone refers to shades between light and dark, or white and black, that can be used in drawing to define areas of light and shadow or render the fullness of an object.

Making a set of boxes for a tonal chart.

4. Label the first box on the upper left-hand corner "#1." (Lefties can begin in the upper right-hand corner and work left.)

5. Box #1 will stay white.

6. Label the next box #2.

7. Starting with box #2, lightly and evenly shade the rest of the top line of boxes.

8. Label the next box #3.

9. Start with #3 and evenly shade over the rest for a shade darker than box #2.

10. Label the next box #4.

11. Begin with it and make another layer of shading over the remaining three boxes.

12. Label the next box #5.

13. Begin with it and make another layer of shading.

14. Label the last box #6.

15. Make the final layer of shading in it.

Back to the Drawing Board

If you get ahead of yourself and get confused between shape and the detail on the surface, or confused about what makes volume and what makes texture, just take a step back. Sit until you can see where you are and what you should do next, including a good erasing.

Chapter 10 ➤ *Toward the Finish Line*

Here is a filled-in tonal chart.

You can do this for a six-box tonal scale, or you can make it nine boxes or twelve boxes, as many as you want. Start with six boxes for now. You have a range from white to light to medium to dark.

Now, on the lower row, practice matching the various tones you made on the top of the chart. Start by trying to match the darkest tone. Keep shading it in until it matches the upper box. Then, try to match one of the light tones, then try to match one of the mid-tones. Continue until you have matched all the tones of the scale and filled in the bottom part of the chart.

In this tonal chart, we've filled in the bottom row of tones to match the top row.

Your tonal chart gives you an idea of the tonal range that you can use when you are looking at your drawing and deciding how to add tone to it.

The Art of Drawing

You can make tonal charts using a selection of pencils, different hardnesses, particularly if you like very rich tones. It is important to jot down how you got each set of tones and with which pencils so that you will be able to use the same technique for building up tone on a drawing. Try a chart or two with a different range, a light one or a dark one that might not even begin with white.

Here is a dark tonal scale.

You can make a tonal scale with different textural marks instead of solid tones. Try making a tonal chart that is made up of different textural marks, keeping them all the same for each tonal chart so you can see the range of tone easily. Eventually, you will be able to jump from tone to textural tone and back again while adding whatever tonal value you want because you will "see" them in your mind's eye.

Here are some circles with different textural marks to make the range of tones. Your own tone boxes can be in rows of boxes or looser shapes filled in with a range of tone in one texture.

Try Your Hand

The more you practice seeing and adding tone to an accurate contour line drawing, you will begin to do it sooner, as you move from the planning lines to the drawing of the shapes, because you will be able to see line and tone together.

Here are some additional tonal tips to consider:

➤ Keep looking at your composition and your tonal scale. See the shapes that each tone fits into. You'll have different tones for highlights on things, the light sides of things, the mid-tones, the darker sides of things, shadows, shadows across things, and the darkest cracks and spaces between things.

➤ Get up, walk away, and then come back and look at your work with fresh eyes. You may see things you missed when you were sitting right on top of your drawing. Correct any problems you see.

➤ You may want to darken the shade of your darkest tone to increase the contrast between your lights and darks.

➤ Half-close your eyes, or let them go out of focus. This can help you see tone, and then you can work on detail.

➤ For practice in form, light, and shadow, try drawing eggs, rocks, shells, or even mushrooms.

Weight Is in the Rear, but Coming Up Fast

Let's go back to those basic shapes you collected and practiced drawing in space. In Chapter 9, "Step Up to a Still Life: Composition, Composition, Composition," you drew them as contour line drawings. Now, try them as toned 3-D objects. Pick objects that are simple and not too richly colored or patterned for starters.

1. Establish a light source and direction. See how the light plays on the objects. See the gradation of tone relative to your chart of tonal range.

2. Squint at your arrangement, you will find it easier to see the lights and darks. Squinting makes it easier to see the tones. It softens detail and blurs the mid-tone so that you can see the extremes on your tonal scale.

3. Pick the lightest spots like highlights on fruit or the lighted side of a cube or mug. These areas will be at the light end of your tonal range.

4. Decide on the darkest spots, like spaces between things or a darker object. These areas will be on the darker end of your scale of darks. How dark do you want the darks to go?

5. Pick the middle tone between the lightest one and your choice of the darkest. Try to see that tonal color in your arrangement, what is halfway between light and dark. This play of light and dark has a name, naturally: *chiaroscuro.*

No amount of tonal rendering will make for a sense of weight and volume if the object drawn doesn't have enough space to be three-dimensional. Your careful seeing and drawing of the shape and the relationships between things must come first. Then, contour line on flatter items and tone on things with greater weight can suggest the differences in volume.

Artist's Sketchbook

Chiaroscuro is Italian for light and shadow. It refers here to a system of tonal shading to render an object so it appears three-dimensional.

First Things First: Shape and Space

As with tone, light, and shadow, no amount of detail or texture will help a drawing when the basic shapes and the spatial relationships are not seen and drawn well. When this is the case, you will waste your time adding detail when you should be correcting the shapes and spaces.

Similarly, all the rendering in the world will not make an asymmetrical vase symmetrical, make a bowl sit on the table if it is jumping up, or make two apples look round if they are so close as to occupy the same space on your page.

Sometimes, the best thing to do is start over. If, after a while, it seems that everything you add detracts from your drawing rather than enhances it, try, try again may be the route to take.

Now Start Again

Pick another arrangement to draw. Choose a few objects that seem to require tone to make them appear as full as they are. Keep them simple, geometric shapes like fruit, plain boxes, a cup or mug, or some toy blocks. Try to pick objects that are close in color so the color won't be confusing you. Later you can pick objects that require your ability to establish true color differences using tone.

Back to the Drawing Board

You can work on line and tone simultaneously as long as you remember to keep checking and don't get bogged down adding tone to a drawing that still needs work on basic shapes or spaces.

Try Your Hand

Remember, squinting helps here, regardless of what you mother told you about making faces.

Try Your Hand

You don't have to fill in everything on a drawing; you can get more mileage by just suggesting light, tone, shadow, or volume with some tone, but retain the contrast and sparkle in your drawing. What you leave out can be just as important as what you put in.

1. Make your arrangement and composition. See your composition through your viewfinder frame. Decide on your paper and format—horizontal or vertical. Draw a proportionally equal box on your paper, with very lightly drawn center lines to help site your composition on the page.

2. Arrange a light source. Look at what it does. Try moving the light to the other side, the front, or the back, and see what the light does in each case. Decide which you prefer.

3. Site your view in space and on your paper. Don't forget the center lines, the viewfinder frame, and plastic picture plane as guides.

4. Make some beginning planning lines, then draw the simplest shapes, directions, and angles. Measure them against the sides of your viewfinder frame to see the angles. Lightly draw in the basic shapes.

5. Check yourself against your composition with the viewfinder frame and adjust. Work on seeing shapes as spaces.

 Pay attention to the negative space shapes. They can help a great deal in positioning everything correctly. Check again.

6. Work on it; redraw until all of the objects are correctly placed.

7. Refine the shapes and lines to be more expressive. Look at each item in your composition and say as much about each as you can.

8. Make a tonal chart on the side of your drawing or on a separate piece of scrap paper.

9. Try to see each part of your drawing as having a tonal value, relatively speaking, from the lightest spots to the darkest ones.

10. Look at the light and shadows. Decide on a tonal range that you will use. Know which pencil will make which tone (this is where the tonal chart helps). Establish the light parts and the dark parts.

11. Draw in the shapes of the highlights and the mid-tones and the shadows. Pay particular attention to how a shadow is reshaped when it falls on another object. Add the tone to your drawing, as you see it.

12. Develop the tone on your composition from less to more, based on your tonal range chart and what you can see. Work on the drawing as a whole, not just one part at a time. Build up tones gradually.

You may see problems as you draw, some inconsistency that you missed. Don't hesitate to go back and fix it. Remember that your viewfinder frame and plastic picture plane can help you see your way through a difficult part.

Back to the Drawing Board

Sometimes, as you add a lot of detail, you have to go back and darken the darks for richer contrast, or lighten the mid-tones, or enrich the contour lines. Experience is the best guide here. Building up tone is easy; just keep at it. You can lighten a tone or area that has gotten too dark by erasing lightly. You can use the eraser as a "blotter" and pick up just a bit of tone without disturbing the line. The more you draw, the more you will develop a personal sense of style—and a sense of what suits you and the situation.

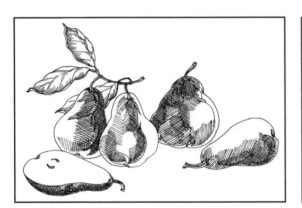

Here are some examples of drawings with tone.

Getting to That Finish Line

Do you see how your shapes now have a sense of volume and they seem to really be there in space?

As you practice adding tone to an accurate contour line drawing, you will begin to add it sooner, after the first planning lines are there to define the shapes and spaces of the composition.

Take your time building up tone and balancing the tones in your drawing. It takes patience and discipline, but you can do it.

You will be pleased with the result, and your drawings will have the added dimension of volume and weight.

You can use tone as much or as little as you wish. It is your choice, as it is your choice as to how much to render, how dark to go, and how to balance the tone and line in your drawing.

Then, of course, there is the matter of deciding when you are done. You are done when you have drawn the shapes, spaces, highlights, mid-tones, darks, and shadows in your composition and balanced all of them for a drawing that describes your arrangement in space. Are you pleased with your tonal drawing?

As Michelangelo said to the Pope when asked about the ceiling painting for the Sistine Chapel, "I will be done when I am finished." Like Michelangelo, you are done when you are pleased.

In Chapter 11, "At the Finish Line: Are You Ready for More?" we will look at detail and texture, surface elements that can tell still more about the objects that you draw.

Your Sketchbook Page

Try your hand at practicing the exercises you've learned in this chapter.

The Least You Need to Know

➤ You can establish volume by adding tone to a line drawing, but adding tone or texture is useless if the shapes and spaces and relationships in your drawing are in need of work first. All that rendering won't help.

➤ Making and using a tonal scale helps you decide on your chosen range from light to dark.

➤ Learn to see the shapes of tones, where they are, and draw them there.

➤ Light and shadow, cast from an established light source, are important to see and draw accurately.

➤ A balance of line, shape, space, tone, light, dark, and shadow is the goal of a tonal drawing, to see and draw the objects in three-dimensional space and volume.

Part 4

Developing Drawing Skills

Don't be shocked if your drawings truly surprise you. By now, you've developed basic drawing skills and are eager to practice what you've learned.

Before you do, though, we'll be looking at journals and sketchbooks—yours and those of a few other artists. Then, because you will need a portable drawing kit to take on the road, we'll suggest both essentials and nonessentials to pack. We'll also peer into some working artists' studios and see what's behind those light-filled windows and how they feel about their work.

We've put a review chapter next, as a reference. And, we'll poke around your house and your garden (and ours) to find some good subjects for your new sketchbook.

At the Finish Line: Are You Ready for More?

After having arranged all things about me in proper order, it is only then that my hand and my mind respond to one another and move about with perfect freedom.

—*A Sung Dynasty Artist, explaining his method*

Congratulations! You have moved from early simple contour line drawings that correctly reflect the shapes and spaces in an arrangement into the realm of tone, value, light, and shadow.

As you try more complicated, finished drawings, you can experiment with new materials, too. Your first work was mostly in the form of exercises. Now, take the time with these more involved pieces to sample some new, heavier paper or a new drawing tool.

New Materials

Artists are junkies for supplies. Many have a lifelong habit—we collect them, organize them, play with them, and hoard them. Alternately, we talk about them, share them, and exchange ideas about them. Whether it's paper or drawing tools, half the fun of being an artist is the "stuff." In this chapter, we're going to share some of that fun with you.

New Papers

Who knew there were so many varieties of something as simple as paper? Artists, that's who! It's time for another trip to your local artist's supply store—this time, to explore the wonders of paper.

➤ Watercolor paper is the stuff that dreams are made of. It's smooth, heavy, resilient, able to stand up to almost anything including a bath and a scrub out if necessary—it's well worth the investment you'll make in it. Watercolor paper comes in varying thicknesses, from 90 lb. to 140 lb. to mega-heavy 300 lb. The surfaces are hot press (smooth), cold press (rather a pebbled surface), and rough (very).

You can buy watercolor paper in blocks, pads, or individual sheets. Take care in cutting down the full sheets. They should be carefully folded and the folded edge creased until you can tear at the fold, leaving a soft torn edge.

➤ Etching or print paper follows rather the same in kinds as watercolor paper and is another lovely surface, although somewhat softer and more fragile.

➤ Charcoal and pastel papers come in pads or sheets. Both types come in tones and colors, which can be seen as the mid-tone in shaded drawings.

Try Your Hand

You can use charcoal to create a mid-tone, also called a ground tone, on a sheet of paper by applying it evenly across the entire surface. You can then make darker tones by adding charcoal, and make lighter tones by erasing out the ground tone.

More Drawing Tools

Earliest man used pieces of cinder or charred sticks to draw on cave walls—and things haven't changed all that much. Artists today rely on charcoal in a variety of forms, as well as more kinds of pens and pencils than you can shake a stick at. Some of Lauren's favorites include:

Assorted artist's materials.

➤ **Charcoal pencils, charcoal, paper stomp,** and **conte crayons** all make their own marks and tones. Each comes in different thicknesses, from stubby and thick to thin and fine, and each comes in different hardnesses as well, from rather hard (for a soft medium) to very soft and smudgy.

➤ **Fixative** is sprayed on the surface of an unstable drawing to protect it from unwanted smudging. It can be worked on after application, and to some extent is reworkable (you can get under it to change something).

➤ **Ink, pens,** and **brushes** are very old media, taking over where charcoal left off. A stick or a clump of animal hair dipped in a pot of pigmented liquid (including blood, mud, or herbal dye) made an ink line, while a piece of grass probably served as an early brush. Today, ink comes water soluble and permanent. Either can be diluted to make washes of varying tints and shades.

➤ **Pens** are as personal as the hand that holds them, from reed and bamboo pens that you can shape to make a particular line, to crow- and hawk-quill pens, to technical pens for a very fine line, to all the new micro-point and felt-tip varieties. You will only know what you like if you buy it, try it, and see what it does.

➤ **Water-soluble pencils** are wonderful to use; they go anywhere and can handle anything. You can use them for a dry drawing, or for a watercolor effect. Built-up layers of color or tone produce rich and sometimes surprising colors.

A pencil sharpener is handy to acquire now if you haven't already. A battery-operated one is great for going out into the field (or stream). If you develop a fondness for water-soluble pencils, a sharpener will be invaluable, because the points need to be sharp to make good lines, and stopping to manually sharpen each one slows you down.

Artist's Sketchbook

A **paper stomp,** whether simply a clumped up paper towel or a specially purchased one, a Q-tip, or even a finger can make interesting tones and blurred areas. Harder lines can be drawn or redrawn on top for more definition. Any unstable surface that could be smeared if touched must be protected with a **fixative,** which is sprayed on a completed drawing to protect it after you've finished.

The Art of Drawing

Brushes are just as personal in preference and use. There are wonderful Chinese brushes that hold a lot of liquid down to fine camel hair that makes the thinnest of lines. Be careful with any brush. Don't leave it sitting in water on its bristles. Wash brushes frequently as you use them, and always keep them flat next to you. If you use a brush for permanent ink, be very sure that you have cleaned it, or there will be a build-up of ink at the base which will affect its shape. Brushes are expensive, but buy the best ones you can. By the way, they make great birthday presents for an artist (hint, hint).

You can make a page of marks or a tonal scale from any new medium to test its uses and range of possibilities.

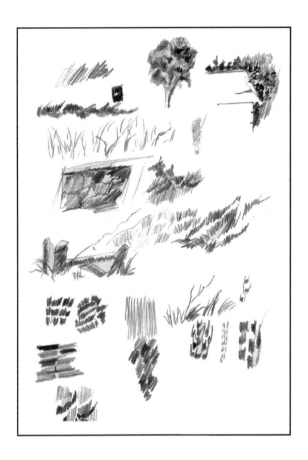

More Techniques

Okay, we've talked about supplies. Now, let's try a few additional techniques that will improve your ability to see and draw the shapes and spaces in a composition as you add either tone or detail and texture.

Drawing in Circles Is not Going in Circles

Circles and ellipses can be seen as building blocks or basic shapes for a lot of objects in composition, because the shapes of all the parts are what make the whole.

Use circles and ellipses to draw space into things right from the start. This will help in making sure that you have left enough room for things. A circle in space is a sphere, or a ball. An ellipse is space is an ellipsoid, rather like a rounded-off cylinder. Practice drawing them as a warm-up and practice seeing them in the objects as you draw in the basic shapes.

Back to the Drawing Board

Fancier materials can make a fancier drawing, but not necessarily a better one. Experiment, but be sure you remember to see and draw before you start in with new tones and textures.

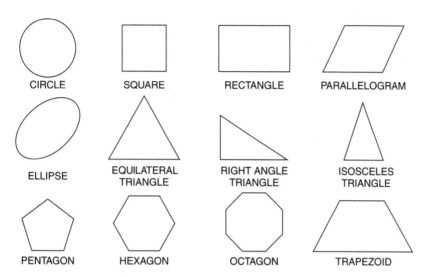

CIRCLE SQUARE RECTANGLE PARALLELOGRAM

ELLIPSE EQUILATERAL TRIANGLE RIGHT ANGLE TRIANGLE ISOSCELES TRIANGLE

PENTAGON HEXAGON OCTAGON TRAPEZOID

Every shape has its own unique geometric equation.

Scale Is Sizing Things in Space

Our eyes are wonderful, subtle lenses that work together to give us binocular vision and the ability to see three-dimensional space. With our eyes, we can gauge how far away things are when we look at them in space, and see the difference in scale. Even across a room, an object is smaller than the same object seen up close. You can see this with a piece of paper rolled up. Try it:

1. Set an object close to you and another similar object of the same size across the room.

2. Roll up a piece of paper and look through it at the object close to you.

3. Adjust the diameter of the roll until it just encloses the object.

4. Now, look at the object across the room. Smaller, eh? It is this difference in scale that you must see and draw to make three-dimensional space and scale on your two-dimensional paper.

Remember to draw what you see and that alone. Don't draw what you can't see. Don't even draw what you think you see—or what you think you know.

Measuring Angles in Space

Remember that the plastic picture plane is an imaginary plane parallel to your eyes through which you see the world. Objects that are parallel to your plastic picture plane appear flat; you are looking straight at a side.

If an object is turned away from you and your plastic picture plane, it appears to recede into space. The ends of the plane that slant away from you are smaller than the ends close to you. Those

Try Your Hand

Drawing in circles and ellipses can make shape, space, and volume in your drawing from the very beginning.

Try Your Hand

Seeing the difference in size and scale is the first step toward drawing space into your work.

131

planes are vanishing in space and must be seen and drawn that way. In Chapter 15, "Into the Garden with Pencils, not Shovels," we will explain the more formal rules of perspective. For now, seeing, measuring, and drawing the angles of things will help you put them where they belong—in space.

The Art of Drawing

You can measure the angles of receding planes against true horizontal or vertical, without using formal perspective rules.

Hold up your viewfinder frame and see the angle that you need to draw against one of the sides of the frame. See the slant relative to the horizontal or vertical of the frame and draw the same relative angle on your drawing. Or, you can hold your pencil up at horizontal or vertical. Look at the angle you want to draw relative to your pencil, decide on the relative difference between your pencil and the line you want to draw, and draw it in.

Back to That Race to the Finish Line

Additional elements that define objects as you are seeing and drawing them are surface detail and texture. Some detail is actually part of an object, structurally or proportionally, but other detail is more on the surface. Texture is an element that is primarily on the surface and follows the shapes and contours of an object.

Sometimes, the pattern of detail or texture can make it hard to see or distinguish tonal values that make the object have volume, so it can be better to get the shapes first, the volume, light and shadow next, and save the surface detail and texture for last.

When you can see and draw an arrangement and balance the various elements, you can really begin to draw anything you want, any way you want.

And It's Details in the End—by a Hair

Our world is filled with detail—good, bad, and indifferent. Sometimes, there is so much extraneous detail in our lives that we need to get away or simplify it. But in drawing, detail tells more about the objects that you have chosen to draw.

Choose some objects with surface detail and texture that define them. Pick objects that appeal to you because of their detail or texture—remember though, you will have to draw them, so don't go overboard at first. Human-made objects are full of interesting detail and texture, but you can't beat Mother Nature for pure inventiveness and variety. Choose a natural object or two that will require your naturalist's eye.

The Art of Drawing

Detail and texture are added information, more or less on the surface. Detail may have more to do with the refined shapes in your objects, while texture may be critical to really explaining what you see on your objects. But the simple shapes come as spaces first. Until you can draw them simultaneously and see line, shape, space, and form, all of them together, you won't truly be drawing.

Take a Closer Look and See the Detail

When the shapes and spaces in your composition are drawn correctly and you have established a tonal range for dealing with the lights and darks that you can see, you can also add surface detail in line, tone, or texture, or a mix of all three.

Some of your object choices will be rich with surface texture and detail. To accurately describe that specific quality about an object, you will need that vocabulary of marks, but only in response to a real seeing of what is there.

Practice a page of marks similar to the page you created in Chapter 7, "A Room of Your Own." You can create a tonal chart with any new mark or texture to see how you can use it to handle tonal variations or detail that is in both light and shadow.

Nature's Detail Is Unending

Why not be a botanist for a day? Pick a branch from a houseplant, a flowering plant, a flower, something from the florist, or something from your own garden or backyard.

1. Sit and see the branch or flower as you may have never seen it before.
2. Look at the direction, length, and width of the stem.
3. Look at the arrangement of the leaves on the stem. Are they opposite (across from each other on the stem) or alternate (one on one side of the stem, one on the other side of the stem, up the stem)?
4. Look at the shape of the leaves. Think in visual terms—what basic geometric shapes are similar to the shape of your leaves?

Try Your Hand

Detail is part of why you pick an object, why it seems to go nicely with another object. Texture is the pattern or surface of an object and further defines it.

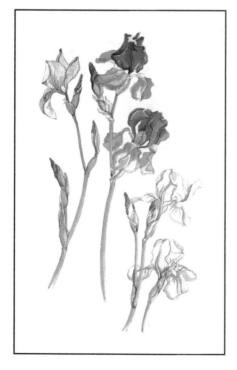

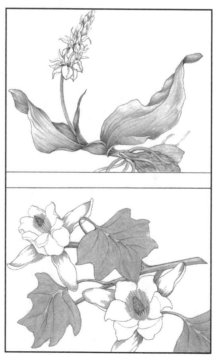

A flowering branch has its own proportion, angles, shapes, and relationships, in the parts and as a whole, so there is a lot to see and draw.

Practice in seeing proportion in nature is practice in seeing it for anything—as well as just good practice.

5. Look at how the flowers sit on or hang off their stems.
 ➤ How are they arranged?
 ➤ How big are the blooms relative to the leaves?
 ➤ What general basic shape do the flowers remind you of? Trumpets, flat spheres, little balls, cones, or what?

6. Flowers are the reproductive organs of their plant. Don't ignore that, exploit it. See all the shapes and draw them.

Flower shapes and detail all have a purpose—procreation and the attraction of those bees, insects, and hummingbirds that do the work of pollinating the flower; drawing the detail tells us about each individual purpose as well.

7. Consider the base of the flower in your decision. How do the back and front of the flower meet?

8. Look at the shapes and sizes of the petals.
 ➤ Are they all alike?
 ➤ Are there pairs of petals? Pairs of three? Maybe five petals, but not all alike?
 ➤ Where do they join the base of the flower?
 ➤ Do they overlap? How much?

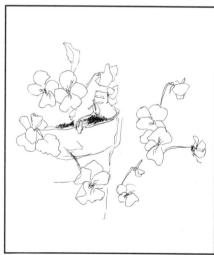

The shapes and angles of petals are as expressive as the parts of the figure.

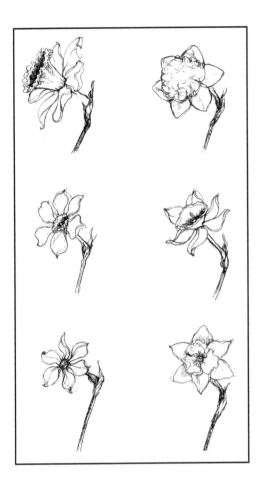

At the Finish Line Again

As you draw, see the botanical detail and the biological detail in your objects from nature. Consider the following:

➤ Think visually, mostly of shape and the relationship of the details to each other. Draw the detail as you see it.

➤ Continue to balance your drawing in line, tone, and texture.

The Art of Drawing

The balance of line, shape, space, form, volume, tone, texture, and God's own detail is ultimately completely personal. No one can tell you what you like and how you should work or what you should go after. Even we can only suggest what you might still need to work on to be able to express yourself in drawing without hesitation.

You may prefer a heavily tonal drawing with less detail or you may love the line aspect and not care about a heavily toned drawing. Experiment and find a balance that is challenging but personal. Look back frequently at your composition to see if you are capturing the essence that you were intending.

The finish line is of your own making.

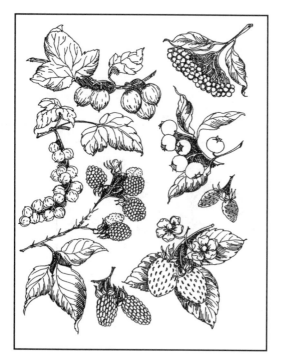

You decide where the finish line is!

Onwards and Outwards

So, are you ready for that unending string of ideas that await you? Subjects are everywhere, just waiting for you to take the time to see and draw.

The next three chapters cover sketchbooks, as well as drawing in and around your house. Then, in Part 5, "Out and About with Your Sketchbook," we will move outside, with a closer look at perspective so that you have all the tools you need to draw anything that you encounter on your travels.

Your Sketchbook Page

Try your hand at practicing the exercises you've learned in this chapter.

The Least You Need to Know

➤ Surface detail and texture tell more about the objects in your drawing, but are secondary to an accurate seeing and drawing of the shapes, spaces, volume, light, and shadow.

➤ See the botanical detail and the biological detail in your objects from nature. Think visually, mostly of shape and the relationship of details to each other. Draw the detail as you see it.

➤ Continue to balance your drawing in line and tone as you add detail and texture. As always, take your time and work hard to really see what you are drawing.

➤ The finish line is of your own making.

The Journal As a Path

> **In This Chapter**
> ➤ Why keep a sketchbook journal?
> ➤ A journal of your own
> ➤ Different kinds of journals
> ➤ The Zen of meditative drawing

To capture the unmeasurable, you must learn to notice it.

—*Hannah Hinchman,* A Trail Through Leaves: The Journal as a Path to Place *(New York: W.W. Norton, 1999).*

The journal as a path, a sense of place, and the journey to get there are paraphrases from the title of a lovely book by Hannah Hinchman. Keeping a journal is a great way to record your thoughts and feelings, your responses, your goals, and your dreams. And a sketchbook journal is a place to record, describe, or just jot down—in drawings as well as words—where you have been, are now, and want to go.

In this chapter, we'll explore the pleasures of keeping a journal of your own, from the why to the wherefore. In addition, we'll be sneaking a peek at the journals of working artists, from Georgia O'Keeffe to some of our friends and neighbors.

Why Keep a Sketchbook Journal?

You can make your journal anything from a mixed bag—including shopping and to-do lists, if you want—to a separate sketchbook for drawing. Even then, you can annotate your drawings to remind you of details or the feelings you had as you were drawing, or why you picked the subject you picked. What you were thinking or feeling can get lost in the rush of busy days, after all, and a journal provides the means to keep those moments with you and be able to go back to them for inspiration or solace—or to simply remember.

If you decide to keep a sketchbook journal, you'll be in good company. In the section below, we've gathered the words of some well-known artists from their sketchbook journals.

Artists on Their Work

I have always been willing to bet on myself—to stand on what I am and can do even when the world isn't much with me.

—Georgia O'Keeffe

We're fortunate that many of the world's best-known—and best-loved—artists kept journals, because that means we can let them speak for themselves about how they feel about their tools, their studios, and their work. Artists, in fact, are quite eloquent when they're writing about their passions.

How They Feel About Their Studios and Tools

Perhaps no one's studio says so much about the artist's work as that of Georgia O'Keeffe. Her studio is so large it's like being outside, which is exactly the feeling one gets from her works as well. Many of O'Keeffe's better-known canvases are quite large, as well—much larger than life, as was the artist herself.

Corrales, New Mexico, artist Marianna Roussel-Gastemeyer notes that her studio is easy to find: "Just follow the pottery shards to the door." Just down the road, another Corrales artist, Cindy Carnes, has situated her studio to capture the ever-changing face and light on the Sandia Mountains to the east. (And just down the road from Roussel-Gastemeyer and Carnes, Lisa types these lines.)

When it comes to tools, artist Frank M. Rines notes in *Drawing in Lead Pencil* (New York: Bridgeman Publishing, 1943):

It has been said that a good workman never complains of his tools. Very true, but have you ever noticed that a good workman never needs to complain, that he always has good tools.

As you'll recall from previous chapters, we couldn't agree more: Having the right tools is half the fun.

How They Feel About Drawing

Writers are at the forefront of those who appreciate drawing. D.H. Lawrence, for example, once noted, "Art is a form of supremely delicate awareness meaning at oneness, the state of being at one with the object." But artists themselves have much to say as well. Here are some wonderful quotes from artists about the artistic process:

The long, arduous and often painful struggle in seeking truth and beauty requires not only a deep and passionate love for art, but also a deep and passionate love for life.

—Harry Sternberg, Realistic/Abstract Art *(Pittman Pub., 1959)*

The goal of the artist is the achievement of the truly creative spirit. It must be earned through discipline and work. Among other disciplines, drawing is basic.

—Harry Sternberg

I do not like the idea of happiness—it is too momentary—I would say I was always busy and interested in something—interest has more meaning than the idea of happiness.

There is nothing—no color, no emotion, no idea—that the true artist cannot find a form to express.

The process, not the end work, is the most important thing for the artist.

To fill a space in a beautiful way—after all everyone has to do just this—make choices in his daily life, when only buying a cup and saucer.

—Georgia O'Keeffe

Care should be taken to not have more than one center of interest. Extremely important too is the leaving of white paper. The parts of a drawing that are left white, or in other words, not rendered, are just as necessary as are the parts that are drawn.

—Frank M. Rines

These—artists of the world—are akin to the scientists only in that their effort is to bring things near, but even there they part, for the scientist must need to use the telescope or the microscope, whereas the artist brings them near in sympathy.

—John Marin

The Art of Drawing

Here are Frederick Frank's "10 Commandments" of drawing:

Source: *The Awakened Eye,* (New York: Vintage/Random House, 1979).

1. You shall draw everything and every day.
2. You shall not wait for inspiration, for it comes not while you wait but while you work.
3. You shall forget all you think you know and, even more, all you have been taught.
4. You shall not adore your good drawings and promptly forget your bad ones.
5. You shall not draw with exhibitions in mind, nor to please any critic but yourself.
6. You shall trust none but your own eye, and make your hand follow it.
7. You shall consider the mouse you draw as more important than the content of all the museums in the world, for ...
8. You shall love the ten thousand things with all your heart and a blade of grass as yourself.
9. Let each drawing be your first: a celebration of the eye awakened.
10. You shall worry not about "being of your time," for you are your time, and it is brief.

The eye that sees is the I experiencing itself in what it sees. It becomes self aware and realizes that it is an integral part of the great continuum of all that is. It sees things such as they are.

—Frederick Frank

Different Kinds of Journals

Chances are you will end up with a few different journals. Lisa, a writer, keeps one journal in her nightstand for those random middle-of-the-night flashes of brilliance, another on her desk to jot down thoughts that have nothing to do with what she's working on at the moment, a third by her reading chair, and another in her car (you probably don't want to be on I-25 when Lisa's recording one of her inspirations in the next lane). And then she has an additional journal where she copies down great quotes she's come across in her reading, snatches of (or entire) poems, and thoughts from other writers she tries to collect in one place.

When it comes to drawing journals, you may want to try a similar approach. Here are some of the possibilities.

Travel Journals

You can take a travel sketchbook with you on a trip if it's small enough to carry easily. In fact, think of all your traveling art supplies as a kit, which may include

> ➤ A sketchbook.
> ➤ A few pencils and packs of leads (leave the sharpener home).
> ➤ Two erasers (just in case).
> ➤ Small clips to hold your paper in place if it's windy.
> ➤ Maybe some tape or rubber bands.
> ➤ A few sheets of heavier paper cut to a good size.
> ➤ A lightweight board.

Add things to your travel kit as you see fit, but remember that you will have to carry it to be able to use it.

Try Your Hand

If you are going farther out in search of yourself, take water and some food, a jacket, and maybe a phone. Don't hesitate to push the envelope of your world. Just be a scout about it, and be prepared.

Closer to Home

You will want a larger sketchbook or supply of loose sheets in a portfolio for drawing close to home. Most of your learning drawing will be done in these.

If you remember your dreams or have frequent flights of fancy, you may want to keep a separate expressive journal. Try to make a drawing that captures or reflects your memory, and write down what you remember. You may be surprised at the direction your work takes.

Nonfiction and drawing in a journal combine differently, usually requiring a realistic drawing. They can include a more elaborate travel journal for a special trip, or a recipe book with all your favorite dishes and some how-to drawings to explain what you mean or how to arrange everything—a cookbook in the making.

The Art of Drawing

Poetry, fiction, and drawing could occupy another sketchbook or be one of the ways you use your general one. Poetry and short fiction (your own or someone else's) can balance or expand on a drawing—or the other way around. Entries can be illuminated with realistic or imaginary and expressive drawings. Early on, you may stick to the business of learning how to draw, but later you may find that expressive drawing suits you best.

A gardening journal can be a great sketchbook, where you can record that season's experiments, problems, triumphs, and notes for next year, as well as all the glorious detail of the growing season in your special garden.

Other journals could include a fishing journal, or even an exercise or diet journal (draw what you want to eat, but won't!).

Two pages from a gardening journal: A gardening journal can include sketches of your garden—or dreams for next year's garden.

The Art of Drawing

A journal recording the joys of motherhood—what happened during the nine months of waiting, certain details about the birth, and early drawings of your newest family member—will be treasured later on, by both you and the child. You could also do the same for a new pet. After all, like babies, they will provide you with lots of material.

Your Journal Is All About You

There's nothing like a journal for being yourself. Approach a journal with the understanding that it is yours alone, *for* you as well as *by* you. You don't have to put it under lock and key, but do let other family members know that you don't want them to look there. Some may have trouble with curiosity, of course, so you may want to keep your journal somewhere safe, if you'd rather they didn't look.

Among the many good things a journal can provide are

➤ A sense of self.

➤ A sense of place.

➤ A sense of purpose.

➤ A sense of time.

➤ A place to explore ideas and save them for later.

➤ A verbal and visual vocabulary.

➤ A place to get past first solutions.

➤ A place to see the detail past what is predictable.

Back to the Drawing Board

In *The Artist's Way* (New York: Jeremy P. Tarcher, 1992), Julia Cameron suggests writing three "morning pages" every single day! While you don't have to do something quite this structured, knowing that you can use a journal to get rid of the extraneous details of life can be a very freeing experience. Try it, and you'll see what we mean. You can also draw those three pages or try for a mixture of the two.

Using Your Journal

You will learn the most about drawing in your journal by working from life. You don't have to follow these steps exactly or even at all, but we provide them just in case you do want a framework to follow as you begin to use journals.

1. Decide on a subject, a composition, a view, a vantage point, a frame, and a format, even if roughly drawn on your page and viewed only with your two hands.

2. See and draw in your sketchbook journal as carefully as you have in the preceding exercises.

3. Consider how much time you'll have to make an entry so you don't rush.

4. Try to draw every day—practice is the key.

The Art of Drawing

Make lots of notes on your drawings as to color, shape, weather, temperature, shadows, and anything else you want, to remind you for later. You can use the detail notes for drawing, or just to remind you of where you were that day. Record and enjoy the details that are different or unusual. It will get you past your usual observations and opinions of things. Write to enjoy and remember—but don't let your mind drift away from the job of seeing visually.

Expressive Drawing

Expressive drawing can be a release for some of your inner feelings and thoughts, and you can experiment with color if you like.

Bear in mind that different cultures view color distinctions differently. For the Japanese, for example, white is the color of mourning and black is for celebration, rather than the reverse in our western tradition—unless, of course, you live in New York City, where you "must" wear black. When it comes to color, let your own feelings guide you.

Color	Western Thought	Eastern Thought
white	innocence	mourning
black	depression	strength
green	jealousy	growth
blue	despondency	truth
yellow	treason	nobility
red	sin, anger	love and passion
purple	royalty, religion	

Research has shown that certain colors are associated with certain feelings. Take a look at this chart. Do you agree? If not, you may want to make a chart of your own (you could use one of your journals), documenting what various colors mean to you.

Drawing as a Form of Healing

Healing takes lots of forms. Often, giving yourself the present of time and solace, and even silence and solitude, can be a healing gift. Whether you use drawing as a therapeutic adjunct or as a therapy of its own, its healing aspects are one side effect that's worth pursuing.

Like anything that takes you out of yourself, drawing can be a way of channeling negative energy in a more positive direction. Why throw that pot at your beloved when you can draw a picture of how you're feeling instead? Even if you feel your drawing ability is still in its infant stage, you can draw a nasty picture of someone you're angry with—and laugh yourself right out of your snit.

Therapeutic Drawing

Cut down on those shrink sessions and bills and put the self-help books in a closet. The time you spend drawing and expressing yourself on paper can be surprisingly therapeutic. You could feel elation and peace from setting aside time just for you. You could begin to value yourself more. You could feel very real accomplishment at learning how to draw when you thought you couldn't. You may use that feeling to tackle other things you thought you couldn't do, like stopping smoking, losing weight, organizing your time more efficiently, learning a new computer program, or even changing your job to something more satisfying and creative—like drawing!

> *A drawing a day keeps the doctor away.*
>
> —Dan Welden

Spontaneous Drawing

You can try some of those beginning exercises again, particularly the drawing without looking and drawing negative space, two of the more right-brained exercises, to see what responses you have now. They might unleash a different creativity or an interest in abstraction, or a new experience in using texture. What's important here is spontaneity; don't think, Old Lefty, just do it!

Artist's Sketchbook

Zen is more than a religious practice, it's a philosophy and way of life that comes from Japanese Zen Buddhism. At its most basic, Zen can be thought of as a holistic approach to being that takes for granted the inter-connectedness of all things and encourages simplicity in living in order to live with the complex.

Zen and Drawing

Zen in drawing is actually what this is all about, getting to a meditative, intuitive place (the right side) and letting go all the disturbance (Old Lefty) in order to just be, see, and draw.

When it comes to drawing, having a Zen approach means allowing things to develop as they will, without the need for control that marks so much of our lives.

A Zen way of life incorporates everything from meditation to ordered simplicity in order to better appreciate the interconnectedness of all things. It follows, then, that a Zen way of drawing might be one simple line which points in a surprising new direction.

Whether it's Zen, spontaneous drawing, therapeutic drawing, or just plain old revenge drawing, keeping track of your moods in a sketch-book journal can be a surprisingly simple way of rediscovering yourself.

So, armed with some new materials and techniques, go forth into your everyday surroundings with a fresh vision of what you see.

Your house and immediate surroundings are filled with things to see and draw ... and then there is the wild blue yonder.

Your Sketchbook Page

Try your hand at practicing the exercises you've learned in this chapter.

The Least You Need to Know

➤ A sketchbook or illuminated journal is a place for you, your thoughts, dreams, experiments, tests, notes, remembrances, hopes, musings ... and drawing practice.

➤ You can have as many sketchbook journals as you have reasons for having them, or just because you couldn't resist.

➤ Setting aside the time to draw can be a great gift to give to yourself or someone you love.

➤ Peace and serenity are hard to come by in our world. Drawing as a meditation can be the path to spiritual release and learning.

This Is a Review—
There Will Be a Test

In This Chapter

➤ Look how far you've come

➤ Reviewing what you already know

➤ Slowly you draw, step-by-step

➤ Taking stock and moving on

The goal of the artist is the achievement of the truly creative spirit. It must be earned through discipline and work. Among other disciplines, drawing is basic.

—Harry Sternberg

Since you've come with us this far, you've probably got quite a collection of drawings by now. Part of what scares people—especially adults—about learning to draw is the fear of not being good. But you know what? That's Old Lefty, rearing his ugly head yet again. Your right brain knows that you can't get to the good stuff without making a few messes and more than a few mistakes. But don't take our word for it. Let's go back through your drawings, so you can see for yourself just how far you've come.

Through the Looking Glass

Going back through your drawings can be a revealing experience, even if you only started them a few weeks ago. Your first surprise will be just how much progress you've made in your technical skill. That's because just drawing something every day means you're practicing, and practice will improve any skill.

Before you start judging your work too harshly (don't let Old Lefty have any say!), why not use the checklists in this chapter to see what you've learned. You may even want to tab this chapter for future reference, because we've pulled in every lesson you've learned up until now in one convenient location.

Seeing as a Child

In Chapter 2, "Toward Seeing for Drawing," you took your first tentative baby steps toward seeing as an artist does—with your right brain. By now, you've heard us saying this for so long, it's something that's as basic to you as breathing.

Still, remembering to see everything with the openness and creativity of a child—with your right brain—is one of the most important things you can do for your drawing.

Look/Don't Look

In Chapter 3, "Loosen Up," you tried several drawings without looking at the page after you'd set your pencil to draw. Drawing without looking at what you're drawing helps you banish Old Lefty to his tidy, ordered corner, where he belongs.

You may want to try a new drawing-without-looking exercise now, just for practice.

Guides Are What You Make Them

Whether you use a guide like a plastic picture plane or a viewfinder frame, or draw freehand, the first step in drawing is seeing. To help you decide which is the best way for you to begin, we've prepared a review of these three approaches to seeing what you draw.

Plastic Picture Plane Practice

In Chapter 4, "The Picture Plane," we introduced you to the plastic picture plane. We've referred to it since, but it's possible you haven't used yours again since Chapter 4. If that's the case (or even if it's not), why not get out your plastic picture plane and practice with it? (Say that 10 times fast.)

Try Your Hand

Take some time now to go back through your drawings and see how far you've come.

1. Pick a subject for your drawing.

2. Line up your plastic picture plane with your eyes, keeping it perfectly still. Rest it on a table, or hold it straight up and down at a level that you can see through and draw on at the same time.

3. Close one eye and take a good long look through your picture plane. See what you can see, not what you think.

4. See the image through the lines that you put on the picture plane, but try to note where things are relative to the lines:

 ➤ What part of the image is in the middle?

 ➤ What part is near the diagonal?

 ➤ What part is halfway across?

 ➤ On which side of each grid is each part?

 ➤ Does a particular line go from top to bottom or across?

 ➤ Does a curve start in one box and travel to another before it disappears?

 ➤ And then what?

5. Uncap your marker and decide on a place to start.

6. Start to draw your subject, line by line.

7. Keep drawing.

Try Your Hand

No matter where you look, or what you're looking at, see it with the wonder and first-time awe of a child.

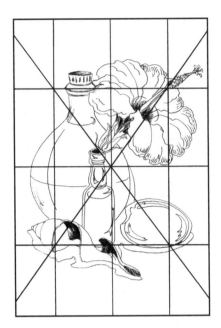

Isolating an object with a plastic picture plane.

When you have put in all that you see in your object, take a moment and observe the accuracy with which you have drawn a complicated drawing. Try to see where the plastic picture plane made it easy for you to draw a difficult part, like a table in perspective, or the scale of two objects, or the detail on the side of a box, or the pattern of a fabric that was in folds.

These potential problems are no longer problems, once you really see and draw what you see.

A View Through Your Viewfinder Frame

In Chapter 5, "Finding the View," you were first introduced to the viewfinder frame. Just for practice, why not get out your viewfinder frame again?

1. Decide on something to draw. You can keep it simple.

2. Position yourself, your drawing materials in front of you, and the object out in front of you at an angle (45 degrees) where you can see your whole subject.

3. Pick a viewfinder frame that surrounds the subject quite closely on all sides.

4. Draw a proportionally equal rectangle on your paper.

5. Reposition the viewfinder frame until your subject is nicely framed within the window and spend some time really seeing your subject through it.

6. Close one eye and do the following:

 ➤ Observe the diagonals and center marks on the viewfinder frame.

 ➤ See where your subject fits against the sides of the frame.

Back to the Drawing Board

Use your viewfinder frame to know where a particular piece of your subject belongs. Be sure to draw only what you can see in the frame, and nothing else.

➤ See where your subject touches the floor or table.

➤ See where its top is.

➤ Look at the angles.

7. Begin to draw your subject on your paper in the same place as you see it in the frame.

8. Using an imaginary vertical line, check all the angles you've drawn to see how they stack up.

9. Add details, as you can really see them and relate them to what you have drawn. *Take your time.*

Using the viewfinder frame.

Or, Let Your Conscience Be Your Guide

As you work the drawings throughout the rest of this book, you can use any, all, or none of the guides, from your plastic picture plane to your viewfinder frame. It all depends on how confident you feel. If you are not actually using the guides, it's because you are using them automatically, in your mind's eye (or is it your eye's mind—it's so hard to keep them straight ...).

If you lose your place, use a guide; that's what they are there for. We will remind you of them from time to time, but from now on, you'll choose how to use them and whether you can, even part of the time, just see and draw.

Accentuate the Negative

In Chapter 6, "Negative Space as a Positive Tool," you learned how to draw negative space. Here's an exercise to help you review what you learned there.

1. Divide your paper into four equal quadrants.

2. Hold the viewfinder frame very still and frame your subject in a window.

3. Pick a "spot of space" somewhere inside your subject to start, and really see it. Close one eye and "see" that spot until it becomes more real than the subject itself. You will know when this has happened because it will pop forward as a spot of space while the subject itself will fade or recede.

4. See where that spot is relative to the grid lines on your viewfinder frame. You can also look at the spot through your plastic picture plane to isolate just where it is relative to the grid.

5. Use the grid on your paper to draw the first spot of space on the paper.

6. Think relatively and relationally. Try to see where your spot is relative to the marks on the frame, the grid on the plastic, and the light lines on the paper.

The Art of Drawing

The most important thing about drawing negative space is to stay focused on the space. Forget about the actual subject; pretend it's not even there. Remember to keep one eye closed each time you find your next spot of space. Find the shape of that spot by seeing it relative to your grid marks. Think about comparing the shapes of the negative space and the edges of those shapes. Are the lines horizontal or vertical? If they are neither, try to see the angle relative to horizontal or vertical and draw what you see. The trick to drawing negative space is drawing the holes, not the thing.

As you draw more and more of the negative space shapes, it will be easier and easier to fit in the remaining ones. The spaces around your subject will actually define your subject.

When you have drawn all the negative spaces on your drawing, check each one in turn against the subject itself. Make small corrections to the shapes of the negative spaces as you see them. You can lightly shade the negative space shapes as you refine them, if you'd like. Your subject will take turns with the space around it—one will appear positive and the other negative, then they will flip.

When you are finished, your drawing will be a very different record of seeing. Your subject will come out of the space you have drawn around it!

Making Arrangements

In Chapter 9 you made your first arrangement of objects to create a still life. You learned about vantage point and viewpoint, and how looking at objects from different angles could change their appearance. Now it's time to practice drawing an arrangement again.

Lauren (upper) and one of her students (lower) arrange a few objects in a pleasing way, and then draw by the guidelines—step-by-step.

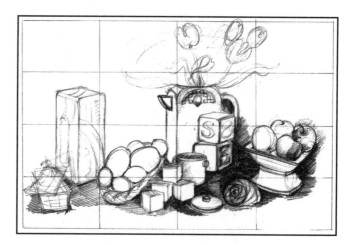

Slowly You Draw, Step-by-Step

Just for practice (and isn't that what this is all about?), make another arrangement of objects or furniture to draw now. You'll follow the same steps as always, using the guides as much or as little as you need them.

Try Your Hand

Put things flat or at angles to see how they vanish, or become smaller as they recede, or turn away from you. Circular shapes, like tops of cups, mugs, or vases, get flatter as they are turned away from your view.

1. Arrange yourself comfortably.

2. Select your objects or your view.

3. Arrange your objects, still life composition, or move the furniture to suit you.

4. Decide on your viewpoint and eye level.

5. Adjust the lighting if necessary.

6. Establish a format and size of drawing.

7. Take a moment to decide on your probable medium and paper. If you are not sure, go for a high-quality piece of paper; you never know ….

8. Use the viewfinder frame to see your choice.

9. Make a box on your paper that is proportionally equal to your viewfinder frame at any size. Remember the diagonals to keep the box and the frame in proportion.

10. Use your plastic picture plane or your viewfinder frame to see the arrangement or view in space.

11. Site what you see on your page.

12. Start with light planning lines for the simple shapes, lines, angles, and the general outline.

The Art of Drawing

Try to see objects as if they were transparent. See their space; imagine a dotted line at the back of where they are to ensure there is enough space for the objects to really be there in space. If an object is too close, it cannot really be there in the same spot with another object. You can look straight down on your arrangement, even diagram it to help you see the space that you have to create for each object.

Making a List and Checking It Twice

As you draw, you'll want to consider the following:

1. Check your initial light drawing for accuracy.

2. Check the shapes, the spaces, and look at the negative spaces, how things overlap, and which way the angles are. See the basic geometric shapes in space.

3. Use your viewfinder frame to gauge any angle relative to horizontal or vertical, and the grid marks on the edge of the frame.

Try Your Hand

If you have a problem, use the plastic picture plane and transfer what you see to your drawing.

4. Use your pencil to do the same. Hold it at horizontal or vertical next to an angle and see the difference.

5. You can use a carpenter's angle measure to see an angle and transfer it to your drawing.

6. Draw a box for something that is hard to draw. Put the box in space, then draw the thing in the box.

7. See relationally. As you are sure of one shape, relate the others to it. Keep checking and adjusting until you are happy with your drawing.

Form and Function

Now, begin to work on form.

➤ You can add tone, or try to define the form with line, or you can leave it a contour line drawing.

➤ If you choose to add form, adjust your lighting if necessary.

➤ Make a tonal chart for the values in your arrangement.

➤ Squint to see the extremes of value in you arrangement and subdue the detail and mid-tones.

➤ Pick out the lightest spots and the darkest.

➤ Add some tone to the middle shades, from the lighter ones to the darker ones.

➤ Try to see tones as having shapes on your subjects.

➤ Look at shadows next to things and under things as well as shadows on other things.

You can work toward a very tonal drawing or you can merely suggest volume, perhaps just with shadows. Add detail and texture as you see them. Use those naturalist's eyes of yours for a clear seeing of detail.

The Art of Drawing

Rendering texture requires a mark that is appropriate for describing the texture. Experiment on a separate piece of paper.

Detail and texture may also require a lot of planning and measuring, especially if there is a pattern on china, a fabric print, or fine detail on seashells.

Getting Some Distance on Your Work

Get up and look at your work from a distance, with fresh eyes. Don't hesitate to go back and fix something. Work patiently—it is your drawing.

As you work, be alert (the world needs more alerts). See the lines, tones, textures, and detail begin to work together.

Determine if your work is getting to be all one tone with little contrast. You can change your tonal range in a number of ways, including:

➤ Lightening the lights

➤ Darkening the darks

➤ Darkening the main lines in the contour line

➤ Erasing out part of the texture or tone to just suggest it

Your Learning-to-Draw Cheat Sheet

We thought it might be helpful to have a cheat sheet, with all the "rules" in one place, so we created this Learning to Draw Cheat Sheet, which also appears on the tear-out card

inside the front cover of this book. You can paste this list inside the cover of your sketch-book or tack it up on the wall near your drawing table, referring to it as you work. Meanwhile, you'll always be able to find it right here, in case that tear card gets too dog-eared from constant use!

1. Take yourself and your work seriously. Make yourself a place to work that is just for you.

2. Set a time to work. Make a date with yourself.

3. Look around for some first subjects as ideas.

4. Arrange yourself comfortably so you can see your subject and your paper easily.

5. Select your objects or your view.

6. Arrange your objects, still life composition, or move the furniture to suit.

7. Look at things flat or at angles to see how they vanish—that is, become smaller—as they recede. Ellipses get smaller or flatter as the object is turned away. Look at the main angles in your view.

8. Decide on your viewpoint and eye level.

9. Adjust the lighting if necessary.

10. Establish a format and size of drawing.

11. Decide on your medium and paper.

12. Use the viewfinder frame to see your choice.

13. Make a box on your paper that is proportionally equal to your viewfinder frame at your chosen size.

14. Remember the diagonals keep the box and frame in proportion.

Back to the Drawing Board

If an object appears too close, it cannot really be there in the same spot with the other object. You can look straight down at your arrangement, even diagram it to help you see the space that you have to draw in.

15. Use your plastic picture plane or your viewfinder frame to see the arrangement or view in space.

16. Site what you see on your page.

17. Start with light planning lines for the simple shapes, lines, angles, and the general outline.

18. Check your initial light drawing for accuracy.

19. Check the shapes and the spaces. Look at the negative spaces, how things overlap, which way the angles are. See the basic geometric shapes in space.

20. Look to see objects as if they were transparent. See their space. Imagine a dotted line at the back of where they are to ensure there is enough space for the object to really be there in space.

Try Your Hand

Remember, for fun or for help, use your patio or sliding glass door as a big plastic picture plane.

21. Use your viewfinder frame to gauge any angle relative to horizontal or vertical and the grid marks on the edge of the frame. Use your pencil to do the same. Hold it at horizontal or vertical next to an angle and see the difference.

22. Use your carpenter's angle measure to see an angle and transfer it to your drawing.

23. If you have a problem, use the plastic picture plane and transfer what you see to your drawing.

24. Draw a box for something that is hard to draw. Put the box in space, then draw the thing in the box.

25. See relationally. As you are sure of one shape, relate the others to it. Keep checking and adjusting until you are happy with your drawing.

A Form for Form

Now, begin to work on form. You can add tone, or try to define the form with line, or you can leave it a contour line drawing.

1. If you choose to add form, adjust your lighting if necessary.

2. Make a tonal chart for the values in your arrangement.

3. Squint to see the extremes of value in your arrangement and subdue the detail and mid-tones.

4. Pick out the lightest spots and the darkest.

5. Add some tone to the middle shades, from the lighter ones to the darker ones.

6. Try to see tones as having shapes on your subjects.

7. Look at shadows next to things and under things and on other things.

8. You can work toward a very tonal drawing or you can merely suggest volume, perhaps just with shadows.

9. Add detail and texture after you see the shapes and the form.

10. Use those naturalist's eyes of yours for a clear seeing of detail.

11. Rendering texture requires a mark that is appropriate for describing the texture. Experiment on a separate piece of paper.

12. Detail and texture may also require a lot of planning and measuring if there is a pattern on china, a fabric print, or fine detail on seashells.

13. Get up and look at your work from a distance. Look with fresh eyes. Don't hesitate to go back and fix something. Try the reverse end of a pair of binoculars. Consider the view from a mirror.

14. Work patiently—it is your drawing.

15. As you work, see the lines, tones, textures, and detail begin to work together.

The finish point, as always, is your choice.

The Art of Drawing

See if your work is getting to be all one tone with little contrast. You can change your tonal range by lightening the lights or darkening the darks or darkening the main lines in the contour line, or erasing out part of the texture or tone to merely suggest it.

Exercising Your Rights

As you may have realized by now, none of the exercises in this book is a one-nighter. You'll want to go back to each of them again and again, because each of them has something unique to teach you that practicing can only improve. Don't forget, practice makes perfect, and that's part of what learning to draw is all about!

In the rest of this book, you're going to be drawing everything from pots and pans to landscapes to animals to people, so you may want to review the exercises in this chapter a few more times before you take that big step. Or, if you're like us, you're ready to get out there and start drawing!

Your Sketchbook Page

Try your hand at practicing the exercises you've learned in this chapter.

The Least You Need to Know

➤ Looking back through your drawings will help you see just how far you've come already.

➤ You'll want to go back to all of the exercises in this book more than once. Each of them has something unique to offer. Use the crib list to remind you of how to go about it.

➤ Use the checklist to remind you of steps toward seeing and drawing.

➤ Practice makes perfect!

All Around the House: A Few New Drawing Ideas to Try

I have probably drawn as many chairs and desks and corners and interior objects as I have landscapes.

—Hannah Hinchman, Bloomsbury Review *Interview, Jan/Feb 2000.*

The skills for drawing all that follows are yours—or, at least, within your grasp—if you proceed step-by-step. Each of the next seven chapters has a theme area for you to explore: from inside your house to your garden, or out and about in the countryside, on a village street, at a boatyard, on a farm, at the zoo—anywhere you choose to go with your sketchbook or a full drawing set-up.

Your House Is Full of Ideas for Drawing Practice

In this chapter, you'll begin by taking a walk through your own house and seeing what you've already got, just waiting to be drawn. Chances are, you've got a wealth of material.

You can try any subject as a sketchbook/journal entry, or you can set up to try a larger, more finished drawing that you will work on a few times. If so, pick a nice piece of paper and spend the first session planning, arranging, lighting, and siting your arrangement on the page.

Time Is of the Essence

On the plus side, your house has all your favorite stuff. On the minus side, it has most of your distractions right there, too. Of course, highly disciplined professionals like Lauren and Lisa long ago came to terms with these distractions. (And if you believe that one, we have a bridge that you could buy ...)

Seriously, though, being earnest about your time is the first step. Maybe you have had enough success with this book to be more committed to your own work. If that's the case, keep it up!

Once you've found some stuff around the house you want to draw, you'll want to set a time to work. Do enough of your daily chores to get by, but only just. This is the hard part, leaving those dishes so you can draw. You may hear your mother's voice in your head, telling you you're being self-indulgent or childish. Lesson One: Ignore her.

Get your coffee, your lunch, whatever you need, and give yourself a time slot to work. Some people find actually writing the time on their calendar is enough to make them arrive in their studio, ready to work.

Turn on the answering machine, turn off the computer. Turn on some music, turn off the TV. Put out the dog and let in the cat.

The Art of Drawing

The most important thing is to make this time your own. That means that if the UPS man rings the bell, you won't answer; he'll leave the package on your stoop or with a neighbor. It means that even if you hear your long-lost lover's voice on the answering machine, you won't give in to the urge to pick up the phone. You won't go to see what the dog is barking at now, even if the coyotes are howling, too. Uninterrupted time is what we're talking about here. Make a date with yourself—and then keep it.

Back to the Drawing Board

Rearranging is one thing, but major renovation takes time away from drawing. Don't use it as an excuse for not drawing!

Your Kitchen Is a Storehouse

A good place to start is right in your kitchen—you'll be near the coffeemaker. However, you'll want to avoid the refrigerator, for obvious reasons—you'll end up snacking instead of sketching. What you will choose to draw in the kitchen—or anywhere around the house, for that matter—will fall into three categories:

1. Objects seen up close and personal

2. A composed still life arrangement

3. A corner of a room—as is, or you can rearrange the furniture

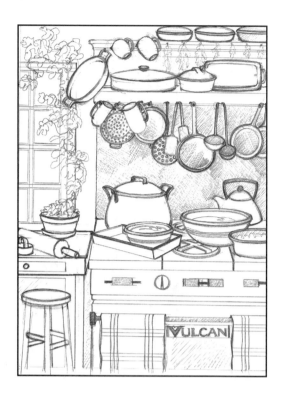

Anything from around your house is fair game as a drawing subject.

You will learn by trying all of these things. Perhaps, after you have tried to see it and draw it, you will also begin to see your house differently and end up rearranging it (unless, like Lisa, you do this all the time already).

But now, since you're all settled with your coffee and your drawing pad in your kitchen anyway, let's poke around and see what we can find to draw.

Silverware

Forks, spoons, and knives can make the most interesting of subjects for a drawing. Reach over and open your silverware drawer and pull out one of each ... or three of one. Arrange them on a placemat, or set up an entire place setting, complete with a vase and fresh-picked flower, and draw that.

Silverware and place settings are just the beginning. Open your cupboards, too.

Set your table and draw it, too!

Pitchers and Bowls

When you wander through your local art museum or galleries, you'll probably notice that pitchers and bowls abound in still lifes. These objects are artists' favorites for good reason; they have lovely curved lines that are fun to draw, and their varying shapes and sizes can add interest, too.

If you decide to draw a pitcher or a bowl (or both), you may want to use some other objects in the kitchen for your arrangement as well. A tea towel arranged at the base of a pitcher can add both dimension and shading. Some apples or oranges placed in a bowl can add color (even when you're drawing in black and white) and tone.

Make a simple still life by setting some fruit in a bowl and then drawing it. Or just draw your plate rack—dishes included, of course. Then, bring it all together.

The truth is, just about anything in your kitchen is a potential drawing subject. So whether it's a loaf of bread, a jug of lemonade, or thou, get thee to a drawing pad.

Not Just for Sleeping Anymore

If you've finished your coffee (and your still life), you've probably got lots of energy now. That's good, because it's time to get up and wander into some other rooms. Let's start with the bedroom, where there's a wealth of things just waiting to be drawn.

First, take a look at the entire room. How is the furniture arranged? Is it pleasing? Pick a vantage point you like and quickly sketch what you see. You may want to toss a scarf over a bedpost to add some texture, or move a plant to create a more eye-pleasing arrangement. You may decide to leave the scarf and the plant where you've moved them after you've finished drawing, too; that's part of the fun.

Next, pick some singular arrangement in your room that you'd like to draw. Lisa has an old spider plant set in an equally old basket on an antique chair she got at a Nebraska auction for 25 cents (everything in Lisa's house comes with a story attached). You might have some of your favorite photos or keepsakes arranged on your dresser, or a lamp and some books on your nightstand. The possibilities are endless.

Back to the Drawing Board

Watch out with stripes—you have to pay attention to where they go and where they come out. Make a flowered pattern work by carefully measuring and planning before you start drawing.

Lisa's spider plant on antique chair, drawn by her daughter.

Fabrics

Fabrics can make a surprisingly pleasing composition. Even if you don't sew, your clothes, comforter, pillows, and curtains are each of a different fabric, and setting one against another can create an arrangement you'll want to draw.

It may help to pretend you're Martha Stewart. Artfully arrange a few pillows against your headboard. Add a breakfast tray (oh yeah, we all have those handy). How about a pretty nightie, or a fabric throw? (Or some craftsmen's tools, a saw or two, and that Harley …) Arrange your fabrics as if they're casually thrown, without them looking like a mess.

Fabrics present their own unique problems. They are the essence of surface texture, with all sorts of spots, lines, patterns, plaids, flowers—you name it—sitting on top of some flexible material that has fallen into interesting but hard-to-draw folds, creases, and overlaps.

The solution is to draw the shapes first, as always, but this is ever so much more important with fabric. Then look at tone, the lights and shadows of the folds of fabric. Try to lightly shade to define what the fabric is doing.

When you can see in your drawing what the fabric is actually doing, then and only then should you start adding the surface texture. See it disappear as the fabric folds under itself. Or is it covered by another object? Does it come out on the other side? Don't rush along here; pattern and texture take time and patience.

An artful arrangement of fabrics can make a lovely drawing.

Shoes

Even if you're not Imelda Marcos, you've probably got more than one pair of shoes. Lisa is not a shoe maven, but her closet reveals riding boots, hiking boots, two pairs of heels (both from the '70s), sandals, and loafers. If you've got a pair of riding boots, try leaning them against the leg of a chair, and then drawing them. Or put the sandals on a throw rug and throw in the towel, too. What you draw is limited only by your imagination.

Even your shoes can make a pleasing arrangement.

Hats and Gloves

Picture a pair of elbow-length gloves draped across the brim of a wide-brimmed hat, and you've got the makings of a lovely drawing. But even if your gloves and hat are less elegant, they're still a good start for an interesting arrangement.

Let's say the only hat you can find is a ski cap. Do you have ski gloves, too? No gloves at all? Why not brew up a steaming cup of cocoa? Draw it and it will warm you up on the coldest of winter days. Get the idea?

Set your hat and a basket on a table and draw them.

Drawing in the Living Room

Let's try another room. How about your living room? Is this a formal place, reserved only for company? Or do you have a "great room" where your entire family gathers at the end of the day? If it's the latter, chances are you'll find everything from open books to unopened mail, from television remote controls to Gameboys.

Anything in your living or great room is fair game, including your spouse snoring in his or her favorite chair. But even if that chair is unoccupied, it may be just the thing.

Try Another Chair

The first chair you drew was a fairly simple one, so this time, try drawing a chair that's a bit more elaborate. You're in the living room, so you've probably got a number of choices—from a well-worn recliner to an antique rocker or even, perhaps, a Victorian settee or fainting couch. Take a look at the different textures of wood or fabric. What pleases you most?

> **Back to the Drawing Board**
>
> When it comes to drawing a chair, you may decide to return to your plastic picture plane to get the angles just right. If so, that's fine. Remember, artists use aids like plastic picture planes and view finder frames all the time, so there's no reason you should feel like you're cheating if you do, too.

Chairs make simple and convenient drawing subjects.

Antique Lamps—and Antique Things

Lisa's husband teases that she will never have enough antique lamps, and, while Lisa disagrees and insists that she bought the last one this past weekend, finding antique lamps to draw will not be a problem if you're at Lisa's house.

Antiques—whether lamps, tables, or even Underwood typewriters—are terrific drawing subjects for a number of reasons. They're unusual (you won't find them at every Wal-Mart), they're attractive, and they usually have enough visual interest to carry off a drawing all by themselves, without adding a thing. Lamps, candles, and the warm glow they give off, provide interesting challenges to the careful observer.

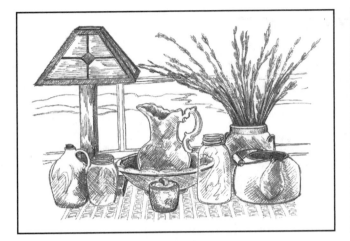

Light up a drawing by including an antique lamp or candlesticks.

The Art of Drawing

Try for unusual mixes, things that might not typically be put together. The arrangement may really surprise you. Consider humor or at least whimsy as you look for things and arrangements. The world is too serious, so have some fun as you draw.

Objects That Reflect You

We all collect something, it seems, something that we just can't resist in a shop, or something that we find on a trip, or something we found in nature, and then all of a sudden there are more of the same, and a collection is in the making. These are the things that personal drawings are made of.

Lauren has been a collector since childhood, when she filled her dresser drawers with shells, rocks, pinecones, and a collection of hundreds of wildflowers pressed in waxed paper. (Clothing was less important then.) Now she has a large studio to house all her collections, which are her favorite things to draw.

Use the things that you love in your drawings to give them a truly personal quality.

Bathroom Basics

After all that coffee you had in the kitchen, you've probably visited the bathroom once or twice already since you began this chapter; let's head there now once again and see what you can find to draw here. Even this most utilitarian of rooms will surprise you with its potential drawing subjects.

What's on your bathroom counter? Half-empty bottles of lotion, empty cans of mousse, open mascara tubes, and broken lipsticks … or a pretty arrangement of seashells in a basket? A razor, nail clipper, dirty towel, and soap scum? Whichever way, there's something there for you to draw. Sure, the seashells in the basket will make for a more visually pleasing drawing, but the detritus will make for an unusual one that may be visually striking in its own right. Pretty is as pretty does, after all, and beauty is in the eye of the beholder.

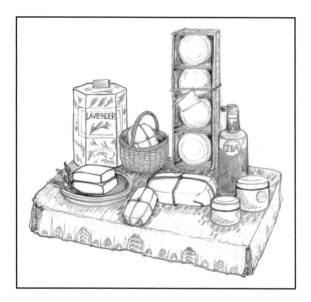

Don't toss those empty bottles—draw them instead! Or draw those seashells in their basket. Any arrangement in your bathroom can be the makings for a drawing.

A Sunny Window

Find a room that has a sunny window. Does the sun pour through in the early morning or just before sunset? Maybe it gets filtered northern light, a favorite of artists, or dappled light filtered through the leaves of a tall old tree.

What's on your windowsill? An arrangement of colored bottles can be the basis of a simple but lovely line drawing—without one color pencil being used. If your window is framed by sweeping sheer curtains that flutter in the breeze, another nice drawing subject is at your fingertips.

Two lovely window arrangements to draw (see next page).

173

By now, it should be clear that the possibilities for drawing subjects in your home are limited only by your imagination. So grab your pencil and paper, and get to work!

Out of the House and onto the Patio (Door)

While your materials and subjects can vary endlessly, the process is essentially the same every single time you begin a new drawing. The minor variations are your needs at the time and your choices as to how to proceed, what medium to use, or how finished a piece you are trying for.

Remember, for fun or for help, use your patio or sliding glass door as a big plastic picture plane. Put a few objects on a table right outside the door and try to draw them on the glass. Use a *dry-erase pen* that makes a readable line. You can draw your patio or deck chairs on the glass, or maybe some potted plants or a trellis planted with a vine. You will find that objects need to be very close to the door, or they will be very small when you draw them on the glass. If the light outside is strong enough, you can make a tracing of your drawing on lightweight paper, using the door as a big light box. In an urban landscape, use your apartment window or glass terrace door; draw the buildings you see, complete with *their* windows, terraces, and fire escapes.

Where the finish point is will always be your choice. You are done when you are done.

Back to the Drawing Board

Dry-erase pens are pens designed to mark on smooth surfaces and wipe off easily. Delis use them for writing the day's specials. Look for them in an art or stationery store.

Once you begin to look at the things in your house as objects to be drawn, you'll find the possibilities limited by only your imagination. Don't be afraid to experiment. Nothing's a mistake when it comes to drawing; everything's a learning experience. So grab that coffeepot and your pencil and get to work!

Your home truly is your castle when it comes to drawing subjects.

Your Sketchbook Page

Try your hand at practicing the exercises you've learned in this chapter.

The Least You Need to Know

➤ Anything in your house can be a subject for a drawing.

➤ Exploring your house for things to draw can be a journey of discovery as well.

➤ Distractions are not allowed!

➤ Make a date with yourself.

➤ Take your time—and have fun!

Into the Garden with Pencils, not Shovels

When I spoke of flowers, I was a flower, with all the prerogatives of flowers, especially the right to come alive in the Spring.

—William Carlos Williams

Enough time spent wandering around your house—it's time to get outdoors and see what else there is to draw. Not surprisingly, there's a wealth of material just outside your door. Go ahead, open it up, and step into the wonderland of drawing subjects that is your garden.

In the beginning, there was Eden, that most famous of gardens. Sure, Adam and Eve were banished, but we've been working our way back ever since. With a sketchbook in hand, you can succeed where Adam and Eve failed (and even get that troublesome snake nailed down in an illustration) by drawing a garden that will last and last.

Botanical Drawing Is an Art

A flower offers a removed beauty, more abstract than it can be in the human being, even more exquisite.

—Maria Oakey Dewing, "Flowers Painters," Art & Progress 6, No.8 *(June 1915).*

The first step in drawing anything in nature is learning to see it and draw its parts, such as the separate parts of flowers, with the same attention you've learned to give to all details. From petals and stamens to leaves and stems, every part of a flower has a wealth of detail, there for the seeing.

The parts of a flower. You don't need to know their names, but you do need to examine them in separate detail in order to render them on the page.

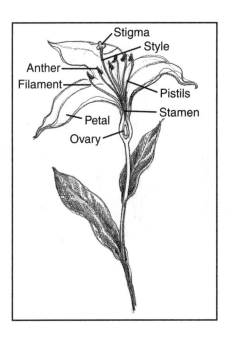

When you first start out drawing specimens from nature, it's best to work at a scale that's 75 percent to 100 percent of the original, so you can see and draw the detail.

Playing with scale comes with practice, and once you're comfortable with working close to reality, for fun you can try 200 percent or 400 percent—and really see the detail.

Take Your Sketchbook with You

What if you haven't got a garden of your own? What a great reason to head for the hills or the botanical garden, or even the "ritzy" section of town. Pack up your drawing supplies in the trunk. For drawing *al fresco*, you may want to add the following to your drawing kit as well:

➤ A stool, for sitting

➤ An easel or drawing board, for setting your pad on

➤ Clips, to hold your sketchbook in place

➤ An umbrella or hat, for shade

Whether you're drawing in your garden or someone else's, be aware of place. A sense of place is a strong element in garden drawing, whatever the view. Consider the following before you set up your stool and easel:

1. Make sure it is clear where you are. Light and shade are as important to a drawing as the objects themselves.

2. How does it feel?

 ➤ What is the light like?

 ➤ What time of day is it?

 ➤ Do you feel the warmth of the sun or a cool breeze, welcome shade on a hot day, or the briskness of fall?

Artist's Sketchbook

Al fresco, Italian for "in the fresh air," is the term for doing things outside—including drawing, of course.

Try Your Hand

No matter what the weather, make your garden subject as special as it is through all the seasons.

Try to capture the feel of the weather and the season, as well as the day itself, in your drawing. Atmosphere!

It Started with Eden

> *Whether the flower or the color is the focus I do not know. I do know that the flower is painted large enough to convey to you my experience of the flower and what is my experience of the flower if it is not color.*

—Georgia O'Keeffe

When it comes to flowers, a rose is not just *a* rose, as Gertrude Stein said, it is *the* rose, *the one* you are looking at right this minute. Sure, it has similarities to other roses, but it also has a detail that is all its own.

Learn to look for this singularity in all of nature. Think about individual plants as individuals. Lauren likes to think of them as if they are friends, especially in the spring (the season as we write this), when she has been missing them. Then, it's like greeting old friends and meeting new ones.

There's nothing like the feeling when those first crocuses and daffodils come up in the garden. It's a reminder of the cycle of life, of renewal and rebirth. No matter how utterly blue you've felt all winter, seeing those first brave shoots of green push through the snow reminds us that summer is just around the bend.

Whether it's springtime, summer, or autumn, you can use whatever's blooming in your garden to practice drawing flowers and leaves. This practice will help you achieve precision in your drawing technique, as well as honing your powers of minute observation.

Every flower and leaf of every plant has a shape and detail all its own.

Be a Botanist

Being a botanist doesn't have to mean going back to college. You can learn a lot about plants simply by observing them, and, when it comes to drawing, observation time is time well spent.

Try Your Hand

When drawing a new species, remember to look for the angles and proportions. Each butterfly or lizard has its own shapes, proportions, coloring, and texture to explore as you draw. Shells, particularly, have a strong line or axis from tip to end that needs to be seen and drawn. The myriad of detail in nature is its strength and its wonder.

1. Begin by examining the basic shapes that are familiar, including
 ➤ Cones.
 ➤ Disks.
 ➤ Spheres.
 ➤ Trumpets.
 ➤ Fluted shapes.
 ➤ Balls.

2. How do the pistils and stamen attach to the stem? (You may want to refer back to the drawing at the beginning of this chapter to see just what and where pistils and stamen are.)

3. Count the petals. Do they appear in pairs or groups? Are they symmetrical? How do the flowers fit on the stem?

4. Look at leaves on the stem. Are they alternately or oppositely arranged? Look at the stem connection.

5. Get botany or gardening books to read about detail and structure if they are new to you. Just flipping through the pages will begin to give you a better idea of what flowers are all about.

Work on a Blooming Stem

Okay, enough studying! It's time to try drawing a blooming stem. For your first subject, you'll want to look at buds, seeds, and stems, and decide what you'd like to draw. Once you've picked out a subject, use the drawing checklist that appears on the tear-out reference card in the front of the book, and get to work.

As the season progresses, look at seeds, pods, berries, nuts, cones ... anything you can find in your garden or any other garden, and draw those, too. The more you draw, remember, the more practice you get. Eventually, the shapes and forms will be remembered by your hand, familiar and easy to execute.

A variety of blooming stems.

Butterflies, Insects, and Seashells, Too

The eye that sees is the I experiencing itself in what it sees. It becomes self-aware and realizes that it is an integral part of the great continuum of all that is. It sees things such as they are.

—Frederick Frank

Your flower drawings can include all the winged visitors to your garden and a mix of seashells around the pots or along the paths. Chinese and Japanese nature art has always included butterflies, insects, and seashells to compliment the flowers and foliage, and you can do this, too. Add what you see in your garden, from butterflies and hummingbirds in northern gardens to snakes and lizards on tropical patios.

Garden drawings don't have to be just flowers and plants. Don't forget the insects, shells, and butterflies. When drawing a bird or butterfly, you might want to have a good reference book on hand to study. For precision, try copying high quality, detailed images before you venture outdoors. This effort will enhance your nature studies when you try to capture the moment in the wild!

Go Wild!

When you draw a leaf that has become a fragile net of veins, you are really marveling at the wonder of nature and finding a way of capturing that fragility.

—Jill Bays

The Art of Drawing

Lauren learned flower fairy tales and woods lore from her grandfather, who was an avid naturalist and artist. The fleeting delicacy of wildflowers and the pristine climate they thrive in is there to be enjoyed, but should be carefully respected and protected. Don't pick wildflowers; go out and visit them and draw them where they live. You will both be better off for the effort.

Wildflowers are Lauren's favorites; they have always been. They were like friends when she was a kid, and are still. For Lauren, the best part of spring is seeing them return, waiting for a special one, and hunting in woods or fields to find a wildflower that she hasn't seen

lately. Wildflower meadows are great places to find beautiful and plentiful drawing subjects. The natural arrangements are fun and freeform, without the pressure of a highly arranged still life. Or, take the challenge to see a great composition lurking in that aimless meadow.

The natural beauty of wildflowers is a natural for your sketchbook, too.

The Almighty Vegetable

You can tell how much the Italians love their gardens by looking at Italian artwork. The attention to detail and the variation is endless. One of Italian artists' favorite subjects (other than overweight women and prophets, that is) is the almighty vegetable. But don't run back inside and open the crisper of your refrigerator. Let's try drawing some vegetables before they've been separated from their leaves and vines.

Drawing in your (or someone else's) vegetable garden is a season-long endeavor. You can begin at planting time, when the first compost is mixed with the newly defrosted earth and you lay in the rows where you'll plant your seeds. Try to capture how that fresh-turned earth smells (especially if your compost includes manure …).

Next, it's planting time. Draw a quick sketch after the seeds are raked in. Get the idea? You're making a record of a season in your vegetable garden, one step at a time.

Soon, the first fragile green seedlings will pop up. Get out there with your sketchbook and draw them, too. Sure, the drawing will still be mostly dirt, but soon enough your garden will be bursting with growth, and you'll have your drawing to see how far it—and you— have come.

Before you know it, the first pickings will be ready. Draw them drooping from their vines, and then draw them in their baskets, freshly picked.

How did mere dirt end up as so much bounty? Too many vegetables, so little time. Still, take a minute to sketch the bumper crop, before the big giveaway. Be sure to include that sign at the end of your driveway: "Free Zucchini."

After the harvest, the empty vines and stalks may already be beginning to brown. Draw them before you rake them out and compost them. There! You've recorded a season in your vegetable garden. And next year, you can do it all over again. Drawing vegetables, vines, and stalks is a great practice in discovering a variety of shapes and forms and how they emerge and evolve across the season—and the pages of your sketchbook!

Record an entire season in your garden, and you can flip through it during the winter to remind you of all the work you don't have to do when it's cold outside!

Garden Pots and Tools

The Italians are also masters at container gardens. Their balconies and doorways are always decorated with collections of pots and planters, filled with variety in color and texture.

The Art of Drawing

Pots and saucers in drawings must be seen and drawn carefully to keep them from tilting and tipping or looking flat. Remember to establish eye level and look hard at the ellipses on the pots and saucers. The closer they are to eye level, the flatter they are; the further down below eye level they are, the wider they will be. The pots need to be symmetrical. And don't forget to check that they are really vertical: A light line up the center helps to check. Make sure you have drawn them accurately before you start rendering them.

Planters, window boxes, and container gardens are all small exercises in perspective, which we'll be discussing in Chapter 16, "What's Your Perspective?" Draw them using informal perspective. Establish eye level. See them as geometric shapes in space: cylinders, spheres, cubes, and rectangular boxes. Make them sit or hang correctly, and then fill them with detail.

Garden tools against a stone wall or the side of a garden shed make a charming arrangement with as much challenge as you are up for that day.

Everything in your garden is fair game for a drawing.

Gardens Other Than Your Own

When Lauren was in college, she cut most of her figure-drawing classes for trips up to the greenhouses and barns that were at the edge of campus in the agriculture school. She drew every afternoon in the warm moist air of the greenhouses, breathing deeply enough to

Back to the Drawing Board

When you're out and about, take care to shield your work by carrying it in a portfolio and protect it by placing a sheet of paper under your hand as you go so you don't smudge it.

remember the scent until the next time she could get there. When it was warmer, she went to the barns and drew baby pigs and sheep, and sometimes the colts in the fields. Her sketchbooks, when she turned them in, were a surprise to her instructors, but they had realized she was not attending the life class—she was out drawing life.

As we've said, "gardens" can include garden centers, greenhouses, botanical gardens—not just a garden of your own. Chances are, your local nursery won't mind a bit if you set up your stool and easel in the middle of their greenhouse. They may even ask to purchase one or two of your drawings—your first sale!

One word of warning: Outdoor drawing attracts attention, which isn't always good for altered states of consciousness. If you prefer to work unobserved, you'll need to find a nice, quiet place to work, without outside interruptions. And that includes making sure there's not a bull on the same side of the fence as you are!

What Else Is in Your Garden?

Our gardens are reflections of ourselves, our experiments, and our fantasies. They are places of the soul, and so are perfect for drawing. Your garden can be simple and austere, practical or fanciful, fussy or tailored … and so can your drawings. Try to reflect your garden's personality in your drawings, then try another, very different garden, with a different approach. Make your garden drawings as personal as the gardens themselves.

From Figures to Frogs—And a Few Deer and Gnomes

Statues, from figures to frogs, with a few deer, wheelbarrows, and gnomes thrown in for fun, can be present in your garden and your drawings. The somewhat diminutive scale of garden ornaments can be fun to play with in a drawing. Flowers are fun with scaled-down garden statues because they become relatively larger than usual.

➤ Ornamentals and statues go from classical to comic, from flashy to peaceful and contemplative, from natural materials to designer high-tech looks. Whatever you choose, remember: It's your garden and your drawing.

➤ Arches and gates are other wonderful opportunities to practice perspective, which we'll be discussing in Chapter 16. Draw the basic shape in informal perspective, but use diagonals to help you locate the center of any opening or arch correctly.

Try Your Hand

Shadows on a plain wall can be a fascinating subject for a drawing.

➤ Garden paths, long and winding or short and straight, add direction and structure to a drawing. Make sure you have drawn them with eye level in mind so they lay flat in the gardenscape.

➤ Walls are great backdrops for the detail in a garden, but they are also interesting subjects in themselves. Get the angles right and watch that the rock shapes don't become monotonous. See the small shapes and angles that make each rock different.

➤ If you are lucky enough to have rocks, a rockscape, a rock-lined reflecting pool, or a waterfall, you have a world of places to explore in your drawings.

Whether it's a plethora of flamingos, drying flowers, or birdhouses, the ornamental objects in a garden can make for wonderful drawing subjects.

Birds, Birdhouses, Feeders, and Squirrels

Our gardens also are home to a year-long variety of birds as well as the sometimes unwanted squirrels. Lauren's yard has a collection of feeders that are very busy all day long. She can watch the early feeders from her hot tub as she drinks the first of her many cups of coffee, and she has a daily competition with three squirrels to see who's out of bed first. Some mornings, she can catch them as they come out of their nest in a far tree.

All of what happens in your yard is material for drawing, too. The feeders and birdhouses are great for practicing perspective, too. You can hang them at various heights and draw them using informal relational perspective, or you can draw them with formal two-point perspective as an exercise. Eventually, you will find they are easy to see and draw at any angle or height.

The birds and squirrels move around quickly, but if you have a good viewing window, you can begin to make some sketches that capture their gestures, shapes, and proportions.

The fauna in your garden are as much a part of nature as the flora. Draw them, too. Birdhouses and feeders provide opportunities to develop your perspective skills and learn about geometric shapes, while also beginning to observe and try your hand at drawing living creatures.

Chairs in the Grass

Chairs in the yard are just like chairs in the house, except you can get a little tan while you are drawing. Adirondack chairs are a challenge, picnic tables need to be drawn so they stay flat on the ground, round tables with umbrellas are well worth the time to see and draw, and even a line of clothes drying in the breeze can make a nice drawing. Be aware of shadows and the shapes they make. They can add a lot to a simple drawing of a chair in your yard.

The possibilities in your garden—and beyond—are limited only by your imagination. So get out there and see what you can see and draw.

Get off your chair and draw it! Begin to see how to create an environment and a mood, or capture a moment in a blowing breeze, with your drawing.

Your Sketchbook Page

Try your hand at practicing the exercises you've learned in this chapter.

The Least You Need to Know

➤ A garden is perhaps the best reason for learning to draw: It provides an unending supply of delight and challenge.

➤ Be prepared, even in your own yard. Use a hat or umbrella. When going out in the woods or fields, take adequate protection against insects and the sun.

➤ Be a botanist when drawing from nature. Look at each specimen as an individual, and see what makes it different and special.

➤ Take advantage of garden centers, botanical gardens, if you are a city dweller you may need to resort to your local market or grocery store for a bouquet of flowers.

➤ Have some fun with statues, gates, or waterfalls. Remember: It's *your* garden drawing.

Part 5

Out and About with Your Sketchbook

To learn about drawing the world around you, we'll be looking at perspective, that important way of seeing three-dimensional space that artists use. Then, we'll go outside to use your new-found knowledge and apply the principles of perspective, starting with your house, your neighborhood, and onward to the larger landscape of your world.

What's Your Perspective?

In This Chapter

➤ Realizing you are not lost in space

➤ Exploring your point of view

➤ Getting things in proportion

➤ Finding the vanishing point

Dear Theo,

In my last letter you will have found a little sketch of that perspective frame I mentioned. I just came back from the blacksmith, who made iron points for the sticks and iron corners for the frame. It consists of two long stakes; the frame can be attached to them either way with strong wooden sticks.

So on the shore or in the meadows or in the fields one can look through it like a window. The vertical lines and the horizontal line of the frame and the diagonal lines and the intersection or else the division in squares, certainly give a few pointers which help one make a solid drawing and which indicate the main lines and proportion ... of why and how the perspective causes an apparent change of direction in the lines and change of size in the planes and in the whole mass. Long and continuous practice with it enables one to draw quick as lightning.

From The Complete Letters of Vincent van Gogh

Perspective is a set of rules to explain how to draw objects in space and make adjustments for the difference between what the eye sees and the mind knows, or thinks it knows. For example, the mind knows that a cube has six equal sides, but when a cube is seen in space, the sides seen at an angle seem to diminish as they recede.

Perspective has always been a challenge to artists, and many, like van Gogh, made elaborate contraptions to help them see and draw things in space. Perspective can seem a challenge for you, too, but you can use it as a tool to help you improve your drawing.

In this chapter, we'll bring perspective into clear focus and simplify it so even an "idiot" can understand. In fact, there's nothing terribly complicated about perspective; it's just a matter of recording on the page what the eye is really seeing.

Understanding Perspective

We are used to seeing three-dimensional objects on a two-dimensional piece of paper because of the development of photography, but photography was only an idea during the Renaissance and almost until van Gogh's time.

The development of photography, as a means of completely accurately representing three-dimensional space, changed a lot of things for artists. For example, they couldn't compete with a camera when it came to reproducing reality, so they began to experiment with their own ways of "seeing" things, which led into all the modern schools of painting that we now know, such as cubism, impressionism, and abstract expressionism.

But while modern schools of painting may have altered reality, the fact of *perspective* remains a given in the way we perceive the world around us. Perspective is a kind of *trompe l'oeil*, in which we know an object's actual size, even though it seems very small. The moon, for example, looks as if it would fit between your fingertips, but you "know" that it is actually much bigger.

How to render perspective on the page has long been a problem and a fascination for artists. When it's handled well, the eye of the beholder will accept it as naturally as it accepts a "real" scene in space. A chair that's smaller than another, for example, will "feel" farther away.

Perspective Simplified

Perspective can be divided into a number of subcategories, which we'll keep as simple as we can:

➤ **Informal perspective** is a way to see the relationships between objects in space. It's what you see on the picture plane, drawn on paper by observing and measuring things against things, shapes against shapes, spaces against spaces, and one against the other.

➤ **Aerial perspective** is the relative blurring of objects, color, or detail in space. *Scale* is seeing that objects get smaller as they recede in the distance. Foreground objects appear to have more detail and color or color intensity. Images in deep space are less distinct and less colored.

➤ **Formal perspective**, a more exacting way of looking at and drawing objects in space, is based on planes or sides of objects, like walls of a house, "vanishing," or diminishing, to points at either side of the horizon line. It is not always necessary if you see and draw relatively and make a few observations about things in landscape space.

Artist's Sketchbook

Perspective is the perception of objects farther away as smaller than objects that are closer to us.

Trompe l'oeil is French for "trick of the eye." Trompe l'oeil techniques involve making the eye "see" something that is painted seem so three-dimensional you can't quite believe it isn't really there.

Back to the Drawing Board

We think it's important to think of perspective as a useful tool rather than a problem. After all, perspective is everywhere, so you should use it to your advantage rather than hide from it.

The Art of Drawing

Van Gogh had to drag his perspective contraption out into the fields to use it. You can use the window of your car and sit there, coffee for company, and draw right on the car window. Of course, you can't drive everywhere that you would like to be in order to draw, but you can use the car window as a tool to learn to draw well enough so that, in time, you won't need a tool at all. Then you can go anywhere that your legs will carry you. Remember, NEVER sit in your car with the motor running and the windows closed; make sure the engine is off—fumes and pollution are duel dangers, to you, and to the environment!

Perspective and the Picture Plane

You had practice drawing with a plastic picture plane to see the three-dimensional space in a still life condensed onto the two-dimensional surface of the plastic. Your patio or sliding glass door can be used as a big picture plane through which you can see three-dimensional space condensed on the surface of the glass, and you can draw it right there for fun or to see how things in space relate to each other.

Out and about, you can try looking at a landscape or a building through your car window, for a moving picture plane. Try it to see a complicated bit of perspective, like a dock or bridge, or look at a complicated roof. You will see that all the angles, shapes, and relative scale that make landscape space look accurate is right there on your car window. As with the sliding glass door, objects will appear quite small, but you will get the idea.

Use your car window to remind you that all you need to do is see and draw.

Perspective in Pieces

Perspective can be dealt with in various ways:

Informal Perspective

➤ Scale and relativity

➤ Measuring and siting

➤ Aerial perspective

We'll look at each of these methods in a few pages. Formal Perspective

➤ One point

➤ Two point

➤ Three point

Artist's Sketchbook

Scale in drawing is the rendering of relative size. An object or person or tree, as it is seen farther away, will seem smaller than another of the same size that is closer.

Artist's Sketchbook

Eye level, or the **horizon line**, simply refers to your point of view relative to what you are looking at. It is the point at which all planes and lines vanish.

Let's consider *eye level* as the key to understanding vanishing points and one-point perspective. As you look at an object in a still life or the corner of a room or out at a landscape, it is eye level, in your view and on your paper, that most determines the actual image.

When drawing landscapes or things in perspective, the *horizon line* is the line to which all planes and lines vanish. As you look out on a landscape, you can be looking up at, straight at, or down at the view, the horizon line, and the vanishing points, to which everything will disappear (seem to get smaller).

You can think of eye level as how and where you are viewing the landscape—looking up, looking at, or looking down. In landscapes, eye level is also referred to as the horizon line. Where you position yourself and where you position the horizon or eye level in a drawing greatly affect what you see and how you draw it.

Your eye level is your point of view relative to what you are looking at. Points begin to "vanish" above or below the center, or "horizon" line. Notice how the perspective of the house changes above, at, and below the horizon line.

Eye level

Below eye level

At the bottom of the previous page, and here, at left are three drawings, one executed at eye level, one above eye level looking down, and one below eye level looking up.

Above eye level

Now, let's look at the three ways of viewing formal perspective.

➤ **One-point perspective** is a single straight-on view into space. To envision one-point perspective, look down a street, straight down a plowed field, or along a fence or a tree-lined country lane. The road, the trees, the fences, or the rows in the field will seem to vanish toward a central point straight out in front of you at eye level.

Eye level

Single vanishing point

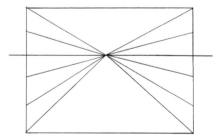

One-point perspective: View down a few roads toward a central vanishing point.

➤ **Two-point perspective** is based on the fact that planes seen at an angle will recede in space. They are directed toward vanishing points on either side of the horizon line or eye level.

201

Lines of houses, buildings, fences, bridges, roads, trees, or anything else, seen at an angle, will follow and recede to the points on either side, often far outside the area of the picture itself. It can be easier to try to see perspective simply as angles in space rather than needing to draw in the vanishing points.

Two-point perspective is vanishing points on the horizon or eye level.

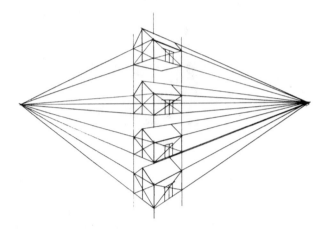

➤ **Three-point perspective** adds a third vanishing point and represents a fairly radical viewpoint. Try it after you have mastered informal, one-point, and two-point perspective.

Three-point perspective adds height or depth, for a radical view.

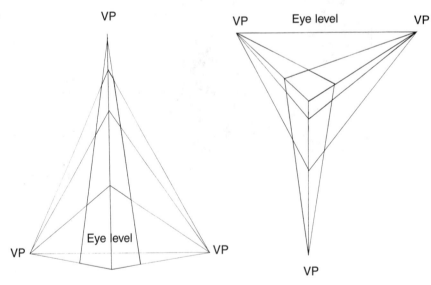

Three-point perspective above eye level.

Rectangle/cube looking down

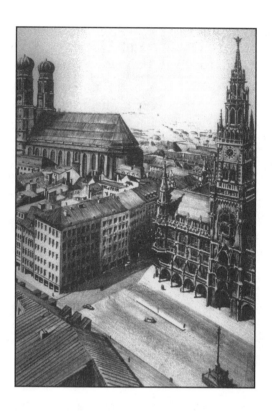

Our technical editor, Dan Welden, contributes this beautiful drawing illustrating three-point perspective looking down.

Tools for Landscape and Perspective

When you're out in the world drawing, being prepared is key to rendering perspective both effectively and easily. Here are some helpful hints:

➤ Sharpen lead pencils for landscape drawing with a sharp pocketknife or utility knife to make a chisel point. It makes a unique mark that seems appropriate for landscape work, but you may find that you like it for all sorts of drawing, once you try it.

➤ Be a scout when you are out and about. Take supplies so you can enjoy yourself and get some work done.

➤ When out drawing landscapes, take the time to look and find the view that you really like. Don't settle for the first spot that you see.

➤ Use your hand to frame your arrangement, composition, or scene.

➤ Take along a viewfinder frame and/or a plastic picture plane to help. Draw a few boxes to match your viewfinder frame ahead of time and use them with the frame to see your view.

Try Your Hand

Sharpen lead pencils for landscape drawing with a sharp pocketknife or utility knife to make a chisel point.

Getting Small and Smaller in Space

Whether you begin to draw perspective outside or in the comfort and privacy of your studio is up to you and the weather.

You can decide how much you want to use formal perspective, with all the vanishing points and lines, or whether you prefer to see relatively and just draw. Perspective always comes in handy for difficult views and complicated buildings. Try to learn the basics and then decide as you go.

Try Your Hand

Try sketching a small thumbnail version of a view to see how you like it and decide whether you should move to the side or look from higher or lower to get another vantage point. Try a view, and move on and try another until you are happy.

1. Establishing your view is first, whether you're inside or out. Try a few fast thumbnail sketches to see if you like the shapes and angles. Don't worry much about perfection; just do them.

2. Decide on the view that you like and look at it. Decide where you are relative to the view. Are you looking up, down, or straight at the main part or center of interest in your drawing?

3. After you have established eye level and the horizon line lightly on your drawing, you can begin to draw in the shapes you will draw in perspective. Start with something simple like a cube. Inside, a cube is easy to find; outside, pick a simple building, like a cottage, to start.

4. Perspective is all about seeing planes in space, so you want to begin with an object that is turned away from you, at an angle. The sides of the object, cube, or cottage, will vanish, or get smaller, as they go back away from you in space.

Learning to See, Measure, and Draw in Perspective

Perspective is not that hard, and for the more obsessive-compulsive of us, it is rather fun. So, with the addition of a ruler to help with the lines, you are ready to try it.

1. Site your object on your paper and decide on your eye level or horizon line. Hold your paper horizontal; it will give you more room.

 ➤ Is your object correctly placed, relative to your eye level?

 ➤ Is it above, at, or below eye level?

 Draw it on your paper. Most times, you will site your cube or cottage slightly below eye level, until you decide to draw the castle on the hill or your fantasy mountaintop cabin. The sides of your object will recede to points at the far sides of that line.

Back to the Drawing Board

If you were looking straight at the middle of the side of your cube or cottage, both horizontally and vertically, you would see it as a square or rectangle, with no vanishing point. But here you are in the real world, where things are at angles and the sides of things tend to vanish to the points on the horizon line or eye level.

2. The first step in perspective is to measure the height of the object you are going to draw on the paper. Look at the corner of the object and measure the height of that nearest corner and draw it. You can measure the height against your pencil with your thumb.

3. Draw two points on your horizon line or eye-level line at either side of your paper.

4. Now, lightly draw lines from the top and bottom of your corner to the points on either side. These lines represent the planes or sides of your object vanishing in space. Easy, huh?

5. Next, you have to establish the length of those sides. Are they equal? Which one is longer and how much? See them relatively, and measure them with your pencil against the height, which you have as an established "given."

6. Draw vertical lines for the far ends of the two sides of your cube or cottage.

7. Draw in the top if you can see it. The sides of a rectangle vanish to the same point, so you can draw in the light lines to make the top. See the following figure.

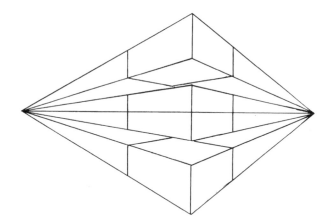

We've drawn a cube in perspective to illustrate these steps.

Not so hard, is it? The rest is just more of the same.

Closing the Roof

Let's finish off your first perspective drawing and put a roof on that cottage or cube. A roof—a simple one on a cottage or a cube, anyway—is another set of planes that are parallel to one side wall of the structure and vanish to the same point.

The roof is also centered on the end wall of the structure, which means that you have to determine the middle of the end wall. It's easy!

1. Draw light diagonals in the end wall from corner to corner.

2. Then, draw a vertical line up through the X made by the diagonals. That line is the middle of the plane or wall seen in space.

3. Measure the height of the roof, called the gable or peak, by comparing it to your base unit, the near corner that you measured to begin.

4. Draw in the peak of the roof.

5. Draw lines from that point down to the two top corners of that side or plane, and you will have drawn the shape of the gable end of the roof.

6. The ridge of the roof is the top. That line is parallel to the side of the structure and vanishes to the same point. Draw a line from the peak to the point where the side walls vanish. That is the ridge line of the roof.

7. The far end of the roof meets the back corner of the structure and is roughly parallel to the front end of the roof. It actually slants a bit more than the front end of the roof. See if you can figure out how much.

Try Your Hand

Fences and walls can be seen as long planes that vanish to a point. If they change direction, then they vanish to the other side.

A road or bridge can be seen like a house. The road is a very flat plane vanishing in space and a bridge is a complicated structure, but its parts vanish to one side or the other.

See how easy it is to draw a simple house in perspective? Lauren (upper) and one of her students (lower) give it a try.

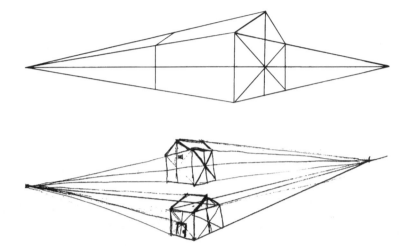

From this point on, perspective is careful measuring and plotting of lines to position other elements like windows, doors, and chimneys correctly, and drawing them so they vanish to the right point. A complicated house has more shapes to draw, that's all.

The more you practice simple shapes in perspective, the more you will see the angles and relationships. In many cases, you will be able to estimate the angles for simple situations and use the vanishing points for more complicated ones. Is a new career in architecture or landscape planning in your future?

These lines and curves are in ratio to the base unit line.

Measure for Measure

When you're working with informal perspective, measuring is key. Here are some aspects to take into consideration:

1. Take measurements by holding up a pencil at an unvarying distance from your eyes. Keeping it at arm's length will keep it constant, and the constancy is important for that single view.

2. Use the pencil to measure a line that can be your base by marking it along the length of the pencil with your thumb.

3. Then, apply that measurement to gauge the relative ratio of another line, shape, or space.

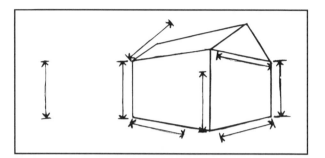

Comparing the basic unit of measurement against other lengths.

The Art of Drawing

Find a unit of measurement, something that you can measure against your pencil or the view finder frame, a base from which you can compare and measure other lengths. You'll use this base to compare other things, lines, and spaces in your composition.

Think about your base unit and what you want to measure against it as being in a ratio (1:1, 1:2, 1:3, 1:4, etc.). You can use the table below to help you determine lines and curves, or create your own base unit.

4. Establish the angles, measurements, and relations that are crucial to creating viable space.

5. See where roads converge and bands of trees get smaller.

An angle measure helps you to see angles of perspective in space, so you don't have to draw in the vanishing points except in a really complicated piece. The more you draw, you'll learn to estimate vanishing points, and see them as angles. That will be close enough for a lot of drawings.

The Art of Drawing

Make yourself an angle measure, just like the ones that carpenters use to measure angles. Fasten two strips of mat board or cardboard together at one end with a brass fastener. Spread the strips to mark a particular angle, a wide or narrow *V* shape, and transfer the angle to check your seeing and drawing of it.

Use a paper angle measure to see and transfer angles to a drawing.

A Few More Tips on Planes in Space

To determine the middle of a plane turned in space, such as the wall of a house to position a door or window in the middle, or to find the middle of an end wall to position the roof, draw diagonals in the rectangle that represents the wall or plane. This works whether the plane is facing straight at you or at any angle, and whether it is above, at, or below eye level.

As in the figure below, a line drawn through the crossed diagonals and parallel to the verticals will be in the middle. You can measure along the front of the plane to establish the middle, and draw a line from that point through the crossed diagonals to the middle of the other side.

Diagonals drawn through a plane vanishing in space establish the center of the plane.

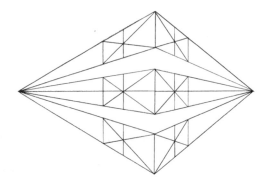

Some more points to consider:

➤ You can divide a plane as many times as you want by drawing successive sets of diagonals.

➤ You can fit the curve of an arch into the rectangle after you have centered it. It's an easier way to draw it.

➤ You can draw a dock or bridge and get all the piers correctly placed by using diagonals to evenly break up the space.

➤ You can divide a plane that is tilted in space, such as a roof, to determine the middle, for placing the chimney or a dormer correctly.

Try Your Hand

Your central point of interest can be off center.

In a complicated street scene viewed straight across, such as the one below, most of the planes can be facing square on. At the edges of your vision, however, things will start to vanish to points at either side of the horizon or eye level, or to a center vanishing point.

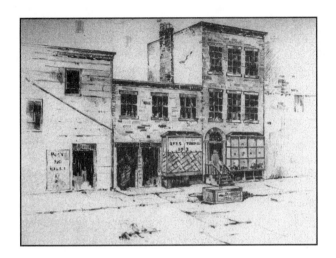

A street scene viewed head-on with things vanishing on the sides.

In a complicated scene viewed at an angle, like the one following, the various planes of houses, walls, fences, and smaller items like cars, trucks, and even bikes, bridges, gates, or phone booths will be receding or vanishing to the two vanishing points at either side of eye level.

A complicated scene where things vanish to the sides.

Detail, Detail, Detail: God Is in the Details

Detail will be covered as we encounter it in Chapters 17, "This Land Is Your Land," and 18, "Made by Man: Out in the Landscape," where we'll explore working outside. Detail tells more about what you see and why you chose a particular view, but it should follow naturally after you have accurately drawn the basic shapes of the landscape and gotten a sense of the space and the view.

Your Sketchbook Page

Try your hand at practicing the exercises you've learned in this chapter.

The Least You Need to Know

➤ Perspective is a useful tool in seeing and drawing landscape space and putting three-dimensional space on two-dimensional paper.

➤ Often, measuring and seeing relatively (informal perspective) is enough to achieve a good sense of space.

➤ Formal perspective is a tool for accurately drawing three-dimensional objects in space.

This Land Is Your Land

<div style="border:1px solid;">

In This Chapter

➤ Getting out in the world

➤ Landscape drawing tips

➤ What to take, what to wear

➤ The elements of a landscape, piece by piece

</div>

We need the tonic of wildness—we can never have enough of nature.

—Henry Thoreau

The land, in all its splendor, majesty, and complexity, has always fascinated artists. We all seek a sense of place, and we relate to landscape images both because they are comfortable and familiar and because they are exotic, unfamiliar, or even dangerous. We like them all. And so the experience or drawing *en plein air* will both challenge and delight you and literally take you to a place you have never been.

Go Out for a View

Pack all your troubles in an old kit bag—and draw, draw, draw. That old song didn't talk about packing a bag for no reason. There's nothing like getting out *en plein air* to get the creative juices flowing, to make you feel like you're, well, getting out of the house—which you are.

When you're ready to get out of the house and begin trying your hand at some landscapes, remember your supplies. Don't forget your hat, use some sunscreen, wear a sweater, take a jacket—do we sound like your mother? In addition, you may want to pack yourself a picnic dinner, in anticipation of capturing that brilliant sunset landscape.

But Which One?

You can look at a scene various ways and draw it differently each time. Claude Monet did dozens of paintings of haystacks, from different angles, at different times of day, in different

light. The Sandia Mountains, east of Corrales, New Mexico, where Lisa lives, for example, change from moment to moment, which is not always conducive to working on a deadline. Lisa moved her desk several years ago so she doesn't have a mountain view (she wasn't getting much done but mountain-viewing)—but she still finds a lot of excuses to get up and see them anyway.

Eastern Long Island, New York, where Lauren lives, presents landscapes and seascapes that change not only with the time of day, but every day. If there's a particular landscape in your worldview that captivates you, don't be afraid to draw it again and again and capture its elusiveness, like Monet.

A scene that seems familiar can present you with many variations. It is for you to choose how to proceed. Landscape depiction can be broken down into three scales:

1. Close-up studies of objects in nature are about the specimen, its shape, proportion, detail, and texture.

2. In the middle, there is room for a view with some detail in the foreground, objects, foliage, and/or structures in the middle ground, and a sense of space behind.

3. The big picture is about space, vistas, and purple mountains' majesty.

Faraway views might have some foreground detail, but are about the sense of space in the view. Aerial perspective, the progressive softening of color, detail, and distinctness in deep space, helps suggest that distance. You'll find more detail on aerial perspective in Chapter 16, "What's Your Perspective?"

Artist's Sketchbook

En plein air is a French term meaning "full of fresh air." It refers here to painting done out-of-doors. Because classic painting had been done in studios, painting outside was a radical move.

Framing the View

Once you have decided on the distance from which you are seeing your view or scene, then you have to decide exactly what piece of the panorama you will draw. You can't fit it all in, you know.

The Art of Drawing

Remember Euclid's notion of dividing the space from Chapter 9, "Step Up to a Still Life: Composition, Composition, Composition"? He divided space so that the point of central interest was slightly off center in both directions. This is an excellent example to follow when it comes to landscape drawing.

Use your viewfinder frame to scope out the view and crop the view until you decide. Move it from side to side and look at the different variations on what you see. Look at the

diagonals in the landscape as you decide. Try to find a view that draws you into the scene and is a balanced but interesting composition.

Your thumbnail sketches will help rule out arrangements or views that are less interesting.

On the Line—the Horizon Line

As we discussed in Chapter 16 and earlier, any accurate seeing and drawing of three-dimensional space begins with eye level or the horizon line. Situating yourself in space determines the vantage point from which you will be seeing and drawing the landscape.

You can be looking up at, straight out at, or down on a view and the drawings will be quite different. You can see the difference by making small sketches of a particular place or view from different viewpoints. Try it and see:

➤ Sit on the ground.

➤ Sit in a chair or on a rock.

➤ Stand up.

➤ Climb on your car, a rock, or up a tree to see the scene change as you change where you are.

On the Page: Siting Your View

How you position your view on the page will also greatly affect the composition and how effective your drawing is when finished, so take some time to position the image to its best advantage at the start.

Landscapes have *high horizons*, *middle horizons*, or *low horizons* that affect the view and the sense of space.

➤ If you want a sense of deep space, you can move the horizon line higher on your page. There will be more foreground and the horizon will feel farther away.

➤ If you want to concentrate on the sky, move the horizon line down farther on the page, somewhat compressing the foreground, middle ground, and background space.

➤ You can leave it in the middle or anywhere in between that suits you and what you are trying to do with your landscape.

Try Your Hand

High, middle, and **low horizons** represent how eye level is perceived and rendered in a drawing.

Some Thoughts on Landscape Space

As with any kind of drawing, landscape presents its own special set of considerations:

➤ Strong horizontals in the landscape make a better composition.

➤ See and use winding roads or fences to lead the eye into your world. Remember to draw fences and hedgerows or lines of vegetation in a field.

➤ Shapes of hills overlap in interesting ways.

➤ Identify the center of interest—what you are trying to show about the view that you see. Think of a visual story. Set a scene into the composition, then add other elements and some detail.

➤ When you add structures, pay attention that they are drawn correctly and at the same vantage point and eye level as the landscape.

Tools for Landscape and Perspective

As we've suggested previously, sharpen lead pencils for landscape drawing with a sharp pocketknife or utility knife to make a chisel point. It makes a unique mark that seems appropriate for landscape work.

Also, be a scout when you are out and about. Take supplies so you can enjoy yourself and get some work done. Include as much as you think you will need and then some. Be prepared, in other words.

When out drawing landscapes, take the time to look and find the view that you really like. Don't settle for the first spot that you see.

Use your hand to frame your arrangement, composition, or scene. Take along a viewfinder frame and or a plastic picture plane to help. Draw a few boxes to match your viewfinder frame ahead of time and use them with the frame to see your view.

Seeing and Drawing the Landscape

Try sketching a small thumbnail version of a view to see how you like it, and to determine whether you should move to the side or look from higher or lower to get another vantage point. Consider the following as you draw your small thumbnail version; these points will help when you get to your larger drawing as well:

1. Try a view and move on and try another until you are happy.

2. Drawing the landscape starts with the horizon line or eye level, then moves on to big land forms.

Back to the Drawing Board

One reason why trees are poorly drawn is because so few artists have realized the need for studying their formation and growth, both as groups and as individuals. When you see them as you do people or animals—having gestures, proportion, and shape, as well as growth patterns that will determine how they look and how you draw them—your drawing will improve tremendously.

3. Making things in the landscape sit down and stay put is merely seeing and drawing them in space. Usually if there is a problem, it is in maintaining a consistent eye level and drawing things at their relative place above, at, or below eye level.

4. Use your experience with perspective, either informal observing, measuring, and drawing of the angles in a structure, or formal perspective and vanishing points, or a hybrid of the two.

5. Find and draw intersecting wedges of land as interesting shapes.

6. Use tone to define big shapes before adding detail.

Aerial perspective helps a great deal in establishing deep space. This can be achieved by allowing the far distance to be less distinct and softer in color, tone, and detail.

Detail up close, on the other hand, is stronger and clearer, more colorful, and full of tone or contrast.

Whether you're rendering close-up detail or distant perspective, you can use the tear-out reference card checklist to remind you of the steps toward a drawing.

Photographs: To Use or Not to Use, That Is the Question

Photographs can help with detail, but not really to learn to see and draw. If you go out to sketch and draw, by all means take along your camera for detail—but don't rely on it exclusively. You can annotate your drawing using the photo and put in areas of detail rather than the whole picture's worth, but it's better to draw in order to capture what is important to you.

The Landscape in Pieces

Elements in the landscape become part of the whole, but can be considered separately to learn more about each of them. So you can think of the landscape in pieces, we've taken a landscape apart so you can consider those pieces before they become part of the whole.

Trees and Shrubs

As with roses, a tree is not a tree is a tree, it is *the* tree, the *one* that you are drawing. It must be seen as an individual. When you think of the tree as an individual, almost like a person, you'll discover that it has both gesture and direction. It has its own proportion and shape, from tall, columnar evergreens to wide, spreading oaks.

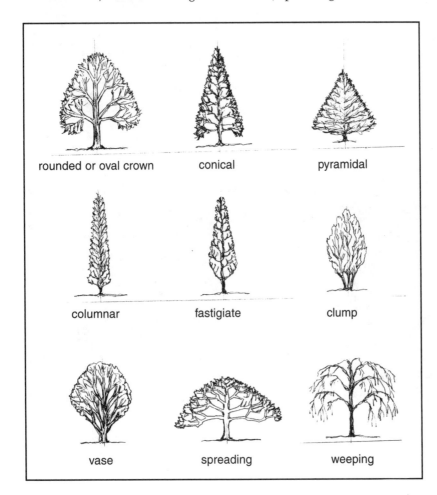

Every tree has a character all its own.

rounded or oval crown conical pyramidal

columnar fastigiate clump

vase spreading weeping

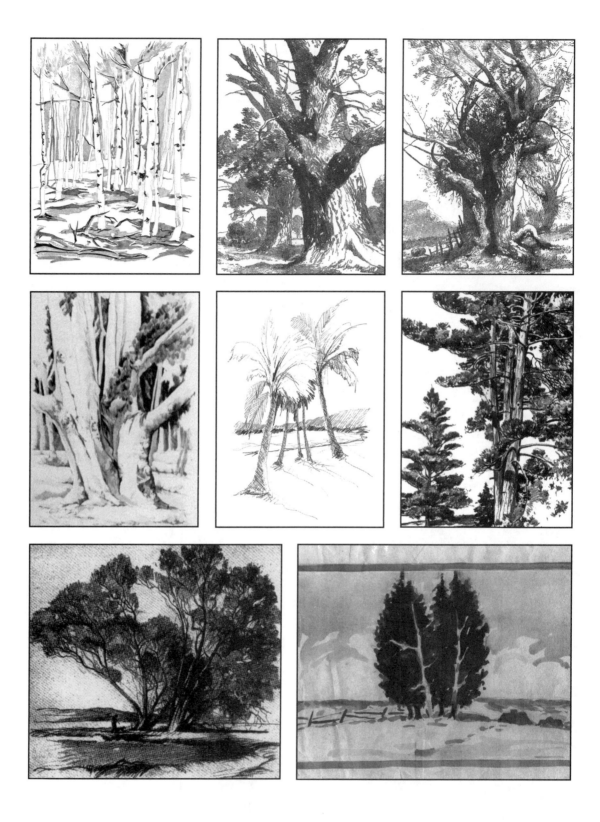

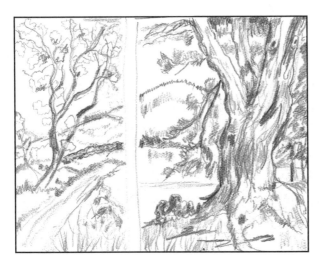 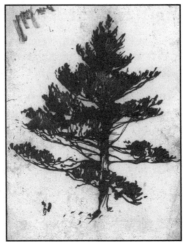

Trees present a myriad of possibilities for texture, composition, perspective, and light and shadow studies.

Foliage is another detail that needs special attention. Don't draw a head of broccoli like painters used to before *en plein air* painting became popular and artists started really looking at trees. Of course, if you can't see those individual leaves, it's possible you need new glasses or contacts.

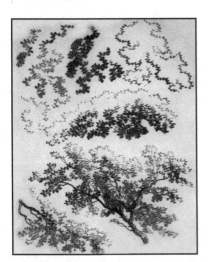 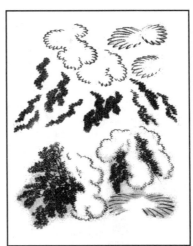

Different foliages have different textures. Look at the various ways these examples illustrate them. There's more than one style in which to render foliage! What's your style?

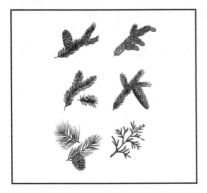

A Tangle of Textures, Vines, and Grasses

Vines and underbrush are great fun to draw; you can get as lost in the drawing as you can get out in the underbrush itself. Pick a place that has a lot of complexity, but some kind of structural device that frames or limits the tangle.

A stone wall or some large branches can work well to frame a mess of underbrush. A trellis or arch will support a massive vine, and you'll get an interesting contrast between the curves of the vines and the architecture of the trellis. Follow these tips when drawing this type of foliage:

➤ Draw the vines or the tangle lightly at first.

➤ Start seeing the overlaps of branches and the twining of vines as you draw them.

➤ Use tone to emphasize where one branch goes over or under another.

➤ Work in some flowers when you can. They are set off by the underbrush nicely.

➤ Play with the tones of the background. This will greatly help to set off and define the complexity of the tangle.

➤ You can squint or blur your vision as you work on the background. You will see the beginnings of shapes behind shapes that you can define into more tangle in the background. How far you go is up to you.

Wrap a few vines around your drawing pencil.

➤ Grass is a lovely addition, but it needs to move like grass, not look like a rug. Think about direction, gesture, and texture.

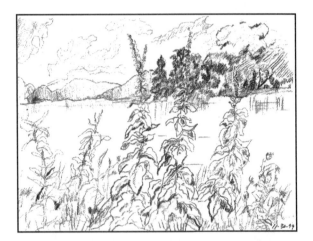

Grass is as individual as any landscape feature.

Beaches, Rocks, and Cliffs

Rocks are wonderful elements in the landscape. They can be playful, formal, architectural, massive ... you name it. When you start drawing rocks and dunes, think about form, shape, space, volume, weight, and texture.

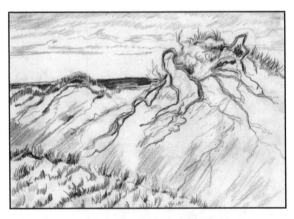

Consider form, shape, space, volume, weight, and texture as you draw rocks, dunes, and other landscape features into your drawing. Take a look at these dunescapes for a selection of solutions to executing a common subject.

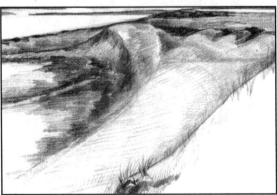

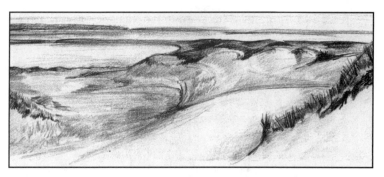

Sky and Clouds

The sky provides a daily show of tones, patterns, and textures that literally change with the wind. Think about pattern and texture, with form for bigger, thicker clouds.

Even though it's not drawn, the sky above these cliffs is an important landscape feature. It's about space—the absence or presence of—as a compositional element of your drawing.

Water and Reflections

Water, water, everywhere—it's easier than you think. Bodies of water need to sit flat, which means eye level and an elliptical curve in the bank or shoreline that works like the edge of a big dish out there in the landscape. Some things to consider as you draw water:

➤ Think about eye level and making the water lay flat like a dish in space, then add light and flickering texture.

➤ Reflections are fun, just see them and draw them like the objects themselves.

➤ Think about pattern on a surface you've already drawn—it could generate an entirely different drawing.

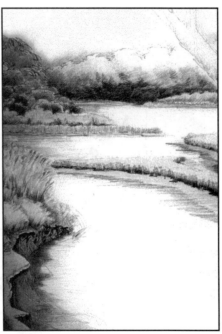

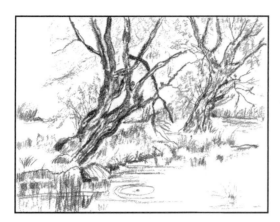
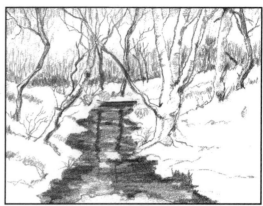

Capturing reflections on water can add interest and detail to your drawing.

The Best for Last: The Small Things

It is no secret that Lauren prefers the small things in nature to the big picture. She spent her childhood hikes looking at the ground, and nothing has changed. The detail in small individual specimens has always fascinated her, and it may be the view that you like best as well.

Wherever you go, look for the small things, and get to know them as you draw them:

➤ In the woods and mountains, there are delicate wildflowers in the spring; at the higher altitudes, they are there most of the summer.

➤ Mushrooms are some of the most erotic, sensuous shapes out there. They can be fun to arrange on a page as if they were talking in a group.

➤ Lichens, mosses, and other fungi are there for the seeing and drawing. Even the galls on tree branches are interesting. They are made by the tree or leaf in response to a bug's trying to burrow in to lay eggs, and every tree makes a different one.

➤ The woodland wildflowers could occupy a lifetime of drawing only they, from the delicate mayflower and Solomon's seal to the exotic jack-in-the-pulpit and lady's slipper. All have their own story.

➤ The seashore is a treasure trove of goodies to see and draw. The complexity of seashells, the funky shapes of crabs, the structure of big pieces of driftwood, the texture of seaweed, shore plants, and the unending rocks are all waiting for you.

A study of driftwood on the shore can be as monumental and compelling in composition as a cliff or dunescape. The drama is in the drawing!

As Your Drawing Progresses

Balancing all the elements of your landscape is a juggling act, but you can use your tear-out reference card checklist at the front of this book to help. Remember that you don't have to fill in every inch of the page to get a good drawing. Remember, too, that you don't have to finish each drawing the same way or the same amount.

Light, Shadow, Atmosphere, and Contrast

Look at tones, the lights, and shadows in a landscape. As you do, consider the following:

➤ Strong shadows can be interesting—but they can be confusing, too.

➤ Make sure that you can see the main shapes of the landscape.

➤ Remember to balance the foreground detail with the amount of space you are trying for.

➤ Experiment with suggesting tone rather than filling it all in everywhere, or changing the tone of an area for greater contrast.

There are endless ways to finish a drawing. No two drawings will ever end quite the same way—it's part of the fun.

Detail Is, As Always, Detail

Careful study of individual landscape elements will make it easier and easier to draw them into the view you have selected. The more you draw trees, the better your trees will look, and so it goes.

➤ Try drawings that are about big land shapes, and try drawings that are about intersecting wedges of land or belts of trees or bands of rocks in interesting patterns.

➤ Try drawings of small corners of your world—a favorite place or a hidden refuge, for example.

➤ Try to see trees as individuals. Think of them as wood spirits having their portrait drawn.

Most of all, find the little things in the woods, in the mountains, in the fields, or at the beach that are the tokens or talismans of the place. Bring them home and draw them. That way, you can treasure them always.

Your Sketchbook Page

Try your hand at practicing the exercises you've learned in this chapter.

The Least You Need to Know

➤ Any specimen, scene, view, or vista, from close-up nature studies to the big picture panoramas in the landscape, is open to you—make the time and effort to go out and see and draw it.

➤ The vantage point, eye level, framed view, and format on the page will all contribute to the feel of your landscape.

➤ Close and careful study of specimens from nature will put you in touch with the unmeasurable phenomena in the world. You will heighten your powers of minute observation and discover the great variety in nature.

➤ Drawing from nature increases your sense of place, of really being there, of being truly awake and alive.

Made by Man: Out in the Landscape

In This Chapter

➤ Adding human-made elements to your landscapes

➤ In the countryside

➤ On the waterfront

➤ Trains and boats and planes

Some of the most unusual adventures I have ever had came as by-products of casual sketching trips made after breakfast on days off from my newspaper work. It is a hobby that leads to queer and uncommon human contacts.

—Clayton Hoagland

Not everything in our world was made by Mother Nature, and human-made elements are just about everywhere you look. Whether it's a fence crossing a field, a sailboat rocking in an inlet, or a satellite tower topping a mountain, the things made by humans can add a surprising dimension to your landscape.

Evidence of Human Influence

Of course, there are landscapes without human-made elements, but they are getting harder and harder to find. These days, the human influence seems to be almost everywhere we look, even if it's only the winding road we are looking out at in the distance.

Making peace with human-made elements in your landscape drawings is not so bad. In fact, you can use the many human-made things in your landscape to frame and order the space, draw the eye into your composition, or add contrast and textural detail. At the same time, some human-made elements are more attractive than others, and there are some you'll definitely want to leave out.

Roads, Fences, Gates, and Walls

Roads, walls, and fences are parts of the landscape that can add direction, interest, and vitality to a scene or view. A road, wall, or fence meandering away within a grouping of winding hills can add drama and narrative to a drawing. A half-open gate can make viewers wish they knew what lay beyond it and stimulate the imagination.

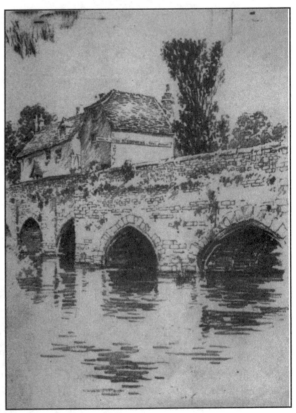

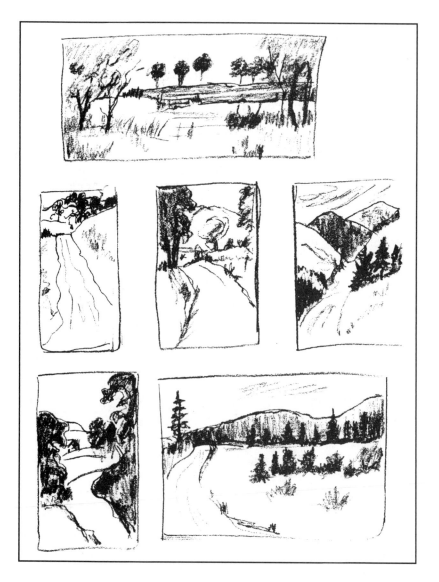

Lauren's grandfather drew some of these roads. Note how each is an individual.

In the Farmyard

You have only to go outside on a farm and you will find something to draw—and sometimes, you don't even have to go outside. Whether you are on a big farm in the Midwest with lots of equipment and big fenced fields, or a little family farm in New England with a big garden, a few chickens, cows, and an ancient old tractor, you will find something interesting to draw.

Haystacks worked for Monet, and as you travel around the countryside you will see the various shapes and sizes in different areas of the country. Big barns are the norm in Vermont, for example, while the bigger structures in Nebraska are the silos for harvested corn.

Corrals and farmyards enclose areas and make interesting angles and shapes. The animals themselves we will deal with in Chapter 20, "It's a Jungle Out There—So Draw It!" They deserve a chapter of their own, after all.

Try Your Hand

Using your viewfinder frame to help compose the mainland masses in a landscape, take certain human-made elements, such as roads, fences, and walls, to make the difference between an ordinary drawing and an extraordinary one.

231

Sheds and barns are technically structures and so are covered in Chapter 19, "Houses and Other Structures," but you'll want to be sure to include them with all that you find when drawing on a farm. You can sneak a peek ahead if you'd like some helpful hints for how to draw them.

Special Uses, Special Structures

And then there are all the unusual erections in the landscape, from mountaintop warming huts to lighthouses on rocky shores, just waiting to challenge you and enliven your drawings. If you are out and about and feel like creating an unusual drawing, try one of the more striking structures that decorate the landscape. Lighthouses, windmills, and towers add height, but they can also be the focus of an interesting drawing.

For you outdoorsy types, there are huts, sheds, cabins, fishing shacks, lean-tos, tents, and campers—as well as log footbridges, trail *cairns*, and forest service and Bureau of Land Management signs.

Artist's Sketchbook

Cairns are human-made trail markings, most often piles of rocks that mark the trailside path. Adding these mini-structures to your drawing can lead the viewer onto the trail, too.

Some of the more un-usual items in the land-scape may be waiting around the corner for you to draw, such as this lighthouse.

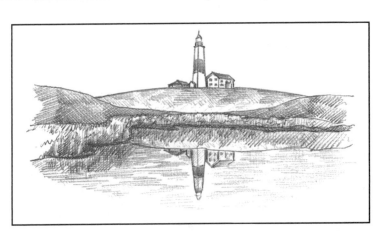

A little closer to home, you could draw in your yard and try a tree house, screen house, gazebo, or even your hammock hanging between two trees. Or, for the city dweller: fire hydrants, parking meters, parking lot shanties, garbage cans, even traffic signals.

On the Dock of the Bay and Beyond

Whether near the water, on the water, or in the water, you will usually find human-made things along with the natural. From canoes on a quiet lake in the Adirondacks to trawlers at the commercial dock in Montauk to sailboats in the Caribbean to the ocean liner you are on in the middle of the Atlantic, boats are there for you to include in your drawings to add to the sense of adventure.

Docks, Harbors, and Shipyards

Docks and shipyards are challenging places to draw. A dock needs to be drawn carefully, and there is a lot to measure. Once you get the main plane of the dock drawn in space, use crossing diagonals to divide the space equally and then again and again for the piers or pilings.

Try Your Hand

If you can get your car close to a dock, try drawing it on your car window (a moving plastic picture plane). You can see the progression of the piers and the perspective of the walkway leading out into the water. Do it for fun and make a tracing if you like it.

The activity in a boatyard can be daunting, but if you enjoy the subject, you will find a way to frame an amount of the activity that you can handle. Your viewfinder frame will come in handy for this. Plus, don't hesitate to filter out unwanted objects and detail. This is called "artistic liberty."

The Art of Drawing

A boat can add just the right touch to a landscape. You might try sketching a fishing trawler overflowing with fish, just back from a day at sea, or a canoe tucked against the shore, waves lapping at its side. As an experiment, leave the humans out of the picture (also because we won't be discussing how to draw them until Chapters 21 and 22); you'll find that human-made things without the men can make your drawing come alive in surprising ways.

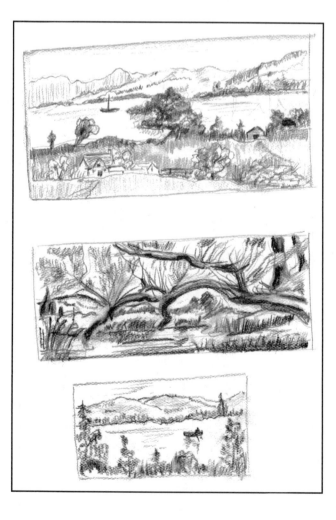

You don't have to be Marlon Brando to create a dramatic waterfront effect.

*Sitting on the dock of
the bay.*

From a Canoe to the QE2

The proportion, shape, curves, and form of boats is a little different from most other things. The hulls of boats have more complicated curves that need a bit of special seeing and drawing to get them right.

*Be sure to take your
time so that your boats
stay in the water.*

The World of Vehicles

They may or may not be your favorite things, but our landscape is crisscrossed from end to end with roads, train tracks, the bridges over them, underpasses under them, and tunnels to get to the other side. A little wood bridge over a walkway might be more to your liking, or you may enjoy the challenge of a suspension bridge or a mountain pass with a tunnel going off somewhere. Try whatever appeals to you, with or without vehicles.

Bridges, Trains, and Tracks

Tunnels and covered bridges and overpasses are everywhere, in the city and the country. They can be the classic Vermont covered bridge, a tunnel through the mountains in Colorado, or the Golden Gate Bridge—the choice is yours.

Back to the Drawing Board

Boats need to lie flat in the water. There is nothing more awkward than a boat that won't stay in the water where it belongs. Try drawing a box in space for the boat and then put the boat in the box. You may want to refer back to Chapter 13, "This Is a Review—There Will Be a Test," where we discussed drawing a box around a more difficult object to help you draw it.

Every mountain is as individual as any landscape feature.

Moving Vehicles

Then there are the moving human-made elements like trucks, cars, fire engines, buggies, wagons, tractors, and merry-go-rounds. You can think of even more, we are sure. Take a look at some of these vehicles that Lauren has drawn. Vehicles provide a contrast between hard angles and geometric shapes in the manmade world, and the often more fluid forms and contours of nature. Place a person or two in the landscape and you've included the link between both worlds!

Combines, boats, planes, automobiles— more than just modes of transportation.

Your World Is What You Make It

By now, you can see that everything in the world is fair game for your pencil and sketch-book. Go on—get out there in the world. It's just waiting for you to draw.

Your Sketchbook Page

Try your hand at practicing the exercises you've learned in this chapter.

The Least You Need to Know

➤ Untouched landscape is hard to find, so make peace with elements of human design.

➤ Human-made elements can add order and interest and welcome diagonals to lead the eye into the composition.

➤ Drawing boats in the water, or any vehicles, requires some special consideration and careful seeing of the proportion and detail.

➤ Your world is what you make it, so go draw it the way you would like it to be.

Houses and Other Structures

The artist's ability lies first in seeing the picture before he has begun it.

—*Clayton Hoagland*

Houses fascinate us. After all, we all live in a house of some kind, whether it's a tall apartment building, a small ranch, a lovely Cape Cod, a farmhouse, an old Victorian with lots of gingerbread trim, a cottage on the beach, an old funky adobe, or a modern, sculptural mansion.

Whether it's drawing a house or another building, the most important thing, as Clayton Hoagland notes, is to first "see." In this chapter, you'll learn how to do just that.

A World of Buildings

Houses, barns, sheds, and other structures are perhaps the most prevalent elements in landscape drawings and paintings. They are almost everywhere you look, so, of course, they'll find their way into much of what you draw as well.

City Mice and Country Mice

Whichever kind of mouse you are and whatever kind of house you choose to draw, you will encounter largely the same challenges and problems.

Seeing your view (the vantage point, eye level, framing, and format on the page) and the accurate transferring of your view to the page is the same, whatever the subject and detail.

Lauren's grandfather drew this tent.

Every house is as unique as its owner. Whether a city or country house, these buildings present to the artist the challenge of perspective and composition, simple or elaborate. What's your vantage point?

The Old and the New

Whether your house is an old charmer, a stunning modern, or anywhere in between, you can make a drawing that is a portrait of all its special qualities. Draw your house at different times of year as well, and get some of those landscape and garden elements in. Trees, in particular, change from season to season, and can change the way a house looks dramatically.

Old or new, every house has something unique to recommend it. On your next trip abroad, take along a sketchbook to study perspective in centuries' old forms and structures. You'll get some great drawing practice, and have a wonderful travel journal through which to remember your journey.

243

Try Your Hand

Take your time when drawing a house—and take the time to draw it more than once, at different times of year.

Making It Stand

Start with simple houses and barns and sheds. Then move on to more complicated structures or street scenes. Of course, you have to begin with decisions about vantage point, eye level, framing your image, your format, and position on the page.

Whether you are looking up, at, or down at your subject will affect all that you see. Some of the ways you can view a house include

➤ Up under the roof to see all the detail under the eaves.

➤ Straight at the house, concentrating on doors and window trim.

➤ Down on the roof from above.

Of course, those are only three suggestions. Be creative—view a house through a window, or past a tree. The possibilities are endless.

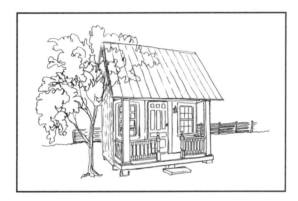

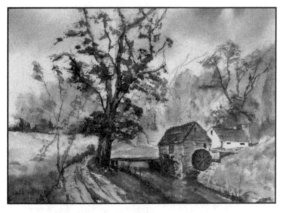
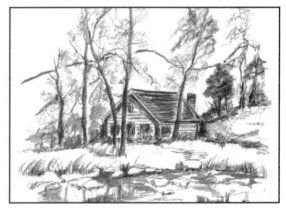

Informal perspective is great for quick, casual sketches of houses. Take a look at how individual drawing styles and drawing materials produce different results!

Informal Perspective

For a casual sketch of a house or an exploratory drawing to decide on a view or framing or format, you can observe and draw the main angles in a house by carefully establishing a base unit of measurement and some basic angles.

Then, add to your drawing as you can see the relation between each part. Draw carefully and check all the relative parts of the structure before you begin the detail.

Formal Perspective

When you want to be more formal, begin with eye level and a light siting of your house on the page. Then, draw in your vanishing points and begin to draw the planes of the house in perspective. You can refer to the steps in Chapter 16 if you'd like some help as you go.

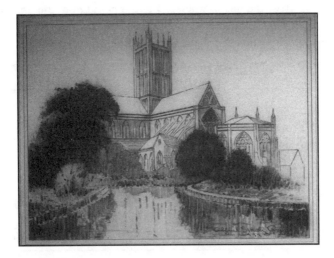

You can copy famous architectural structures from high quality images in books or periodicals to gain more insights into formal perspective.

Keeping the Pieces in Proportion

Whether your drawing is an informal sketch or architectural rendering, you will need to measure carefully for doors, windows, and any other trim details that you draw to keep them in scale and evenly arranged. You can use the steps on the tear-out reference card if you'd like some help with this.

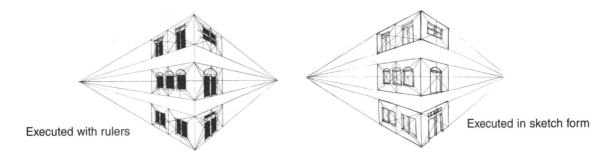

Executed with rulers

Executed in sketch form

Using diagonals to divide a house plane will assure accurate placement of the windows and doors.

It's in the Details

Windows, doors, roofs, stoops, railings, steps, gutters, soffits, overhangs, patios, porches, pools, and ponds—these are the details that houses (and yards) are made of. Go for a close-up view and render one of those details in particular. Even a crack in the adobe can make for an interesting close-up house drawing.

The Art of Drawing

Even if you're not doing a close-up view, the details will separate this house from the one next door—and the one in the next town. Try a portrait of your own house or one for a friend. Draw all your neighbors' houses, then knock on their doors and sell them the portraits!

The individuality of a particular house is as simple as its details. What element strikes you as the most compelling around which to organize the composition of your drawing?

In the City

Skyscraping apartment towers, modest brownstones, and elegant townhouses are in almost every city, along with office buildings, factories, and warehouses. They can present an interesting street scene or skyline with lots of city detail.

You can soften the linear quality of a cityscape with rooftop gardens, window boxes, front-stoop planters, sidewalk gardens, or a city park background. The highly articulated perspective relationships don't overpower the drawing.

In the Country

The countryside is a haven for artists and poets, wherever they find it. The peace and tranquility are both inspiration and subject. In the country you'll find the time, the space, and

the peace to work creatively. Try to give yourself the gift of time in the country, even if you think that you live in the country already.

Look for houses in the country that reflect an open-to-nature quality. Find yourself a fantasy farmhouse—the Victorian of your dreams or the Adirondack lodge that you've always wanted—and draw it. Who knows? It might be a way of visualizing it into your life. But be careful what you wish for, you might get it.

Here's the country house of Lauren's dreams. Try drawing your own dream house, too. You might even get what you wish for! Country and farmhouses blend architectural elements with a functional integration into the landscape.

Materials and Techniques

The materials and textures used to build your house need their own marks to differentiate them. Cedar shingles, clapboards, rough cedar siding, smooth aluminum siding, brick, stone, metal, and stucco are a few of the materials that can be represented by tones and marks.

 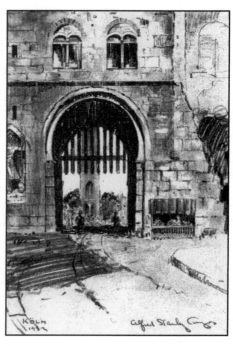

Experiment with different pencils to render different house textures on the page. The medium you choose can assist you in rendering that wood or stone facade.

Period Pieces and Special Places

Period pieces and special places present their own special interests—and issues. Decide what you are going after before you begin. If you intend to add a lot of elaborate detail, you will probably need to begin with an accurate base, drawn in formal perspective.

For sketches, even a house with lots of gingerbread trim can be drawn loosely with a minimum of perspective. As with any house, it will be in the details that you find a classic house's particular interest.

Classical Beauty

Architectural detail can be sketchy and suggested or it can be very precise, requiring a lot of measuring and planning. Here are some helpful hints to guide you as you begin to draw those classic beauties.

➤ A front view of a Victorian with gingerbread trim can be carefully and lightly sketched by measuring with a pencil held out at arm's length. Once you are pleased with the placement and proportion of the windows and doors, you can begin to add the trim detail and be reasonably certain that you will end up with an attractive loose rendering.

Back to the Drawing Board

You may want to review Chapter 16, "What's Your Perspective?," and refer to the steps on the tear-out reference card as you try to draw structures for the first time. Every house presents its own unique challenges. Going step-by-step can help you avoid making mistakes.

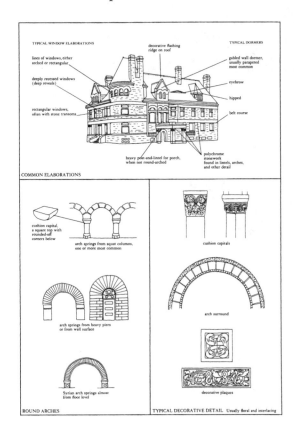

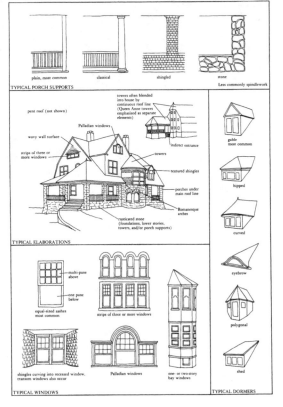

Architectural details.

➤ Remember to look for interesting structures like arches, arbors, pergolas, gazebos, elaborate screen houses, greenhouses, and wraparound porches. They require careful seeing and drawing, but they make great subjects and can add a sense of place or atmosphere to a scene.

Down on the Farm

Drawing farmhouses invites detail. There is so much going on and, seemingly, a structure for each activity—from maple sugar shacks out in the woods in Vermont to huge dairy barns in New York State, from cattle ranches in Idaho to windblown, abandoned farmsteads in Nebraska. There are small family farms, citrus groves, tree farms, truck farms, and immense factory farms.

Try drawing the barns, silos, and sheds in a farmyard. Fences, corrals, and stone walls will add interesting diagonals and texture while defining the land shapes and inviting the viewer into the composition. You won't run out of structures to draw on a farm for some time.

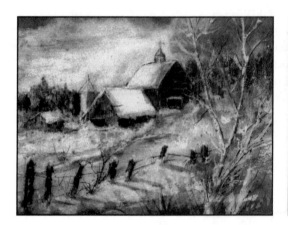
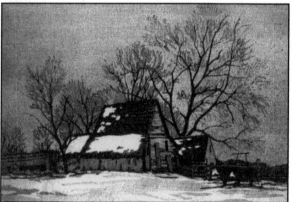

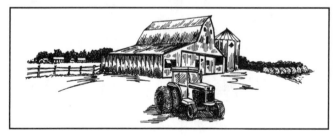

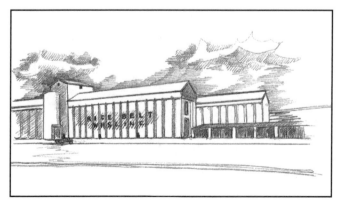

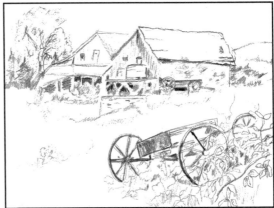

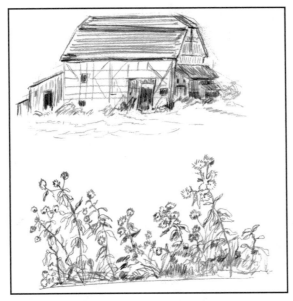

Farm structures are as varied as the landscape. What choices will you make to compose your drawing?

Out on the Edge

And then there are the more special structures in your landscape, places you might be particularly fond of, from mountaintop huts to lighthouses on rocky shores, just waiting to challenge you and enliven your drawings.

Try drawing some of the unusual structures you find on your travels, such as lighthouses, windmills, towers, huts, sheds, cabins, fishing shacks, lean-tos, tents, tree houses, and screen houses. And don't forget the cliff dwellings of Mesa Verde—and the pit houses of Chaco Canyon.

Don't forget those cellular towers and high-voltage electric lines stretching across the plains. Or Hoover Dam stretching across the

Try Your Hand

Experiment with different pencils and other drawing tools to find marks that you like. Try sharpening a pencil to a chisel point to make a flat mark for wood texture.

Colorado River. Human-made structures add high drama to Mother Nature's works, and they can add drama to your work as well.

Windmills, towers: Nothing is too unusual for your drawing pencil and sketchbook!

Your Sketchbook Page

Try your hand at practicing the exercises you've learned in this chapter.

The Least You Need to Know

➤ Houses are fascinating to draw and there is no shortage of them in the landscape.

➤ Informal sketches can accurately describe a house and its personality if they are carefully seen, measured relatively, and drawn progressively from the basic shapes to the finished detail.

➤ A formal rendering in perspective is another kind of portrait.

➤ Try drawing houses into your landscapes, especially on trips, so you can include styles and detail that are unusual.

➤ Don't forget about the exciting, exotic, and estrange in your choices of houses to draw. Why stay home when you can go have an adventure—and draw it, too?

Part 6

Drawing Animals and People

It's time to start putting some life into your drawings, and in this section, you'll learn to draw both animals and humans. Both require seeing the action and gesture, then the proportion and form, followed by detail.

Learn why the nude has always been the object of artists' affections—and why it may turn out to be yours as well. You'll also learn about gesture and movement, and how to render them on the page.

It's a Jungle Out There— So Draw It!

In This Chapter

➤ Drawing animals

➤ First, gesture

➤ Then shape

➤ Detail and scale

Animals = action. These two words go hand in hand in art. Their lives are of necessity active and their activities are reflected in an alert grace of line, even when they are in repose or asleep. Indeed, because of their markings, many animals appear to be awake when they are sleeping, and many mammals sleep so lightly that even when apparently asleep they will move their ears in the direction of a sound that is inaudible to us. So there is always a feeling of perpetual motion about animals, and to draw them successfully this must be borne in mind.

—Alexander Calder

Interior and exterior landscapes are one thing, but now it's time to populate your drawings. Whether it's animals or people, re-creating living things on the page takes both practice and patience.

As Alexander Calder points out, animals = action. Capturing that action is the first step in creating dynamic animal drawings.

Drawing Animals

Earliest man covered the walls of caves with drawings of animals in a basic attempt to know them, relate to them, hunt them, revere them, use them, learn from them, dominate them, and celebrate them. Unlike the spears and arrows that appear next to them in these ancient drawings, animals continue today to be among artists' favorite drawing subjects.

You may want to let your sleeping dog lie, but there's no reason you can't draw him while he does. But how do you draw a sleeping dog—or a running horse? Let's find out.

In a World of Action, Gesture Is First

Alexander Calder was a keen observer of nature as well as a draftsman who saw and captured the essence of each animal he drew. As Calder himself notes, he looked for the basic action, posture, and gesture of an animal as the foundation of a drawing.

When you begin to draw animals, take plenty of time to see the action and gesture. In your first drawings, you may only get a gesture or a direction the animal is moving, but in time you will be able to add form and detail to an active base that really feels like the animal you were drawing.

Basic Proportions and Shapes

Let's begin by getting those basic proportions and shapes on paper.

1. Once you have your subject framed and your paper and pencil ready, start with a few gesture or action lines that represent the main limbs and direction of movement.

2. When you have an idea of how the animal moves, try to find a base unit of measurement, like the width of the head, the length of the body, or the height from the ground to the chest, and use that as a reference point.

3. Measure that shape, space, or length and see how it relates to other measurements on the body.

4. See the relation between the height and the length of the animal, its legs, how high they are, and how long the body is relative to the legs. Look at the head relative to the neck, the chest relative to the girth of the body, and the size of the head.

Try Your Hand

The more you draw animals, the more at ease you will be with their particular proportions and typical ways of moving.

Try Your Hand

Fill page after page in your sketchbook with fast sketches of animals. Try drawing a part at a time, rather than the whole animal at once.

This giraffe and elephant are reduced to the basic geometric shapes that define how they look.

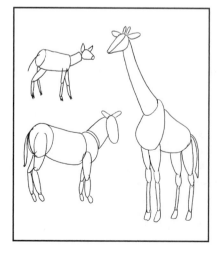

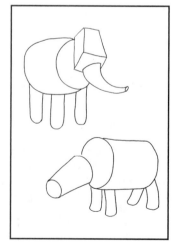

5. Next, think of the body as a collection of spare parts drawn as geometric shapes of various sizes and on various angles, relative to each other.

6. Look for ovals, ellipses, ellipsoids, cylinders, cones, and spheres. Think of the hard-edged shapes, too, then round them off.

7. See the barrel shape of an elephant's big body, the long curving cylinder or cone of its trunk, the even longer, curving neck of a giraffe, the slender ellipses that make up the shapes of a deer.

8. Try to draw each part of the body as a three-dimensional part, not a flat shape. Using ovals and ellipses in light lines helps you think, see, and draw round, full shapes for the body parts.

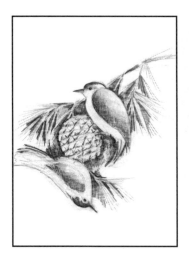

Quick drawings of animals concentrate on gesture and on the shape of basic body parts.

Bulking Them Up

Once you are acquainted with an animal's basic shapes and gestures, you can begin to add some form and bulk to your drawing. Even a delicate deer or a slender bird's leg has some form.

Look at where shapes on the animal over- or underlap. As with inanimate objects, the way one part goes over or under another defines the shapes and how they fit together.

Use tone, and your experience with it, to shade some of the main muscle and body shapes and how they meet.

Lauren's students use tone to shade and highlight animal muscle and body shapes.

Fur and Feathers, Skin and Scales

Snakes and snails and puppy dogs' tails are only a few of the reasons you will want to add texture to your animal drawings.

Your practice with marks, tonal charts with different textures, and a willingness to try out some new marks will pay off here.

A sensitivity to the individual animal and its unique qualities is a good start. Think about the conditions a particular animal has to live in, how they live, how they feed or hunt, what the dangers are, and how they have to adapt. Try to use your thoughts as you render the fur, feathers, skin, and scales.

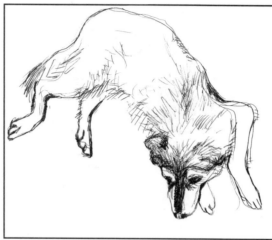
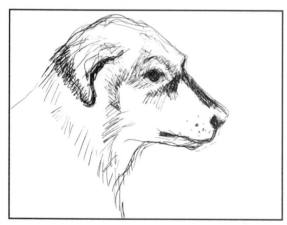
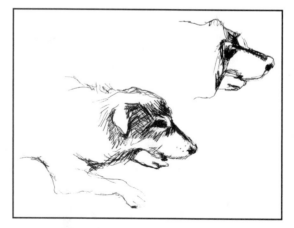

Being sensitive to an animal's unique qualities, practicing with different textures, and a willingness to experiment will pay off with realistic animal drawings. Two of Lauren's students try their hands at a rabbit and a dog.

Go Out Where They Are

You will find animals to draw the minute you go out into your yard, or sit at your window. Your new drawing subjects will greet you everywhere you go, so be ready to grab your sketchbook!

Your Backyard and in the Neighborhood

Our backyards are full of animal subjects—birds, butterflies, squirrels, chipmunks, as well as frogs, toads, lizards, snakes, and snails. Because they are busy with their own lives, they are

disinclined to pose for you, but you can make quick sketches to capture first the action and gesture, then the proportion, shape, and form.

If you live in the country and can sit quietly in your yard, you may be lucky enough to spot deer, a fox, even a coyote; the big guys like bears and mountain lions, you should probably draw from inside.

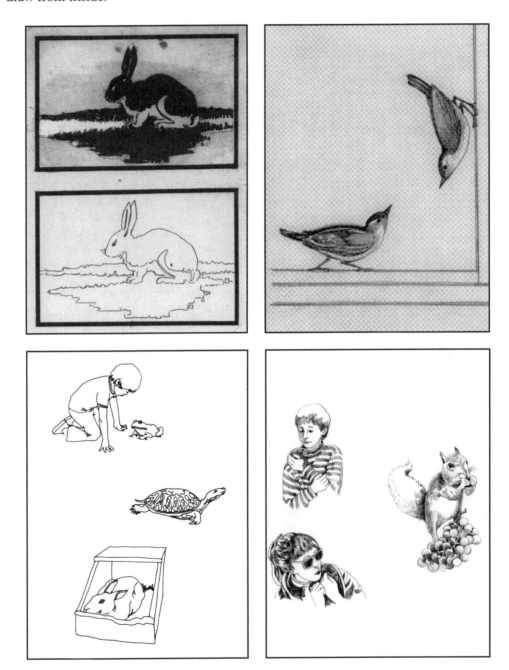

Animal subjects are as close as your backyard. How does your animal subject determine or relate to your drawing's composition? Add the human element, and you've got something wonderful!

Field and Stream, Mountain and Lake

All the pretty places that you may think of for landscape drawings are also great for animal studies. The seashore, for example, offers a constantly changing mix of shells and seashore life. Some of that life you can even bring home to work on later, while some of it (shells, for example) will have to stay outside or be soaked in a little mild bleach to clean it.

When your mate wants to go fishing, don't stay home; take your sketchbook and draw the fish, seashore life, or water birds.

The shore can offer up an interesting array of still life subjects—both living and inert. After that oceanscape, do some studies of the smaller creatures and objects the scene holds within it. Shells are a particularly good subject for practicing how to render texture, while also mastering some challenging shapes.

Natural History Museums and Centers

At the natural history museum, you will find everything you can think of, from a look under a microscope to a dinosaur's skeleton, as well of lots of books to study. Knowing roughly how an animal's skeleton works will make those action and gesture lines mean more. The business of adding form and weight will come more easily the more you study, so check it out.

Practice drawing animal skeletons—wherever you find them. Take a trip to the local natural history museum, if need be, or copy them out of natural science books and magazines. Skeletons can really help you understand the foundation of a living creature's form, as well as its natural actions and gestures.

Farms, Stables, and Parks

Go out and draw the chickens, ducks, cows, goats, pigs, donkeys, horses, ponies—and don't forget all the babies. Drawing domestic animals is a great way to practice drawing animals in relation to each other. When you draw more than one of the same animal, you begin to discover how the animal moves according to its particular anatomy, and how to render different positions convincingly. With time, a certain arch of the neck or turn of the ear can become second-nature to your drawing hand.

Draw animals in groups to discover how their shape and gesture resonates when there's more than one. How do animal groups inform your drawing's composition? What about putting animals into your landscape? Think about the positive and negative space relationship when drawing animals in groups.

Zoos, Circuses, and Animal Petting Parks

A zoo is a great place to draw. You have it all there—not just the wild animals, but their habitats as well. You'll also find gardens, trees, walkways, arches, fences, water, fountains, kids, parents, lovers, and, for your comfort and pleasure, restrooms and food nearby. They may even have Starbucks by now. Get your drawing equipment and go camp out for a day. Then you can do it all— and draw it, too.

Safaris

Safaris can be close to home or the adventure of a lifetime.

Almost any trip can be turned into a part-time safari. It's more a change in your attitude than the altitude. If you can't get as far as you'd like, repair to a zoo or a museum. If you get the chance to try Tibet or a jaunt in the Australian outback, when it comes to your sketchbook, don't leave home without it!

Animal Portraits

An animal portrait can be a casual sketch that captures the personality of the animal, but often it is an attempt to get a more formal treatment and likeness.

Back to the Drawing Board

You will find lots of reference material out there: books, magazines, stock photos, clip art, and Internet photos, to name a few. They can be handy, but will not be the best way to learn to see and draw. Looking at a flat image is not the way to practice shape and form. Even detail is best seen for real and then drawn. Use the world of reference and photos only when you really need them, and try to see your way rather than copying the flatness.

To do an animal portrait, start with the basics: gesture, proportion, and form. Then add as much detail as you feel you can see.

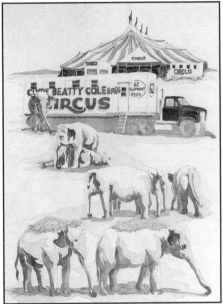

For rendering more exotic animals from life, instead of from books, try visiting the circus or zoo. You'll be practicing new animal shapes and forms, while exploring other fun and interesting drawing challenges, such as the tents shown in this illustration.

Look at what happens when you draw the animal using texture as the technique that illuminates the defining shapes. Here, you see a bear and two badgers.

When studying animal forms, try to capture just the shape to tell you what animal is being rendered. Pay attention to positive and negative spaces. Which animals do you see here?

Problems in Portraiture

When your pet will sit, but not for a portrait, what then? You can wait for a sleeping subject, or you can work on a series of regular poses the animal often strikes, adding a bit of shape, form, and detail as you can see it.

If your pet won't sit for you, you expect an elephant to do it?

You might be surprised at a zoo and find that a wild animal will be a willing subject. Many of them spend afternoons in relative repose, so if you can find a pose you like, you might get lucky.

A Bit on Materials and Techniques

Our focus has been on seeing and drawing animals, including the gesture, proportion, shapes, and form that make each species unique. Detail is the textures and patterns, and the colors and surface tones that are particular or peculiar to that animal—from the soft blotchy fur of a fawn, to the smooth pelt of a seal, thick fur of a husky, slippery skin of a frog, rough hide of a buffalo, shiny scales of a fish, or the horny plates of that rhino on safari.

Experimenting with all your materials and trying new ones as you see them is the best way to expand your vocabulary of marks and textures. Look at someone else's work (ask them if you can), or just stand there and try to imagine how they made a certain tone or texture. The more you practice yourself, the easier you will find it to identify a particular kind of mark or material. As always, let the real seeing and drawing of the animal come first.

Back to the Drawing Board

Photographs, as a reference, can certainly help, and sometimes they are the only way to get what you want. But please don't try to learn to draw from them; they are already flat and your drawings will follow suit, unless you have drawn from life and have enough practice to be able to "see" and draw three-dimensional shape and form. Try to use the photos for detail only.

Experiment with different materials and textures to see what works best for the animal you're trying to convey.

Animals in Your Drawings

If you took our advice and went out in your yard, took that fishing trip, or made that day trip to the zoo, you probably have a lot of animal drawings now. Some of them are sketches and some of them might already include some surroundings, so you are partway there.

Putting them, or drawing them into, a landscape as an addition takes a bit more planning and attention to scale.

Scale and Detail, Indoors or Out

Animals inside are usually easy to place because the scale is easy to judge. If you can already draw the chair your dog or cat is sitting in, adding your pet will require only a clear drawing of the animal, or what you can see of it, which can be the problem. Look carefully at where limbs are tucked underneath and how the body might be curled up in a comfortable position. Then draw what you see.

Like Odin, Lauren's dog, all animals have their favorite chairs. Draw them there for a realistic likeness.

Detail and Scale, Close Up or Far Away

Outside is another story. Scale as it indicates size and distance is important to your consideration of animals in the landscape. The most common example is a seascape, with seagulls that are supposed to be flying above but instead seem to be looming out of proportion to everything else in the drawing.

Practice in measuring against a base unit in your view will help keep those birds where they belong.

If you are trying to emphasize an animal as the central point of interest, treat it like a portrait, with the landscape in the background.

In the next chapter, we'll take the next logical step, and show you how you can have human animals in your drawings, too.

Your Sketchbook Page

Try your hand at practicing the exercises you've learned in this chapter.

The Least You Need to Know

➤ Animals live in a world of action. Seeing and drawing that action and gesture is the first step in getting the sense of the animal you are looking at.

➤ Proportion and shape build on gesture, adding muscle shape to the direction and placement of the main limbs.

➤ The form of the animal should be considered. Even a bird's leg is a three-dimensional form.

➤ Photographs can supply detail information, but are flattened versions of the real thing and not as good for practice.

➤ Quick sketches of an uncooperative pet or wild subject can gradually give you enough information for a more finished portrait.

The Human Body and Its Extremities

In This Chapter

➤ Drawing the human figure

➤ Gesture is all

➤ A feel for body parts

➤ Form and proportion

A drawing of the nude is the most revealing form of artistic expression simply because it is the most immediate and the most personal.

—Mervyn Levy, *The Artist and the Nude*, (New York: Clarkson Potter, 1965).

We are fascinated and enticed by the figure, the most single expressive subject for artistic exploration. When we draw the figure, are we drawing ourselves or all humanity? Perhaps it doesn't matter—the figure attracts us, whatever the reason.

Your sketchbook will be your greatest asset in learning to draw from the figure. Constant sketching is the way to an understanding of the figure and an ability to quickly see and draw a gesture. The more you draw, the more you will see. Your drawings will quickly gain grace, proportion, and form. You will be able to use your own creativity, and your work will be original and unique.

Drawing the Figure

Like the four-footed and winged animals you worked on in Chapter 20, "It's a Jungle Out There—So Draw It!," people move around a lot. Get used to it. Work with the knowledge that they will move and you won't be disappointed.

Drawing people is virtually impossible without a working understanding of the nude figure. Once you do learn it, you may find the shapes and beauty of the figure become your favorite image.

Getting Some Practice and Help

Classes and informal drawing groups with a model are there for the looking. Museums and adult education programs are places to check. You can always start a group, with or without a formal instructor. A model can work with suggestions as to the type and length of poses favored by the group. Working from the figure in a comfortable studio setting can add to the intimacy of the poses and the detail surrounding the model, too.

Use Your Sketchbook

A sketchbook is a visual storehouse, a place to practice, and a fascinating and sometimes poignant record of life as well.

Capture the posture and gesture of your subject in a few moments. Try for a sense of character if you can in some of the angles and shapes.

Artist's Sketchbook

Gesture drawings are drawn from short poses, no more than four minutes and often as short as one minute.

The Gesture of Life

Gesture drawings are a good place to start. The object is to capture the essence of the pose, which might be quite energetic as it does not have to be held very long.

In the section following, we've provided guidelines for trying a gesture drawing of your own.

Direction and Gesture

When sketching from a model, arrange yourself so that you can see easily over your work and have a clear view of the whole figure. You will need to look back and forth from model to drawing often and quickly.

1. Allow about three to four minutes for each pose. You can ask your model ahead of time to change the pose according to a preestablished schedule.

2. Try to capture:

Try Your Hand

Try to mentally experience the pose yourself, particularly the more energetic ones. Feel the tension or off-centeredness, the weight on one foot, or the reach or twist as if it were you.

 ➤ The line of the spine.

 ➤ The twist or angle of the spine.

 ➤ The angle of the head and neck.

 ➤ The angles of the shoulders and hips (which are often opposite to each other).

 ➤ The directions of the arms and legs.

That will keep you plenty busy!

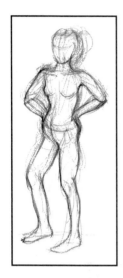
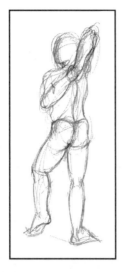
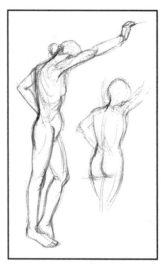

Quick gesture drawings are great for discovering how the human body works, and how it looks in motion. Making gesture drawings will help you learn the proportional relationships of body parts and to follow their natural movement.

Thoughts on Quick Action Poses

Instruct the model to change poses at intervals. With each new pose, begin a new drawing, even if you have not finished. Create a little pressure for yourself. Like a workout, make yourself stretch with the model. Don't erase, just draw and draw. If you need to correct, draw over it and keep going.

If it is possible for you, try to draw in a little indication of form, some roundness in the limbs. Make the shapes where body parts overlap. Feel the parts of the body yourself as you draw.

Try to work evenly around the figure as long as you can. Try not to focus on just one spot—you can lose sight of what you are doing and whether there are still problems to correct.

Use yourself when you run out of models; a mirror or two will give you plenty to work with.

The Art of Drawing

There are lots of ways to work longer on a pose. Go for tone, shadow, likeness, detail, a shaded work, a fine line. They are all worth trying. But the most important thing is a good seeing and beginning drawing. Why spend a half hour or more rendering a drawing that has an inaccurate base?

Body Parts and the Whole: Anatomy, You Say?

Anatomy, after all, is under there. Why not have at least a passing acquaintance? Here's the quickest anatomy lesson ever written:

➤ The skeletal structure of a figure determines the proportion.

➤ Muscle groups and their relative development are the shapes of the body and limbs, but the bones are still underneath.

➤ Fat deposits (relax—we all have them) alter the shapes according to how much of it is where.

➤ Age is another factor in how the body looks. The skeleton loses some of its flexibility with age, muscles change, how and where fat is retained is different, and the quality of the skin changes. Yuccck!

It's all a little clinical, but there it is. You'll find that your drawings will be much better for the time you spend understanding the skeleton and muscle arrangement.

The Hip Bone Is Connected to the ...

Now that you've got those basics, here's more you should know about anatomy.

➤ The skeleton has 206 bones, held together by ligaments. At the joints, the bones are covered with a thin layer of cartilage to protect them against wear and tear. There is connective tissue and fluid to lubricate the joints.

➤ The body is supported by the spine, 33 vertebrae from the skull through the shoulders, rib cage, and down to the pelvis.

➤ The rib cage forms a barrel-like structure to hold and protect the heart and lungs.

➤ The arms hang from the ball-and-socket joint of the shoulder, and bend and rotate at the elbow joint and the wrist joint, which in turn allow the complex flexing of the hand.

➤ The pelvis, a basin-like arrangement at the end of the spine, supports and protects the intestinal system.

➤ Weight is transferred to the large bones of the legs at the ball-and-socket joint of the hip, transferred down the leg at the knee joint, and ends in the base formed by the feet.

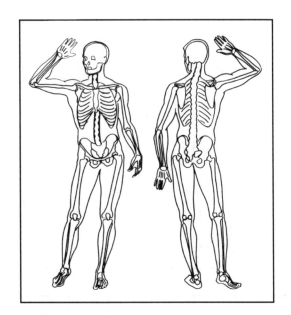

The skeletal system: Familiarity with the skeleton will inform your figure drawings with a knowledge of what's under the skin.

Muscle Is Good

Muscles do the work of moving the skeleton, from large sweeping motions like running to small subtle movements like smiling or breathing. There are over 600 muscles in the body, doing a variety of functions. Attached with ligaments to bones at either end, they can contract and become shorter and thicker, or they can stretch and become longer and thinner. For drawing purposes, we are concerned with the large ones that shape the torso and limbs, and the complex muscles of the face that create expression, a *kinesic* function.

The torso is all the bone and muscles forming the middle of the body, from the shoulders to the pelvis. Flexing and stretching is possible because of the flexibility of the spine, which, as the middle-aged among us know, varies tremendously from person to person. The combinations of twists and turns are amazing, really. The spine even has a double curve when in a standing position.

The front of the torso is a sheet of muscles, including abdominals, which bend the body forward, and sacrospinals, the back muscles, which bend it backward. The chest muscles—pectorals—form the bulk of the chest, and breasts are glandular, with a covering of fat.

The wide range of motion in the arms is a function of the ball-and-socket joint of the shoulder and the clavicle (collarbone) and scapula (shoulder bone), which are not tightly attached and move to allow stretches and reaches.

Muscles in the shoulder section are the pectorals, the chest, the trapezius, the shoulders, and the latissimus dorsi on the back. The shoulder muscle is the deltoid. Arm muscles go from the shoulder to the elbow (biceps on the front and triceps on the back), and another set go to the wrist.

Legs are shaped by large muscles that support the weight of the body and move it about. Gluteus maximus, the large muscles of the buttocks, go over the pelvis to the legs. Thigh muscles (biceps and rectus femoris) go from the hip to the knee and the calf (gastronemus) and shin muscles go from the knee to the ankle.

Artist's Sketchbook

Kinesics is the study of body movements, gestures, and facial expressions as a means of communication.

275

The muscles of the body: Drape a skeleton with muscles and you've got a body ready to move.

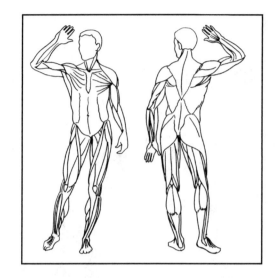

Studying muscle movement will inform your figure studies with a knowledge of kinesics.

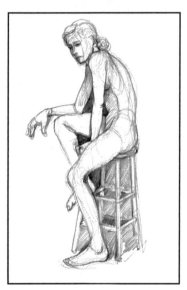
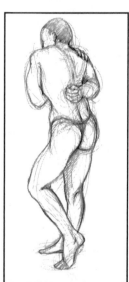

Back to the Drawing Board

Note that these are body types, and are not the same as height. These types occur in all possible variations, degrees, or amounts.

Some Basic Proportions

The Greek physician Hippocrates (460–377 B.C.E.) recognized two body types:

➤ Phthisic habitus—tall, thin physique

➤ Apoplectic habitus—short, thick physique

But these two body types really don't even begin to cover the variations in the human body, and the study of physical anthropology has identified a wide range of body types. William Sheldon, an anthropologist in the 1930s, devised a system based on three main types:

➤ Endomorphic—fat

➤ Mesomorphic—muscular

➤ Ectomorphic—bony

Try drawing the action and position of the figure with the simplest of lines for the spine, shoulder, hip, and limbs. Add some volume to the body cavity, the shoulders, and the pelvic area. You can practice a kind of stick figure, or you can draw the body as a series of proportional ellipses, or you can see it as a group of cylinders and boxes. However you begin, close seeing and drawing of the muscles should follow. The best practice is … well, practice.

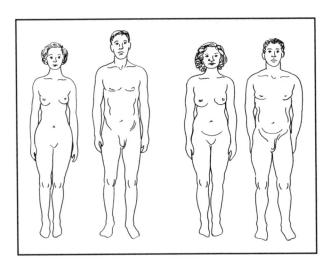

An awareness of body types helps to see the proportions of an individual, for better or worse.

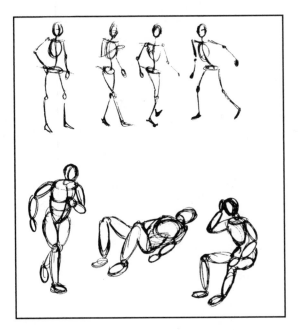
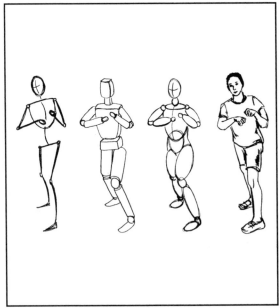

Ellipsoids, as opposed to humanoids, and cylinder/box figures are a great way to start adding volume to a gesture.

Age and Gender: Some Basic Differences, As If You Didn't Know

Body proportion is important to understand. It changes radically from birth to adulthood and is slightly different between males and females as well.

Body, Age, and Proportion

Did you know that the body can be measured relatively at any age, in heads? That's right: an average adult's height is eight heads, easily divisible in heads at the chin, nipples, navel, crotch, mid-thigh, knee, and then calf/foot.

Children's heads are much larger relatively. A baby's head is about one-quarter of its body, as are its legs. As a child grows, so do its legs, while the head size decreases relative to the body and the limbs.

Accurately seeing and measuring the proportions of a figure from childhood to puberty to adulthood is crucial for getting the look of the particular age group.

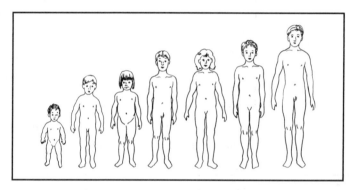

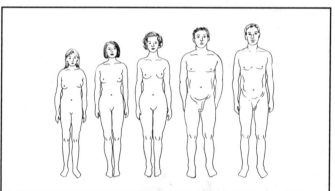

The male nude.

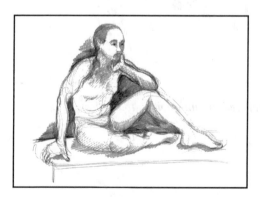

If you don't have the opportunity to sketch live nudes, try copying famous male nude sculptures, such as Michelangelo's *David*.

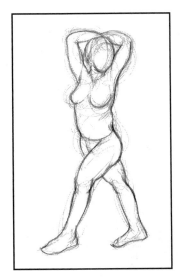 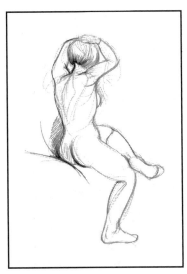

1. Start with a gesture sketch to capture the pose of a female nude.

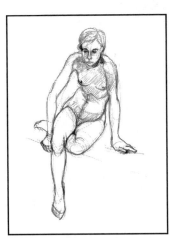

2. Once you've got the pose, begin to refine forms and shapes.

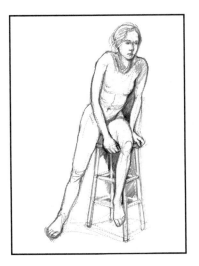 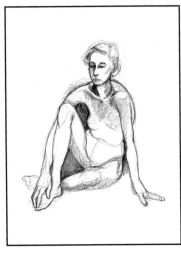

3. Use negative space to further define the pose and enhance a three-dimensional effect.

279

Where's the Beef? Where the Ice Cream Goes

Fat deposits are shapes to contend with when drawing the figure.

Muscle development varies from person to person of either gender, but male musculature is generally heavier than the female. Fat distribution is different, too. Men carry weight at the middle, on the upper back, and lower back. Women tend to carry weight on their buttocks, abdomen, thighs, breasts, and the backs of the upper arms. While today's culture doesn't always consider this attractive, it's a natural part of human anatomy. So relax and open that carton of Mocha Almond Fudge.

Typical areas of fat deposits on the human body.

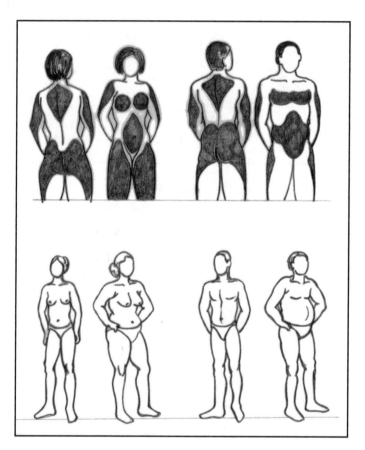

What We Have to Look Forward To

As the body ages, the flexor muscles shorten and tend to pull the body into a stoop. In addition, the spine curves more, the shoulders round or stoop, and the neck thrusts the head forward. At the same time, muscle tone changes, and the muscles become thinner and shrink. Joints, meanwhile, seem larger relatively. Skin and soft tissue gets softer and saggy at the stomach, breasts, elbows, and chin. More ice cream, anyone?

Children, with their longer more flexible muscles, are, not surprisingly, more like animals, always in motion.

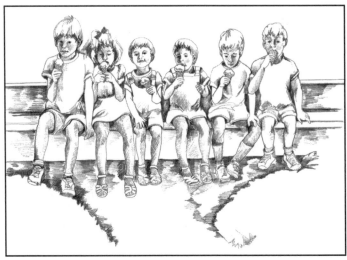

Children are more like animals, in perpetual motion, so you'll want to use gesture drawing when capturing them. The tilt of a knee can express so much! Practice as well the folds of a dress or getting that ponytail to have just the right swing.

Extremities: Getting Over Hand and Feet Phobias

The most commonly drawn figure pose is a lovely torso, with the hands behind the back and the head and feet somehow left off, as with the Venus de Milo. There is a reason for this.

Hands

Hands are the bane of many a figure drawing. There are dozens of small bones and muscles and ligaments in the hand and the wrist which allow us the wonderful range of movement we take for granted, even down to the typing of the manuscript for this book.

Think of the hand as a flat, rather squarish shape, with a wrist joint at one end (it is amazing how often the wrist is ignored), and a curved edge at the other end from which four fingers extend. This plane is flexible and can rotate and bend at the wrist. On one side, there is a wedge-shaped muscle from which comes the thumb. The placement of the thumb in this flexible wedge is what allows us the wonder of "the opposing thumb," the use of thumb and fingers in coordinated effort. Think of doing anything without this gift!

Practice, with your own hand as your cheap model, is the best way to draw the hand. Make that model work for its lunch. Practice, in fact, is the only way you will learn to draw the hand. There's no getting around it.

Here are some hand positions to practice copying. Use arcs to get the relationship of wrist and finger joints. (see next page)

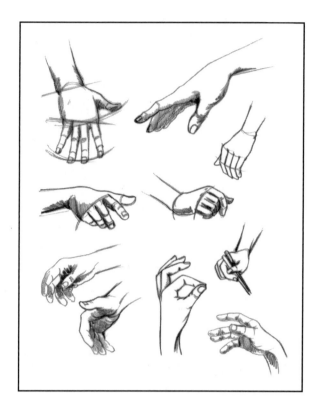

Feet

Feet are similarly avoided in figure drawings. But because they are the base for the body at rest or in action, you need to pay closer attention to them.

Think of the feet as wedged-shaped bases, higher where they are connected at the ankle joint, sloping down toward the front edge, with an arched shape underneath, and ending in five toes for added stability. Here, too, practice will best acquaint you with the shapes and positions. And you have two of these fine specimens to work with, as you probably are not holding a pencil with one of them.

The base of all figure drawings: the feet. Practice copying these foot positions. Visit the sculpture gallery of your local museum with your sketchbook in hand and start sketching the feet of the statues. Try sketching the feet of one statue from different eye levels or views to see how the foot changes as you change your orientation.

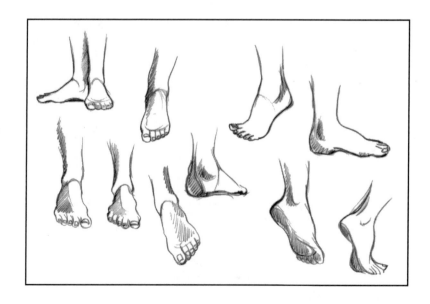

Head and Neck

The head and neck top off a striking structure. The cervical vertebrae go up into the skull and allow the head its range of turning, twisting, and bending. If you've ever had a bad stiff neck, you know how precious this flexibility is.

The head itself is roughly as wide as it is high in profile from the front, although it is thinner than it is high and has an oval shape. In the back, the skull is rounded, behind the shape of the face and jaw. The back of the neck goes up into the skull, while the front of the neck goes up under the chin and jaw. The main plane of the face is modified by the facial features: the wedge shape of the nose, the forehead, the eye sockets, the cheekbones, the mouth and jaw, and the ears on the sides.

Along with studying a few examples here—or better yet, in the hundreds of master drawings in books or museums—just get in there and try some head studies. They'll help with portraiture to come.

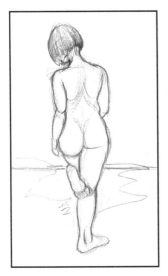
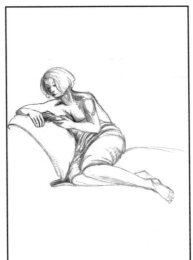
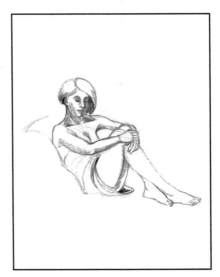

Take a look at these head studies to see how to top off your figure drawing.

More Form and Weight, Now

Okay, ready to try a figure drawing of your own?

1. Start your drawing with a few gesture or action lines that are the main limbs and direction of movement. Then, think of the body as a collection of spare parts, drawn as geometric shapes of various sizes and on various angles relative to each other.

2. Use quick lines to establish gesture, proportion, and shape.

3. Use ellipses for form, particularly ellipsoids.

 In longer efforts, the same is true; just continue to add detail, check proportion, and then add more detail and form.

4. Look at the shapes and the way a shape goes over or under another, especially at the joints. Think of the roundedness of the body, its strength, and its flexibility as you draw volume and weight into the gesture.

5. Try to add tone that rounds the shapes and adds a sense of the smoothness, hardness, flabbiness, flatness, or thinness that you see on the model.

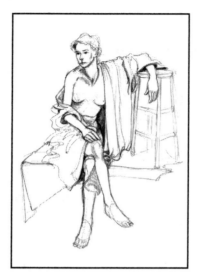
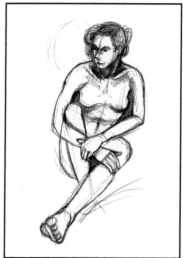
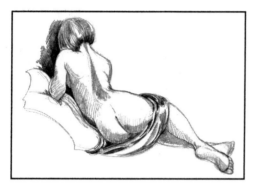

A figure drawing is as simple as the sum of its parts.

In Chapter 22, "Dress 'Em Up and Move 'Em Out," we will approach the head, its proportions and parts, the always popular portrait, a consideration of clothing, and the business of populating your drawings with your friends, family, or perfect (or close to perfect) strangers.

Your Sketchbook Page

Try your hand at practicing the exercises you've learned in this chapter.

The Least You Need to Know

➤ The human figure is perhaps the most compelling and challenging of subjects to draw.

➤ Gesture and proportion are your first priorities to capture the action and movement of a living being.

➤ A working knowledge of anatomy, the skeleton, and muscle groups will help tremendously when you visualize and feel your way into a pose.

➤ As you work toward a more finished figure study, gender, fitness, weight, and age all contribute to the look of the figure.

Dress 'Em Up and Move 'Em Out

In This Chapter

➤ Adding people to your pictures

➤ Facial shapes and proportions

➤ Getting 'em dressed

➤ Getting 'em moving

I'm trying to capture something of the world I inhabit, but it's really about my own journey.

—*Ed Hall, portraitist on the Long Island Railroad*

Because most landscapes seem to have as many people milling around as the houses they live in, it's time to get out there and start drawing these folks. Draw your family, your friends, or that elusive perfect stranger. You know, the tall, dark one? Oh, wait—that's a different book.

In this chapter, we'll show you how to dress up your figures—not just in clothes, but by individualizing their features, bodies, and gestures.

Add That Human Touch

Your landscape drawings will often be enhanced and enlivened by the addition of people, whether singly or in groups. That's because a human presence adds a sense of place, of scale, and of timeliness—as well as a touch of, well, humanity.

When it comes to that human touch, think of your sketchbook as a personal statement of your reaction to life, as well as a place to practice, to record, and to react—rather like a diary, but also as a storehouse of images and ideas for future use.

You can begin by using your sketchbook at home, when the family is watching TV, playing out in the yard (especially if there's a chore you'd rather ignore), or while someone is at the barbecue or asleep in a hammock.

At other times, too, make use of your sketchbook as often as you can. Draw people in the street, on the train, waiting for the bus, at lunch in the park, walking a dog, jogging, sunning on the grass—anywhere you can think of will do.

People are a natural part of any landscape.

A good way to capture a figure spontaneously is to do a Plexiglas sketch, such as these two examples.

No Flat Heads Here: Heads and Faces

So, you've asked a friend or family member to pose for a portrait. Now, let's make sure that you end up with a three-dimensional, proportionally correct face and head, with the eyes, nose, and mouth where they're supposed to be, so you don't lose a friend—or end up in divorce court.

Types and Proportion

Let's start at the top. The head is an oval from the front, rather thinner than it is high. In profile, the head is about as wide as it is high. The back of the skull is rounded and the jaw line curves down to the chin.

As with body types, heads and facial structures come in anthropologically identifiable gradations (what a mouthful—say that 10 times fast):

➤ A dolichocephalic face is long and narrow and has a distinctive convex profile.

➤ A brachycephalic face is flatter and wider.

➤ A mesocephalic face is squarer and has traits of both.

Try to see past generalities as you draw the beginning shapes of a person's head and face, just as you would with their body type.

Eyes, Ears, Nose, and Throat

The head, face, and the position of the facial features can be roughly described with a few quick lines. Then you can draw some additional lines lightly to establish a guide.

On the oval of the front of the head

➤ The eyes are at about halfway.

➤ The nose is about halfway between the eyes.

➤ The chin curves at the bottom of the oval.

➤ The mouth line is about halfway between the nose and the chin.

Try Your Hand

When you are going out, remember to take your sketchbook with you and draw people as you find them—at picnics, concerts, sporting events, speeches, in restaurants, on boats, in planes ... whatever.

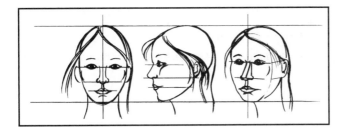

These drawn guidelines, along with the written rules above, will help you position the features on just about any face.

In addition:

➤ The eyes are about one eye's width apart along the middle line.

➤ The nose is a wedge shape in the middle of the face.

➤ When the face is seen in profile, the nose is a triangle out from the face.

➤ At any view, the wedge of the nose is perpendicular to the face.

➤ The mouth is formed by the two lips, centered under the nose.

➤ The chin is the narrow curve of the bottom jaw, a line that comes from just below the ear.

➤ The ears themselves are flaps that are on the side of the head at about a level between the eyes and the nose.

➤ The neckline comes from the ear on the side and under the chin.

The guidelines for the full frontal view, accompanied by the finished portrait.

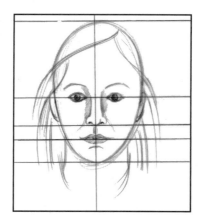

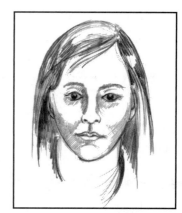

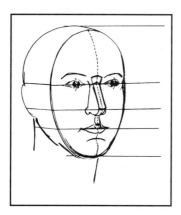

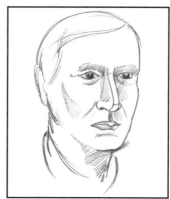

The guidelines for a three-quarter view, accompanied by the initial sketch and more finished drawing where tone and detail are beginning to be added.

Especially for Children

Remember that a child's head and face have their own proportion relative to an adult face and head. Look carefully at the differences:

➤ The eyes are wider and larger.

➤ The nose is shorter, softer (all cartilage and bone develops later), and more upturned.

➤ The mouth is usually fuller.

➤ The forehead is wider.

➤ The chin is smaller.

Likeness and Portraiture

Portraiture attracts most people. After all, we do like to look at our fellow humans and family members. But where do you begin? At the top. The following rules of drawing the face can help you.

1. Begin a portrait with a study of the head and facial proportions of your subject.

2. Check the angles very carefully, including the angle of the pose, whether from side to side or tilted up or down, or both. Position the guidelines for the features so they line up.

3. There is no point in rendering a nose that is just a little bit too high or a mouth that is just a little bit off to the side, so make sure of your base. Draw lightly until you like the shapes.

Examples of an infant's face.

Some Basic Proportions and Shapes

Look for the specific shapes that make up the features of your subject. For example:

➤ Faces are round, wide, narrow, oval, or square.
➤ Noses come in lots of shapes and sizes.
➤ Eyes are close, wide, deep, small or large, squinty or round.
➤ Eyebrows and the bridge of the nose are key transitions.
➤ Cheekbones are high or low, prominent or flat.
➤ Mouths are wide or narrow, full-lipped or thin.
➤ Jaws are wide or narrow, under- or overdeveloped.
➤ Ears are small or large, close or protruding.
➤ Necks are long or short, thin or thick.
➤ Hairline, type of hair, and cut of hair all identify an individual.

The Art of Drawing

A recent issue of *Newsday* had an article about Ed Hall, a veteran commuter on the Long Island Railroad, who has sketched his fellow commuters on the train for the last 11 years.

"I love my species," he said of his fascination with the sleeping faces that are his subjects.

Our features are mostly all in the same place, so it's the little variations that make the individual and the expression.

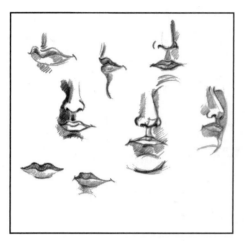 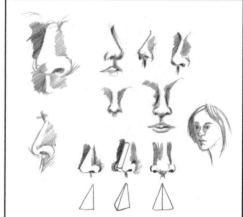

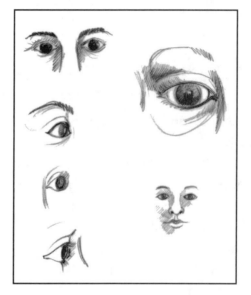

You might want to practice drawing just features to get a feel for their individuality. The nose knows ….

Begin work on the features on your portrait with the same concern for shape, space, and form that you have used on all your work. Consider the basic shapes and then refine them as you go. The more you look at the shape and structure of a feature, the better you will draw it.

Setting a Scene for a Portrait

Setting a scene for a portrait is a nice way to add to the special feeling and the connection to the subject's life or interests. Some portraits are set in intimate surroundings to create a secret spot or a restful feel; others are set in a more public space, or outdoors if it suits the subject. You are the ultimate judge of what's appropriate when it comes to setting, but don't hesitate to try a setting that is unusual.

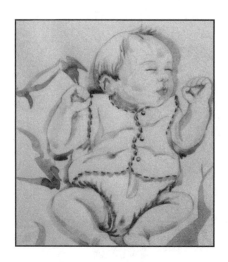

Lauren drew this figure of her nephew when he was a week old.

When You Are Your Subject

When you're your subject, you have even more say in how the drawing will look. One or more mirrors can set you up with any number of views, and you can sit for yourself as long as you like. There will also, hopefully, be less argument about when to take breaks and how long you're making your subject sit still.

One of Lauren's students draws a self-portrait at 8 years old (left), and again as a teenager (right). My, how you've grown!

Self-portraits show the mood of the moment, and hold up a mirror to the artist's view of him- or herself!

Self-portraits drawn on Plexiglas produce a quick-study image.

Details of self-portraits, such as a vivid facial expression or that favorite pet, add poignancy and endearing emotion to self-portraits.

Folds, Drapes, Buttons, and Bows

You might want to go back to the description of drawing fabric in Chapter 14 to review some of the tricks of fabric drawing. Once you've got fabric mastered, clothes will fall right into place. But here are some further hints, too.

Back to the Drawing Board

Often, clothing needs to be seen as form—imagine where, and how, the lines and folds go when you can't see them under, over, or behind the body of your subject. Creases where one shape goes behind another need to be imagined and drawn.

Over and Under: Folds and How to Draw Them

Quite simply, clothing covers the body that you are drawing. Once you've gotten a basic sketch and are happy with the proportions and gesture, you'll want to begin to add the detail of the clothing. Remember that clothing covers a rounded figure, not a flat one. Places like necklines, cuffs, and pant legs need to have a roundness to them.

Detailing: Make the Clothing Fit the Woman or Man

The detail in clothing adds to the pose and gesture of an individual and sets the scene for that person's activity in your drawing. You can sketch it in or you can spend time on the textures and patterns, the style, and the details.

In addition, a few props can often add the detail you're after in a portrait. If you enjoy drawing people, as portraits or as characters in your larger work, you might amass a collection of prop hats, gloves, boots, jewels, flowers, and feathers, just for fun.

Putting People in Your Drawings

If you're out drawing a landscape and there are people in it, you should feel confident enough to add them now. You do, however, need to place them well and keep them in scale with their surroundings.

Generally, careful measuring and relational seeing will get them in the right place. Feel free to return to the tear card at the front of this book whenever you need a reminder about measuring guidelines.

Where Are They?

Inside, the scale of people and things is not much of a problem, because the distances are not great and the people are probably easy to see. Try drawing a friend working in the kitchen, or a family member snoozing in front of the TV, or an intimate friend in the tub or relaxing in the bedroom. The setting of your drawing helps place the person and adds a special feeling about the moment.

Placing people in your landscape can add both drama and character(s).

The Art of Drawing

Seeing and measuring the scale of your figures in the landscape relative to other elements will put them where you want them. The detail in your figures will vary according to their placement and importance in your landscape. Those guys off in the distance need to really be there, but you won't see the logos on their T-shirts.

Outside, however, is a different story; the possibilities are about as endless as the landscape itself. Your figures can be off in the distance and be just another element in the landscape, like a tree or fence. Or, they can be rather in the middle and be part of the action of the drawing, or in the foreground and be the action, with the landscape providing the backdrop and setting for their activity. People in the foreground, particularly if they are interestingly dressed, deserve some real attention to detail.

What Are They Doing? Action, Gesture, and Detail

The body in action probably presents you with some foreshortening challenges. It's really quite simple, though: If you think of people as cylinders in space, you'll know how to draw them. Measure carefully to see where the body parts line up with each other in the foreshortened pose, as opposed to the figure if it were standing straight up.

To draw people at work and at play, concentrate on the action and the gesture in quick lines, adding detail as you can. Sometimes a small detail, like a hat or a fishing pole, is enough to begin to convey a feel for the person or the activity.

No matter what, you'll find that adding people to your drawings adds a whole new dimension. Try it and see. In the next chapter, we'll explore drawing for a special class of people—kids.

Your Sketchbook Page

Try your hand at practicing the exercises you've learned in this chapter.

The Least You Need to Know

➤ The head and face are a challenge, but if you see the proportion and detail, you will be able to draw what you see and capture the uniqueness of your subject.

➤ Adding clothing doesn't have to be complicated; think of it as fabric draped on a body.

➤ Putting people in your interiors or landscapes adds scale and interest as well as a sense of place, time, and individuality.

➤ Remember that clothing goes over a breathing, bending body, and look for the drapes, creases, and folds that make clothing real.

Part 7

Enjoying the Artist's Life!

It's time to put it all together and use your drawing as a way to express yourself. You will learn about different media, projects, and ways to use your drawings to decorate your world. You'll even learn about drawing in cyberspace—and encouraging your children to draw, too.

Plus, we'll go to the museum to see how to look at the larger world of art, and you'll learn how you can understand more about yourself by finding what art you're drawn to.

Just for Children

In This Chapter

➤ Kids can draw, too

➤ It's all in the attitude

➤ Basic drawing materials for kids

➤ Exercises to get kids drawing

The study of composition means an art education for the entire people, for every child can be taught to compose—what it is to know and feel beauty and to produce it in simple ways.

—Arthur Wesley Dow

From earliest man's drawings on cave walls, to the great Renaissance drawings of da Vinci and onwards, to the works of our contemporaries, drawing is a basic human expression. With today's power-based, language-driven, analytical attitude toward education, though, drawing no longer has a place of real importance (generally speaking).

Children are taught the importance of academic achievement, but visual skills are usually thought of as pastimes or hobbies. This means that children draw until they are educated out of their innocent sense of wonder and the ability to just "do" without being caught up in "correctness" and passing judgment on their work. They then abandon drawing altogether.

You, however, can change this: Use what you have learned about drawing and try being a child's guide. Get in touch with your child, grandchild, or a young friend and open up to the world of seeing and drawing, together.

From Symbols to Realism

Young children are confronted with a world of things to see, learn, name, and understand, to say nothing of concepts, ideas, and feelings. They start by drawing stick figures to communicate ideas to themselves and others, and as they draw these "crude" pictures, they are connecting words to their mind pictures. As you'll recall from Chapter 1, "The Pleasures of Seeing and Drawing," drawing itself is nonverbal, but it helps children develop ideas and language.

Young children continue to draw their ideas in symbols while at the same time they learn to see and draw objects as well. And, as their visual perception skills develop, they also learn to concentrate, become more patient, and increase their problem-solving ability.

Older children have already given up symbolic drawing and want to draw realistically, and they are frustrated if they can't. By the time a child is in second grade, in fact, the left-brain world of editorial judgment is firmly in place, and that joy of uncensored creativity is gone.

Stick figures aren't just for kids. These were drawn by some of Lauren's friends.

Educating the Right Side

We teach the "do as I say" method of imparting knowledge, and then we test to establish capability, skill, and intelligence in just that one way, never acknowledging that there are many kinds of intelligence and many ways of working. The truth is that education *is* learning, but it's a left-brained, verbally based, language-driven attitude toward learning.

To teach art and drawing to children—or to learn along with them—helps them learn early on to access the relational right and avoid the crunch when they are frustrated that makes them quit. Using a right-brained approach, children can learn visual (and life) skills to last them into adulthood:

➤ Spatial organization

➤ Attention to detail

➤ Patience

➤ Kindness

In addition, drawing has an advantage as a learning activity. Because it is seen as a pleasurable activity rather than an academic one, it's not thought of as stressful. At the same time, because it's often an ungraded subject, or at least not viewed as stringently as more academic ones, it's relatively free of the anxiety and fear of failure that come with other subjects.

From Hunter to High Tech

Long, long ago, we were more connected—to the land, to our families, to the way we gathered and grew food, to the animals that provided food, clothing, and shelter, and to the expression of ourselves through drawing. In short, the hunter-gatherer's way of life relied on basic skills, interdependence, and cooperation.

As we settled into the lives of farmers and craftspeople, these basic skills were still important. At the same time, the added activities of exploration and the settling of new lands required "multitasking," but also included a growing dependence on domination and superiority.

Today, the hard work and basic life skills required of the agrarian age have been supplanted by the academic learning and analytical knowledge valued in this industrial and post-industrial age. And, when we look forward into the technological age of the twenty-first century, it's clear that all kinds of creative, visionary skills will be necessary for full development.

Back to the Drawing Board

School curricula generally undervalue art in favor of left-brained learning. Drawing can help children organize and develop sequential thought patterns and step-by-step habits. New York State Art Teacher Assessment Supervisor Roger Hyndman has done statistical studies on students with drawing backgrounds—they achieve higher academic ratings.

Visual Learning for All Reasons

Visual learning is a great tool: If you draw something you know it, and to know it, you draw it. As Frederick Frank puts it, "I have learned that what I have not drawn, I have never really seen " Children across the learning spectrum can benefit from learning to draw in a variety of ways:

➤ Drawing can help where skills have been or are compromised because of various challenges. Those with only average academic skills, for example, can have well above-average skills in visual areas, and even enjoy careers as visual artists, artisans, and craftsmen. Research has shown that learning disabilities are often problems in the processing of language-based information, and learning-disabled people often have very strong visual skills.

➤ Whatever a child's skills, new levels of competence and a sense of reward can be attained with effort and patience. Then, with the confidence gained from the new learning and activities, potential career options increase as well. Children who draw no longer view their sense of self as narrow or traditional.

➤ Drawing promotes new energy and confidence in any endeavor, adding important reasoning skills to the battery of left-brain thinking. Drawing a difficult subject can speed the rate of learning the information—and extend the retention time, too.

➤ In the electronic arena, the creative relational mind is a plus; the ability to see the big picture and look at it from another angle and continue to see it anew is a gift.

Human expression has a value all its own. To be able to express feeling and thoughts visually is to encourage one to feel and express those feelings—and a step along the way to greater understanding amongst us all.

We All Love to Draw

In a nonthreatening environment, we all love to draw. That's because the hidden child comes out to play. But traditional instruction in drawing was for older children, usually those who drew well, and was focused on traditional European styles and models. It didn't leave much room for fun.

Today, those of us who help children draw know that they can learn to draw realistically in a creative environment without sacrificing their natural creativity. With older children particularly, the experience can keep them from hitting the wall of frustration when they can't draw to their expectations and quit. The key is that nonthreatening environment— and permission to play.

Drawing can be fun—just look at these, with the theme: Springtime and Easter.

Kids Draw at Any Age

Children need help with drawing realistically before they stop, as they naturally will, the symbolic stick-type drawings they made when younger to describe their world. And teenagers will resist because their language-based left brains have taken over and told them they can't draw.

When you're drawing with a group of children, you'll need to be aware of these differences. If there is a range of skill and age in a group, go for the average. The slower ones will catch up and the more advanced will experiment.

The Very Young

Start drawing with kids when they're young; you can give the gift of visual experience to a very young child and likely affect the child's visual abilities, encouraging his or her ability to be visually inclined and gifted. One possible activity is to play games with basic shapes. Recognition and duplication of those circles, squares, and triangles is good for visual perception and for developing the motor skills and coordination needed for drawing.

The Art of Drawing

By determining the child's particular interests, you can help encourage a child to draw. Many children, for example, love nature and draw wonderful botanical or biological studies. Others love and draw detailed maps, learning the geography as they go. Mechanically minded children might draw parts of things to show how something works—even if that something is a made-up spaceship or rocket. Whatever interests them, they are learning about drawing and learning to follow their interests, a great gift.

Stages from Symbol to Image

Time spent with a child is the best way to know just where he or she falls in the stages of visual development, and, as with all other development, a child may advance beyond and retreat back. The following guidelines will help you determine where best to apply your energies:

➤ At ages three to four years, you can work with basic shapes, but children in this age group will mostly draw symbolically in stick figures.

➤ By the time children are five to six years old, they can begin to draw realistically from simple shapes, but they will also continue to draw symbolically.

➤ Children who are seven to eight years old can draw realistically, but they may revert to symbolic drawings for fun. Let them!

➤ Adolescents from eight to thirteen years old have abandoned symbolic drawing and are eager to draw realistically. They compare and criticize and can easily become

frustrated and give up if they feel they cannot perform. It's especially important to remind this age group that drawing is fun, not competitive.

Children's drawings can reveal their interests and should be encouraged.

Tactics

There are a number of steps you can take to make drawing a positive experience for children.

1. Set up a friendly and supportive world.

2. Talk as an adult, kindly and supportively, but not condescendingly. Kids treated thusly will act more maturely.

3. Talk nonjudgmentally. Avoid performance words, competition or comparison words, and definitely fear or failure words. Eliminate *good, bad, better, best, right, wrong, easy, hard, mistake,* and *cheat* from your vocabulary.

4. Follow their lead on subjects to draw, at least some of the time, or try making a deal to follow a suggestion for part of the time and work on a chosen project for the rest of the time.

The Art of Drawing

Children have the imagination that most of us have lost, thanks to education and the demands of adult life. Encourage a child to use stories as the impetus for their drawing, or let a child develop a story to go with a picture or a picture to go with a story. Your child's imagination may get a boost in the bargain. Use your computer, or take a lesson from your young friend—kids know more—and combine a story with a picture, illustrate a poem, or start a book project.

Materials for Kids

The next step in encouraging kids to draw is to stock up on whatever you don't already have:

➤ Markers, fine and broad-tipped, in lots of colors

➤ Dry-erase markers for drawing on plastic

➤ Mechanical pencils, with a thicker lead (0.7) in a few hardnesses

➤ Colored pencils, as big a set of colors as possible

➤ Erasers, an assortment; tape, scissors, clips

➤ Paper—inexpensive, and lots of it

➤ Boards, plywood to work on

➤ Water-based paint, watercolor or acrylic, depending on the child's age

➤ India ink and pen or brush; water-soluble crayons

Back to the Drawing Board

Be sure to supervise kids—especially very young ones—in the use of art materials. Keep toxic materials or dangerous tools away from children who are too young or who are not mature enough to handle them.

Reference Materials

Accumulate a file of pictures to reference and ideas for pictures or backgrounds. Your young friends can add to the pile, too. They will come up with uses and applications for pieces of graphics that will amaze you. Pictures, postcards, cards, graphics, books and magazines, and wrapping paper are a beginning. Soon, the kids will be bringing in materials you hadn't even thought of.

And then there is the world of objects. Try to set aside a shelf for things to draw. The sky is the limit here. Be playful and inventive, surprising even. Flowers and fruit (dried or fresh or fake), shells, skulls, bones, butterflies, plastic animals with good scale and detail, toy cars, old toys, old blocks and log cabin sets, kitchen utensils and bowls, dollhouse furniture, dolls, broken toys, fishing tackle, sports equipment, action figures, musical instruments, a typewriter (if you still have one), roller skates, and tools—all these merely begin a list that has no end.

Drawing objects are limited by only the imagination, as one of Lauren's students illustrates in these two drawings.

Back to the Drawing Board

You don't need to feel guilty about getting help or using help. And don't worry about copying—actually, you can learn a lot by copying, and your art will still be different because you are different. Just don't try to pass off that great Rembrandt knock-off as your own.

Retraining the Critic

Restrain and retrain the critic in your head (yup—it's Old Lefty again). Get rid of him and invite in your kinder right side as a guide instead. We don't need nasty critics; there is no right or wrong, and no one way.

See the Basics

Getting back to basics is the best approach for drawing with kids. Create a peaceful and encouraging environment, with no judgmental words like *mistake,* no competitive words like *good, bad, better,* or *best.* With younger children, see the basic shapes—the circles, triangles, and squares in anything—and draw them as the beginning. With older children, try to see the three-dimensional geometric shapes in things—spheres, cubes, funnels, eggs, and tubes—and use them as building blocks toward more complicated things.

Banish that critic—it's just Old Lefty, rearing his ugly head.

Eventually, the process of seeing and drawing becomes second nature.

Pick Simple Terms to Explain Things

Children might not understand all the terms that we assume they understand, so it's important to use simple language until you are sure of your explanations. For example,

➤ A line or shape that is

 ➤ horizontal is lying down.

➤ vertical is standing up.

➤ diagonal is leaning.

➤ receding or diminishing is getting smaller in the distance.

➤ A profile is the side of something or someone's face.

➤ A contour line goes all around the edge of something.

You can probably think of more simple ways to describe things, ideas, or projects.

When Problems Arise

As with all activities, you'll have good days and not-so-good days. Remain supportive and understanding if things don't go as you planned, and look for reasons for the speed bump that you might have overlooked. Maintaining a protective and encouraging atmosphere that includes mutual trust will enable the child to work out a problem.

Try Your Hand

Try thinking of lines and shapes as animated, with personalities. Be funny about it. Name them with the child. Draw them as characters to reinforce their identity, then try the same tactic with basic shapes, and even three-dimensional ones. You may get some very amusing results.

In spite of your best intentions, though, problems will arise. So here are some of the possible pitfalls and solutions.

Distractions and Quiet

A proactive approach can be best when it comes to peace and quiet during drawing time. Drawing is best done in silence, because the right brain is not chatty. Try for a quiet, peaceful time, and maybe some soft music. Explain that drawing time is not story time, and that it feels good to sit quietly and draw and tell the stories later.

Tension, Frustration, Fatigue, and Short Attention Span

Whole books are written on each of these, because children are apt to experience any or all of them while drawing. Be as patient as you can. Look for the reason behind the problem, encourage the child to explain his or her feelings, and remain the kind adult.

The older a child is, the longer his or her attention span will be. If any of the above is exhibited at the beginning of the drawing session, it's possible that drawing isn't the problem at all.

Back to the Drawing Board

Avoid generalities or "art speak" with kids (or adults, for that matter). Save it for cocktail parties instead. When you're working with kids, explain specifically what you mean and where.

As a child learns to enjoy drawing, they'll want to do it more often and for longer periods of time. The most important rule for length of session and how often they should occur is flexibility—yours. Don't impose left-brained, adult rigidity on what should be a joyful, fun-filled activity.

Fun Drawing Exercises for Kids

Be as inventive as you can as you look back through the exercises in this book and adapt them for your young friends and family. We've done some of that for you, but don't let us stop you from coming up with some variations of your own as well.

➤ *For the very young*: Recognize and copy. Young children enjoy copying sets of shapes or lines. It's good practice for observing the differences and good for coordination, too.

➤ *After a while, try drawing with basic shapes.* Give the circle, oval, triangle, wedge, square, and rectangle a try. You can set up building blocks and then Lincoln logs in simple groups to serve as models.

➤ *For the older child, to help build a vocabulary of lines and textures, use a variety of simple lines.* Practice dots, straight lines, curves, jagged lines, spikes, spirals, and crisscrossed lines for different shapes, tones, and textures.

➤ *Mirror-image vase exercise.* Kids like the mirror-image vase/profile drawing from Chapter 2, "Toward Seeing for Drawing." Let them invent a simple profile for the vase.

➤ *Drawing without looking.* Review this exercise in Chapter 2, too, and try drawing a hand or a thing without looking.

➤ *Negative-space drawings.* Set up a simple chair, as in Chapter 6, "Negative Space as a Positive Tool," and try the negative-space drawing.

➤ *Upside-down drawing.* Try the upside-down drawing from Chapter 2, but pick a simpler subject to start, maybe a picture of an animal.

➤ *Drawing things that overlap.* Spatial relationships may take some time for a child to grasp. Try making a still life arrangement on a large piece of paper and draw a line around each object to show the space it needs.

➤ *Portraits and self-portraits.* Kids like to draw one another and themselves. Show them the simple proportional lines to arrange the features on a face. Then, hand them a mirror and see what happens.

Kids love to draw themselves—just look at these examples.

➤ *On the sliding glass door.* Drawing on a sliding glass door with dry-erase markers is a favorite with Lauren's classes. Take turns posing on the other side of the door, make still life arrangements on a stool, or draw chairs, boots, baskets, and boxes—maybe

even a bicycle—on the glass. Remember to close one eye to flatten the three-dimensional space and stay very still as you are working.

Here are some drawings kids drew on sliding glass doors. (Be careful when doing this exercise to protect kids from accidents; maintain good supervision at all times and make sure glass panes are marked with masking tape so kids won't mistakingly walk into them.

A Place for Everything: How to Start

Find a place to start, a basic shape, the center of something, the stem of something. Then, use the plastic picture plane or the viewfinder frame to help the child establish the center of the page and the center of the image.

For "Mistakes" or "Problems"

As much as you try to avoid even the language of mistakes, children, particularly older ones, will decide that something is wrong with their drawing. To encourage a creative solution, you can always

➤ Add something to the problem area, like texture.

➤ Change something that is a problem into something else.

➤ Transform something by looking at it differently.

➤ Rearrange something on a new piece of paper (use a window or a lightbox, for example).

Above All, Have Fun

Make the most of the time you have with a child. You will both benefit from the time together. The gift of seeing and drawing is one that a child will have and remember forever.

Your Sketchbook Page

Try your hand at practicing the exercises you've learned in this chapter.

The Least You Need to Know

➤ Children draw naturally, as we all did when life was simpler.

➤ Young children use symbolic stick figure drawings to explore, understand, respond to, and communicate about the world as they see it.

➤ A child can learn to draw realistically as he or she develops naturally and gradually abandons symbolic drawing.

➤ Older children need help to see and draw up to their expectations so that they don't become frustrated and give up.

➤ A protective, encouraging environment helps any child to feel comfortable and to be able to experiment. It's not bad for adults, either.

Decorate Your World

Culture will come when every man will know how to address himself to the inanimate simple things of life

—*Georgia O'Keeffe*

Your drawing subjects are limited only by your imagination. Travel, both overseas and to the local nature preserve, for example, can be enhanced by carrying a sketchbook along with your camera.

Then, there's decorating your world. Once you've learned to draw, you can create books of your own, or customize your home and your furniture.

This chapter is chock-full of suggestions for drawing, both on paper, and on some other surfaces you may not have thought of.

Have Sketchbook, Will Travel

We love to travel, and we love to see and draw whatever of interest comes along while we do. We don't really care where we are—Italian hill towns, ski villages in France, a nice tent site in the Rockies, a beat-up hotel off the coast of Maine, the western desert. With the changing landscape, up-close botanical details, still lifes there for the drawing, or vistas off in the distance, there is always a visual treat.

The Art of Drawing

Give yourself the time to enjoy the beauty of everything around you when you're on a trip. Take your sketchbook along and record the details of the landscape as well as the feelings you experience. Then, when you get back to home base, you can use some of your own drawings to decorate your world at home or work, and go back to those wonderful idylls again and again.

Try Your Hand

They say a picture is worth a thousand words, so use your drawings to amplify, identify, illuminate, direct, explain, or just plain decorate, whenever and wherever you can.

Using Your Own Images

Using your own drawings for other projects is when the real fun begins. Of course, drawing is for its own sake and should continue to be, but now you can use that skill and some of the drawings to personalize your world.

Drawings are a natural in the garden, greenhouse, or just a hello from a sunny window in the depth of winter. Treat yourself to a wonderful bouquet of flowers and draw it. Revisit a childhood love of wildflowers, or discover it now; go out and sketch them, from the delicately scented, early spring trailing arbutus to exotic lady's slippers and jack-in-the-pulpits.

Get down close and look at them, smell their scent, enjoy the splendor of spring, the flush of summer, and the ripeness of fall.

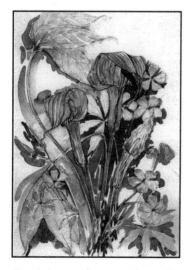 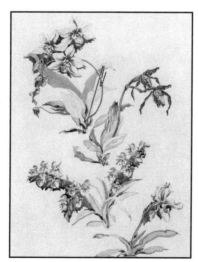 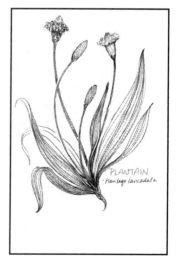

Don't just wake up and smell the flowers—get out and draw them, too.

Now, here's the best part: Once you've got an assortment of botanical drawings, you can use them to illustrate everything from recipes to your walls.

Trading Information: How-To's or Recipes

People are always swapping information, and you can add the visual to your explanations, for fun or even for profit. Illustrations help explain things that would otherwise be difficult or take too many words. How-to steps make any explanation easier to understand, whether in newspapers, magazines, guidebooks, brochures, and of course, in the world of nonfiction—there are how-to books and *Complete Idiot's Guides* on every subject there is.

Try *illuminating* or *illustrating* one of your favorite recipes. Make copies and hand them out to friends. Keep a copy of each as well; you may have the beginning of a manuscript!

Artist's Sketchbook

Illuminating and **illustrating** differ in an important way: Illumination is decoration, such as a border around words or a picture, while illustration shows the information itself in picture form.

Decorate your world by illuminating or illustrating a favorite recipe.

Try Your Hand

Drawing can dramatically speed the learning process and increase your powers of retention.

Illustrating an Idea or a Technique

To try an illustration of your own, begin by picking a subject you know well, such as a gardening technique. Then, follow these simple steps:

1. Write out the steps in detail to explain it to a beginner.

2. Add drawings to your explanation.

Even you will see how much easier it is to explain something with the addition of illustrations.

Now, pick a subject that you don't know much about, or an aspect of a subject you'd like to know more about. Do your research and write out your notes, but also add sketches, using the simple steps above, to help you learn the new material and really retain it.

How-to's become simple to follow with the addition of illustrations.

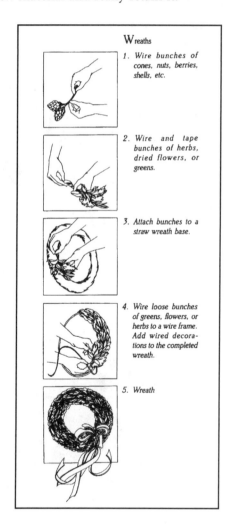

W reaths

1. Wire bunches of cones, nuts, berries, shells, etc.

2. Wire and tape bunches of herbs, dried flowers, or greens.

3. Attach bunches to a straw wreath base.

4. Wire loose bunches of greens, flowers, or herbs to a wire frame. Add wired decorations to the completed wreath.

5. Wreath

Illustrating an Idea

You can use your drawings to illustrate an idea or accompany anything from a collection of poems to a poster advertising an event you are volunteering for. Once you've gotten started, though, local charities and organizations will be beating down your door, so watch out!

The Nature Conservancy's Annual Benefit Dinner Dance

Donate your skills to local charities—illustrate flyers for community events.

The Story of You

At one time or another, we all seem to have tried our hand at writing a story, fiction or nonfiction, whether for a child, out of a specific interest, or because the muse visited and it had to be done. So, take the next step and illustrate it with your own drawings!

By now it should be clear that your life is just as interesting as the next guy's. Why not expand that journal of yours into a larger piece of illuminated work in a separate volume? Whether specifically for your travels or all about your family or your own life, your illuminated journal will grow to be something you'll treasure more and more as the years go by. Take it from two middle-aged gals who know.

Try Your Hand

Your local printer or business office will help you if you don't have a computer and scanner. Look at what they have posted as samples and decide what you want yours to look like.

Illustrate a story—yours or someone else's—with drawings. Here are a few to inspire you.

Illuminating Your Personal Life

Stationery, letterheads, postcards, and personal or business cards are great ways to decorate your world with your drawings.

Original art for black-and-white reproduction works well when it is reduced about 50 percent, so model your original according to what you have planned. Make a rough design to show placement of art and type, then look at your choices of type style. You can offer to make a set of whatever you create for a friend or family member as a most personal gift.

Greeting cards and holiday greetings and invitations to parties are other projects you can try with your own images. Even without a computer and scanner, you can make up a nice card front and have good black-and-white or color copies made at your local 24-hour printer to

fold into cards. Then, you can add your own handwritten greeting or you can write it out in a *calligraphic* hand on the art and make it part of the card.

If you do have a computer and scanner, you can read about using it with your own images in Chapter 25, "Express Yourself."

Reinventing Your World

As you go on with the reinvention of your world, why not start with the redecoration of your castle? Almost any corner of your house can take a little well-placed illumination, such as a flower here or there to cheer you during the winter, a bit of whimsy for a child's room, and in the kitchen, the easiest of all, an arrangement of fruit that never goes bad.

But you don't have to stop there when it comes to redecoration. Any surface can be the object of your newfound drawing skills, as you'll discover in this section.

Cabinets and Furniture

You can use your drawings as the basis for painting on cabinet doors or the drawer fronts of a dresser that needs help. For your first project, here are some simple steps you can follow.

1. Pick a simple stem and bloom or a length of vine with some leaves.

2. Make a photocopy of the drawing you intend to use and establish a color scheme with colored pencils. Keep it fairly simple.

3. Buy yourself enough colors in acrylic paint to mix the colors that you will need. If you'd like, look ahead to the section in Chapter 25 on color for some help.

4. You can transfer your drawing to a cabinet or drawer front by blackening the back of a copy of the drawing with your softest pencil and then taping it carefully and drawing over your drawing lines. The soft pencil acts like carbon paper (remember carbon paper?) and your outline is there on the surface, ready to paint. This will work for several passes, and then you might have to reapply the pencil or finish with another copy of your drawing.

You're sure to be pleased with the new look in your kitchen or spare room, or on your bathroom cupboard or old dresser.

Ceilings, Walls, and Floors, but No Driveways

You can apply this same procedure to a larger surface, either in a repeat pattern, such as a stenciled border around the top of a room, or you could get wild and paint a border on a floor that looks dull. Hey, you can paint the whole floor; it's your castle.

Artist's Sketchbook

Calligraphic writing is handwriting in a particular style, or font, often with a wedge-tipped pen called a calligraphic pen. *Chancery cursive*, like old manuscript text, or 𝕺𝖑𝖉 𝕰𝖓𝖌𝖑𝖎𝖘𝖍, more elaborate and stylized, are two styles you can try from a book or your word-processing software. You can type out your text, choose the font and size, and print it out as a guide, or you can simply use a calligraphy pen in your own handwriting for a nice effect.

Back to the Drawing Board

Be sure to practice how you will paint in the petals and leaves on a sample before you start on the furniture. Practice, as always, makes perfect, which is what you're after when you get to the real thing.

For repeated use, a stencil will be easier in the long run. You can use it for the basic shapes and fill the rest in freehand, looking at your sample as a reference.

To cut a stencil you will need some stiff paper, preferably stencil paper, and a sharp Exacto or mat knife.

1. Draw your design on the paper from your original sketch.
2. Remember that in a stencil the holes will fall out, so you probably need to redraw the parts of the drawing so they are separate. (Remember that stencils use negative space. A stencil of a chair would be a series of disconnected "holes" which wouldn't hold together, so a separate stencil is required for each part of the chair.)

A stencil can simplify a drawing.

Expanded Uses for Your Skills

As your confidence in drawing increases, you may want to take a look at still more potential uses. If you have a lifelong love of fashion, for example, you might want to try some clothing drawings. Or, if you're half as witty as we are, maybe a cartoon or bit of visual political satire will be just the thing. There's plenty of raw material, after all (pun intended). Maybe character studies appeal to you. Or, if it's a flight of fantasy that does it for you, whatever it is, give it a try.

There are books specific to each of these expanded uses, and many more. Look carefully to make sure that the book really shows you things you want to know and is not just a showcase for the artist/author. You'll find some of our suggestions in Appendix B, "Resources for Learning to Draw."

Focus on Fashion

Details, stylization, and stretched proportion are the differences between drawings of people and fashion drawings, along with the fact that while you draw for yourself, fashion drawings are drawn for use commercially. You get paid to do them!

If this type of drawing interests you, begin by studying the fashion drawings in newspapers and magazines to develop an eye for the kind of style that is "in" at the moment, the details that look contemporary, and the degree of "distortion" in the proportion. Evaluate proportion by measuring by the number of heads in the total body height as you did in

Chapter 21, "The Human Body and Its Extremities." When you're doing fashion drawing, there are more "heads" in the total height, that's all—mostly in the legs, for that leggy model look. Practice until you develop a style that pleases you.

Fashion isn't just about clothing, either—look at the detail in this fantasy dragon, just perfect to be embroidered on a couture runway gown.

Cartoons: Humor or Opinion?

How funny are you? Are you an opinionated type? You might be a cartoonist in disguise. Cartoons are great drawing practice, and you don't have to have a lot of skill, as many of today's cartoons reveal. The trick with humorous cartoons like comic strips is consistency, making your characters look the same from frame to frame.

With political cartoons and caricatures, it's a matter of discerning your subject's most prominent feature and then exaggerating it for recognition. Studying the masters can help you see how this is done—from George W. Bush's ears to Al Gore's hairline.

That Twisted Look: Caricatures

If you do have an eye for facial features and how to push them or exaggerate them, drawing caricatures is a possibility. You can look forward to a future at county fairs, or you could move to Paris and set up along the Seine.

Further Out: Your Fantasies

There is nothing that, with a twist of imagination, cannot become something else.

—William Carlos Williams

Some of us are just not content with reality. Why, after all, should reality be the only option? Your fantasies or fantasy worlds are places you can go with your drawings. Just don't forget your sketchbook.

Your Sketchbook Page

Try your hand at practicing the exercises you've learned in this chapter.

The Least You Need to Know

➤ Now that you can draw, why live in a world without your own personal touch?

➤ Illustrations, developed from drawings or done for a specific purpose, can decorate, explain, expand, reflect, or accompany anything.

➤ Presents and cards are among the uses for your drawings.

➤ Decorate your house and world, but do yourself a favor and stay away from the driveways.

➤ Try your hand at expanded uses for your drawing skills as your own interests and tastes lead you, but do some real drawing, too.

Express Yourself

In This Chapter

➤ The wonderful world of color

➤ Care and feeding of your drawings

➤ Art enters the digital age

➤ Arty computer programs and classes

Art is a form of supremely delicate awareness, meaning at oneness, the state of being at one with the object.

—D.H. Lawrence

So, you have amassed quite a collection of drawings by now.

Maybe you're getting interested in trying something a little more involved. Some images of your own might be popping into your minds' eye ... or eye's mind (we never get those two straight).

Now you can begin to consider the wide range of materials and techniques to make paintings or colored drawings. There are endless ways to infuse your work with your own personality and particular way of seeing the world, and color is one of the more interesting ones.

In addition, we'll show you how to care for your work, including framing options. And we'll take a quick look at computer art programs as well.

The process, not the end work, is the most important thing for the artist.

—Georgia O'Keeffe

Moving Into the Realm of Color

There is nothing—no color, no emotion, no idea—that the true artist cannot find a form to express.

—Georgia O'Keeffe

Do you remember the first time you saw a color television? Do you remember that Walt Disney's "The Wonderful World of Color" was originally created to showcase material for color television? It's hard to imagine now, but the move from black and white to color television was a very big deal back in the late '50s. And in 1939, when Judy Garland first opened the door of her Kansas farmhouse into the Land of Oz, the color was a revelation—to her, to Toto, and to us.

Moving into the realm of color in your drawing is a big deal, too. But never fear—we're here to help, with suggestions for everything from materials to matting.

Some Brief Words on Color

I paint because color is significant.

—Georgia O'Keeffe

This is yet another pearl from O'Keeffe, and so it is. Each day of your life is filled with shapes and colors, the weather, the seasons, the places you go, and the things that you see, so add some of that color to your drawings.

As with most parts of this book, a whole book could be written on color, and fortunately, many have been. Along with your own experimenting, it's probably worthwhile to read and study a few of them.

Before you jump, spend some time reading and looking at colored work that you like. Take a good look at color charts, in books and in art stores. Get familiar with the spectrum of colors: the burst of reds, the range of yellows, the forest of greens, the sea of blues, the wealth of purples.

New Materials You Could Try

Colored pencils and water-soluble colored pencils and crayons are a great and painless transition into the world of color. After all, you've already gotten comfortable with a pencil, so adding color is easy! They mix and blend to make any color you can come up with.

Back to the Drawing Board

As you begin to look at colors, do yourself a favor and stay away from the pile of browns. You will find that in learning to mix colors you end up with plenty of them anyway.

Other options in the field of color are

➤ Water-based crayons.
➤ Pastel pencils.
➤ Pastels.
➤ Oil pastels.
➤ Watercolors.
➤ Acrylic or gouache.
➤ Pen and colored inks.

Each of these media has its own characteristics, advantages, and challenges; practice will allow you to develop a feel for them. And, if you're interested in learning about any of them in more detail, we've suggested some books you might like in Appendix B, "Resources for Learning to Draw."

Into the Field of Color

Buy yourself the largest set of colored pencils that you can afford. Is your birthday coming? Even if it's not, no matter, get the big set anyway. Small sets have mostly bright primary colors and fewer subtle colors, and you'll want to play with both.

Primary colors are those that cannot be mixed from other colors:

➤ Red

➤ Yellow

➤ Blue

Secondary colors are those that can be mixed from two primary colors. The secondary colors are

➤ Orange (made from red and yellow).

➤ Green (from yellow and blue).

➤ Purple (from blue and red).

Tertiary colors are another step out on the color wheel, made from a primary and a secondary color. They are a group of lovely muted shades and neutral colors that you'll want to get to know.

Colors across from each other on the color wheel are called complimentary colors; they work well with each other. If they are mixed, they make neutrals. Colors that compliment each other are

➤ Red and green.

➤ Blue and orange.

➤ Purple and yellow.

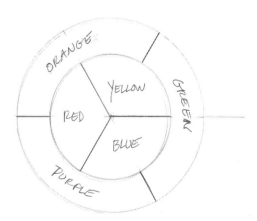

This color wheel is in black and white, but you can use your imagination to visualize the colors.

Blended colors are a mix of two or three colors or two complimentary colors—opposites on the color wheel.

Earth tones and shadow colors are mixes of complimentary colors like purple, with a little yellow to soften it, or a brick red made with green. You will end up with plenty of browns and earth colors, and you can make various grays and blacks by combining four colors, excluding yellow.

*The range of compli-
mentary colors from
warm to cool.*

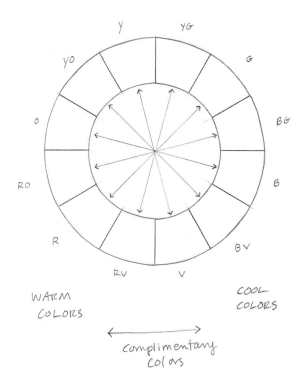

Taking a Stab at a Colored Drawing

Use good paper. The best is 140-lb. hot-press watercolor paper, and 90 lb. is fine for sketches. If you foresee adding water to the water-soluble pencil sketch, however, the heavier paper will work better.

You will find that you can very naturally grab a handful of colored pencils and start in on a simple arrangement.

➤ That fistful of colors is important. Keep switching colors.

➤ Look at each object and see the range of colors you can use, or the layers you can build up to get a tone and a color.

➤ It takes time, but it's fun to see the color happen along with the drawing.

If you want to learn more about any of the colored media, take a class. They're fun and you can learn a lot about color and techniques for handling the various media. You'll be glad you did.

Caring for Your Work

Generally speaking, use the best materials you can, take yourself and your efforts seriously, present your work simply so it can stand on its own, take care of what you don't frame, and the archivists and art historians of the future will thank you. Caring for your work now means your children, grandchildren, and even your Great-great-great grandchildren will have it hanging on their walls (even if they'd rather have it in their closets).

Try Your Hand

To learn about color, make yourself lots of small tonal charts for the colors you have. Try for gradations of tone in an individual color to see what it does, and mixed colors in a variety of tones. Be sure to label the charts so you know how you made a color that you like.

Whether it's storage, matting, or framing, here's some of the best information you'll find for taking care of your drawings after the drawing's over.

On Storage

You've spent a lot of time on your work, so treat it right when you're finished, too. Portfolios keep your work safe, clean, and flat, as it should be. Paper storage drawers are expensive and take up space, but they're well worth it if you've got the money and the room.

The important thing is to store your work somewhere where it will be kept in its natural state: flat. In addition, you'll want to keep it away from damaging sun rays and—even more damaging—water, so next to the garage window or in the basement next to the sump pump are probably *not* the best places.

Matting and Framing

Less is more. Simple is as simple does. White is right. Art, or its mat, should not be expected to match the couch.

In other words, forget the fuschia or lime green mats to match the flowers on the rug. Your work will look best in a simple white or off-white mat and a simple wood frame that can be more or less the color of the other woods where you plan to hang it. The important thing is that the choices help the drawing; it will find its place on the wall.

Try Your Hand

Start with a light color for your planning lines. Lavender works very well because it blends into almost any color, and it can become a shadow if the lines are outside your objects as you define them more closely.

Turning a New Page: Fine Art Meets Tech Art

To: Theovg23@aol.com

From: Vincentvgo@hotmail.com

Arles is bleak, and the blasted mistral keeps me indoors. I go days without speaking a word to anyone. Thank you for the money. With it, I bought a blazing tangerine iMac, which I am E-mailing you on right now. You were right, the Hotmail account was very simple to set up and free, so I can still survive on five francs a day.

—Noah Baumbach, "Van Gogh in AOL," *The New Yorker*

Can you imagine Vincent with an iMac? He probably would have felt more connected and maybe less troubled. One thing's for certain—the high-tech world is having an effect on almost everyone. You can run but you can't hide, so jump in—you might like it more than you ever imagined.

Creating a Virtual Sketchbook

Creating a virtual sketchbook is as simple as a few peripherals for your computer—a scanner and a color printer. Which scanner and printer you buy will depend on both your budget and your desires. We leave it to your local big-box computer store to help you with the myriad choices, but we can help you with the basic how-to's once you've got your equipment.

Scanning Your Images

Most flat scanners are designed to read images up to $8\frac{1}{2}" \times 14"$, so if your drawings are larger than that, you'll have to scan them in sections. The process may be unwieldy and the results, less-than-desirable reproductions of your drawings. If you've been doing a lot of your sketching on the road, though, you probably did so in a small enough sketchbook.

Is there a drawing that you particularly like? Start with that one. Tear it carefully from your sketchbook and then lay it flat on your scanner and scan it in (you'll need your manufacturer's instructions for this, and there's no way we can help you with those).

After you've scanned your image, the program will ask you to save it. Give it a name you'll remember it by: "Laguna Sunset" or "Fisherman on the Gila" are two good examples.

Now, you can look at your work with the imaging program that came with your scanner, or, if you decide you don't like that program, another that you've downloaded off the World Wide Web. One of the things that you can do, once the image of your drawing is saved to your computer, is manipulate it. That means you can erase those extra scribbles in the corner without fear of going through the paper, or you can add some lines to the fisherman's face. Don't get carried away, though—we think real drawing's a lot more fun than virtual drawing.

Printing Your Images

You can also print your images, of course, once you've scanned them into your computer and saved them. If your drawings are in black and white, you won't even need a color printer. Even the popular—and inexpensive—bubble-jet printers do a great job with *graphic images*, which is what your drawing is.

E-Mailing with Your Own Art

Now that you've got it on your computer, you may want to e-mail your art to all your friends. So long as attachments are an option with your particular e-mail, e-mailing your art is simple: Save it as a small .jpg file, add it to your e-mail as an attachment, and then write your note. Poof! Off it goes to annoy one or all of your friends—just like all the jokes that they've already seen three times.

Creating Your Own Illustrated Home Page

To: Theovg23@aol.com

From: Vincent2@VanGo.com

I've started to work again. Check out my home page (and note new address). I designed it with a soft malachite green, a fiery iMac raspberry and a troubled Prussian lilac. I may've mastered the brushstroke and HTML, but am a novice with Java. There's always more to learn.

—Noah Baumbach, "Van Gogh in AOL," *The New Yorker*

There are classes in HTML and Java, two of the most popular Web languages, and there are editorial programs that make it much easier to create a Web site of your own. You can also customize the home page on your Internet program. One example to take a look at is Lauren's home page, the first page of her Web site at www.laurenjarrett.com. Check it out!

Creating your own illustrated home page is now as simple as following the instructions your e-mail provider probably has set up on your ISP home page. You don't even have to know any special programs anymore; the directions will walk you through it all, including how to download the art you've scanned and saved onto your own illustrated home page.

If you're interested in something truly professional-looking, however, we'd highly recommend a Web designer. You get what you pay for, after all.

How to Learn About Drawing on the Computer

We may be the old-fashioned, middle-aged artist/teacher types—although we are anything but old-fashioned or middle-aged—but we think you should do your drawing first, and then scan it.

You will not really learn to see and draw anything on a computer. Sure, you can make pictures, but it's just not the same as direct hands-on drawing.

Drawing with a mouse or stylus and art pad is not the same as drawing with a pencil. There is not the same connection when you can't look at the hand that's drawing and see what's going on. In addition, the feel of a fine piece of paper and the internal dialogue that you have while you're relating to your subject, seeing, and drawing are basic pleasures, time for your inner self, and the path to your own unique creative soul.

Computer Art Programs You Can Learn

Now then, the tirade is over. Computer graphics programs are a different story, because they are a way of using your drawings after you have made them, for everything from cards, presents, posters, and all kinds of commercial uses, should you be so inclined.

Adobe Photoshop and Quark are two great programs for using art. Lauren uses one or the other for everything, and they're well worth the time to learn. Photoshop can do anything you can think of to an image, or montage of images, with or without type. Quark is the favored layout program, but you can use PageMaker as well. Adobe Illustrator uses imported art, too, but it has more bells and whistles.

There are lots of other art and graphics programs available for Macs or PCs. You can draw with a mouse or a stylus and art pad, using the shapes, colors, graphics, and special effects of programs like Canvas, Paint, Appleworks, and SmartDraw, to name a few. In addition, there are specialized programs, such as AutoCad for architectural, landscape, and mechanical rendering; 3-D and special effects programs; and the many programs for Web design and interactives. Take your pick. They all have huge manuals, but you can do it if you try. We admit to being Luddites, and so we stick to the programs that work for us.

Artist's Sketchbook

Graphic images on your computer are any images that are not text-based. Different images have different suffixes (those are the letters that appear after the dot on a filename, including .jpg, .ipg, .bmp, .gif, and many others). Graphic images also take up a lot more memory on your computer, but if you've got a current model, you won't need to worry about them using up your available memory for years, if ever.

The Art of Drawing

Consider private tutoring if you can manage it, or maybe you can share a tutorial with a friend who is also interested, to halve the cost. You will learn much, much faster in a private tutorial. It's like having a personal trainer!

How to Choose a Computer Art Class

There are more and more computer classes out there, with the usual brochures and course descriptions to wade through, including schedules, prices, credits (if you care), and residual computerese (language designed to confuse you) to deal with and experience. Specific courses for complicated graphics programs like Photoshop, Quark, or Illustrator are very helpful places to start.

Our advice:

➤ Ask around. Chances are, someone you know (or their cousin) has already taken the course and can comment.

➤ Find out the instructor's name, and decide if the course material, time, place, and fee are acceptable.

➤ Call the instructor, and make sure you will learn what you want to learn.

Our final word on the high-tech world is that it really is a great tool. Think of it that way and you will learn it and use it properly. Lauren's computer, scanner, printers, copy machine, and fax take up a whole wall in what is otherwise a painter's studio, but hey, we all have to make a living and the two sides coexist quite well. Lisa's computer is her main tool, aside from her old Underwood manual and assortment of notebooks and pens for all occasions, so it gets to live in her way, smack in the middle of her desk.

Do yourself a favor and learn to draw, if that is what you want to do. Then worry about what to do with the drawings later.

Your Sketchbook Page

Try your hand at practicing the exercises you've learned in this chapter.

The Least You Need to Know

➤ After all this drawing, you can begin to think about making some personal images or more elaborate pieces.

➤ Color is a wonderful thing.

➤ Take the time to care for your work. It is part of taking yourself seriously.

➤ Simple matting and framing best sets off your work. You don't have to match the couch.

➤ The high-tech world is upon us. Don't get caught without it.

The Artist's Life

In This Chapter

➤ Artists on their work

➤ A walk through the museum

➤ Taking the Zen path to drawing

➤ Inspiration is where you find it

Paintings must be looked at and looked at and looked at—they, I think, the good ones, like it. They must be understood and that's not the word either, through the eyes. No talking, no writing, no singing, no dancing will explain them. They are the final, the 'nth whoopee of sight. A watermelon, a kiss may be fair, but after all have other uses. "Look at that!" is all that can be said before a great painting, at least, by those who really see it.

—Charles Demuth

In this chapter, we'll be finding out where artists discover their inspiration—and we'll let them tell you in their own words. If you draw for any length of time, you'll soon discover that finding the muse is the easy part; it's paying attention that's a bit more difficult.

Artists also get their inspiration from other artists, and we'll be exploring museums as well. With all this artistic inspiration, you'll be ready to venture out into the world as an artist yourself. Happy trails.

The good picture—No one wonders at it more than the one who created it.

—John Marin

Following the Muse

She's out there all right, that muse the poets are always looking to for help with a rhyme. If you draw regularly and sincerely, she's bound to pay you a visit, too. She can take different forms, but you will know she's there and what she wants of you. And you'll soon discover that you had better pay attention when your muse speaks to you.

Where Artists Find Inspiration

Every artist—whether visual, written, musical, or kinesthetic—knows what it's like to be inspired. While explaining that inspiration is difficult, Lauren has collected a group of wonderful words from artists who really do explain what it's like to be inspired in their own particular ways. Your own inspiration will be as individual and unique as each of these artists'.

My adoration of the great ancients who laid the indestructible, immutable foundations of art for all time shall never dim or tarnish. Their legacy has always been and will always be my spiritual refreshment and renewal. The great ancients worked with God. They interpreted and embodied the glory and wonder of the elements. The moderns work with geometry.

—Max Weber

True art cannot spring but from naivete. Everyone has been a child, and the true artist is the one that has preserved intact all those treasures of great sensitivity felt in early childhood … Time goes on, but the first songs ever sung by nature always sing on in his soul.

—Joseph Stella

The most important thing about a river is that it runs downhill. Simple, isn't it? Art is produced by the wedding of art and nature. Go look at the bird's flight, the man's walk, the sea's movement. They have a way to keep their motion. Nature's laws of motion have to be obeyed and you have to follow along. The good picture embraces the laws, the best of the old did, and that's what gives them life.

—John Marin

Science and art are indeed sisters, but they are very different in their tastes, and it is no easy task to cultivate with advantage the favor of both.

—James M. Dunlop

What They Have to Say About Their Work

Artists are pretty chatty types, for people working in a language without words. In fact, maybe that's why they're so talkative. Or maybe they prefer to write about their work so some art historian doesn't come along and do it for them. Here's what some of them have to say about their work, and what they believe.

My work has been continuously based on a clue seen in nature from which the subject of a picture may be projected. Nature, with its profound order, is an inexhaustible source of supply. Its many facets lend themselves to all who would help themselves for their particular needs. Each one may filter out for himself that which is essential to him. Our chief object is to increase our capacity for perception. The degree of accomplishment determines the caliber of the Artist.

—Charles Sheeler

I grew up pretty much as everybody else grows up … and one day I found myself saying to myself … I can't live where I want to … I can't go where I want to … I can't even say what I want to … School and things that painters have taught me even keep me from painting the way I want to. I decided I was a very stupid fool not to at least paint as I wanted to and say what I wanted to when I painted, as that seemed to be the only thing I could do that didn't concern anybody but myself … and that was nobody's business but my own … I found I could

say things with color and shapes that I couldn't say in any other way … things I had no words for.

—Georgia O'Keeffe

My aim is to escape from the medium with which I work. To leave no residue of technical mannerisms to stand between my expression and the observer. To seek freedom through significant form and design rather than through the diversion of so-called free and accidental brush handling. In short, to dissolve into clear air all impediments that might interrupt the flow of pure enjoyment. Not to exhibit craft, but rather to submerge it, and make it rightfully the handmaiden of beauty, power, and emotional content.

—Andrew Wyeth

An artist must paint, not what he sees in nature, but what is there. To do so he must invent symbols, which, if properly used, make his work seem even more real than what is in front of him. He does not try to bypass nature; his work is superior to nature's surface appearance, but not to its basic laws.

—Charles Burchfield

There was a long period of searching for something in color which I called a "Condition of Light." It applied to all objects in nature, flowers, trees, people, apples, cows … To understand that clearly, go to nature, or to the Museum of Natural History and see the butterflies. Each has its own orange, blue, black, white, yellow, brown, green, and black, all carefully chosen to fit the character of life going on in that individual entity.

—Arthur Dove

The Art of Drawing

It does not bore me to write that I can't paint a pawtreet [sic]. On the contrary it is the greatest joy in life—but I prefer writing it to you rather than the lady, if you will be good enough to tell her that I have retired from the business. Tell her that I now only paint landscapes and religious decorations, that I am a waltzer to delirium tremens or whatever you think may make her congratulate herself on her refusal. I really am shutting up shop in the portrait line.

John Singer Sargent

I like to seize one sharp instant in nature, imprison it by means of ordered shapes and space relationships to convey the ecstasy of the moment. To this end I eliminate and simplify, leaving apparently nothing but color and pattern. But with these I attempt to build an organic whole—a canvas which will stand independently. If I capture too some of the beauty, mystery, and timelessness of nature I am happy.

—Milton Avery

The love you liberate in your work is the only love you keep.

—*Maurice Prendergast*

Museum Walks

There is nothing as nice as a day in a museum, a day full of visual stimulation and the company of the masters, old or new. Museums are also great places for a date, or an affair, or a date with an old affair—not that either one of us has done that, of course.

Try Your Hand

Mr. Homer, do you ever take the liberty in painting nature of modifying the color of any part? Never! Never! When I have selected a thing carefully, I paint it exactly as it appears.

Winslow Homer

The Wealth of Museums

In the museum, it's all there for the looking—rooms and rooms and long halls and hidden corners filled with forgotten gems.

Go and look at drawings, paintings, sculpture, jewelry, objects, furniture, fabric, costumes, china, and more. You won't want to overdo it, so decide what you want to see and then stop before you get overwhelmed.

Then there are all the specialized museums, such as natural history museums and science museums, full of specimens—huge skeletons and dioramas of tiny little nocturnal animals you would never see outside of a museum. There are plants, too, and birds and butterflies enough to last you into the next millennium.

Styles of Drawing Through History

Styles of drawing through history; yikes, we could write forever on that one. Just go to the museum and look, then do it a few dozen more times and you will have a rough idea about styles of drawing through history.

You will see how artists have developed

➤ from the early cave drawings,

➤ to the flattened drawings attempting three-dimensional figures done by the Egyptians,

➤ to the very realistic sculpture done in ancient Greece (by folks who could certainly draw well),

➤ to the more primitive, flat religious images produced in the Middle Ages,

➤ to the interest in perspective and shape in the Renaissance, and

➤ to the fine attention to detail in Flemish paintings by the Old Masters, the strict tradition of studio work in the Classical Period.

Then, the Barbizon artists started painting outside of all things, and the first dissension occurred when the Impressionists started breaking loose. Then there was the heyday of Post-Impressionists, including the Nabis, Fauvists, Cubists, Expressionists, Dadaists, and all the rest of the ways that artists decided to explore and express, right into our recent century and the one we just entered, including the most recent versions of old schools and the "shock of the new."

It's a lot to see!

The Art of Drawing

Art history books will put particular drawings into historical context and add interesting information about the artist or the period or the various schools of thought at the time. But don't take our word for it, take the word of a wonderful painter, Charles Demuth. "Look at that!" is all that can be said before a great painting, at least, by those who really see it.

Learn by Looking, Then Try a Copy

Museums put the benches there just for you—yes, you, with the sketchbook. Go sit down on that nice bench in front of a piece of art that you like. Make yourself comfortable—the benches aren't, but who cares, you could even take a pillow. You can learn from just looking, but get out your pencil and draw what you like or what you want to remember, the diagonals in the composition, the shape of a tree, how a flower was drawn, the features of a portrait—whatever you like, you draw.

Drawing from sculpture or objects is better practice in three-dimensional drawing. That beautiful torso, imposing warrior, or delicately shaped vase is there in space and presents you with a lifetime of potential drawing. Some possibilities:

➤ Arrange yourself for simple views and then try more challenging ones with foreshortening.

➤ Draw parts of figures and the whole.

➤ Draw the details in a set of armor or the looming figures on a crypt, the subtle proportion of a Ming vase, or the scrollwork on a Japanese table.

The more you draw, the more you will see to draw. It may begin to seem as if you can never go home again.

What Do You Like?

By now, you have developed some opinions along with your sore butt. You may not know all there is to know about art, but you know what you like. Some work will pull you back every time you go, while others become part of your visual memory. No matter what, everything has its place.

Sharing Your Work

Another thing that's probably happening by now is that you're feeling pleased with your efforts and your growth from a beginner to a developing draftsman. Chances are your friends and family have seen your work and have perhaps gotten a little interested themselves.

Back to the Drawing Board

Don't be afraid to submit your sketches to other publications if you think they are applicable for the style and content of the publication. You never know, and you can't win if you don't play.

Now, you can begin to share your enthusiasms, your experiences, and your work with the rest of the world. Someone else may do the same for you: What goes around comes around, and all of us will benefit.

Most towns have art groups, art classes, maybe a small museum or community center that shows art, discussion groups, guest lectures, school programs, visiting artists, and local fairs that include art exhibits. It's your choice—whether to join, how much time to spend, should you volunteer or just look—but you do usually get something out of participation in community events. But you won't know unless you try. Here are some possibilities.

To Show, to Publish, or Just to Draw

Sometimes you just need to get out of the house with your work to get a better look at it and where you want to take it next. The white walls of an exhibition hall can allow you to see your work differently, for better or worse. Even if the experience sends you back to the drawing board, you will have learned something and can go on from there.

Publishing your work is a thrill in itself. There's nothing like the printed page and that credit line underneath your image. Start with your local paper if you have landscape or wildlife sketches that might work as decorative spots, or if you have developed a cartoon style or have taken up caricatures of the locals.

All this diversion is fun, but try not to let yourself get diverted from the real business of seeing and drawing every day. It takes a long time to learn how to draw well, and, though you may have come a long way, there is still a long way to go. Trust that it is a good road, and take the time to go there.

Take a Path to the Zen of Drawing

The peace and serenity you can gain from drawing is perhaps the best reason for simply attending to seeing and drawing. We live in a world that is too focused on achievement and not enough on centering and introspection.

Give yourself the gift of balance and oneness with your work and the world. Do your drawing with nothing else in mind but the relationship you are experiencing between your subject, your work, and yourself. The timelessness and serenity is its own very deep reward.

Express Yourself.

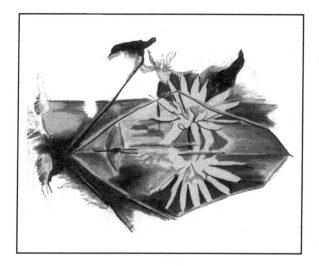

Encourage and Support Your Creativity

Remember to always support your own process, feed your own spirit, and nourish your creativity as the special part of you.

You are the one who has to deal with the outside forces, make time amidst all the distractions, ignore the demands for your personal time, and those who try to discourage your efforts.

Then, too, there is Old Lefty, who's still out there, waiting for his chance, but you know what to do with him by now.

Knowing When to Push Yourself Higher

We know well how difficult the balancing act that is life in the twenty-first century is: supporting one's own creativity, finding the time for work, taking one's work seriously, feeling the peace from the time spent, the satisfaction from the learning and the accomplishment, and yet constantly striving for more.

Remember, no matter what, that you are your own best critic and fan, alternately and at once. Trust yourself, your inner voice, and your instincts, and banish those critical voices where they belong—hung out to dry with Old Lefty.

One Inspiring Tale to End

A recent interview on NPR was with Harry Shapiro, who, at 100 years old, is painting full time. He came to the United States from Russia in 1905 at 5 years old, and grew up in New York, where he was an avid student of American history and took art classes. Shapiro became an illustrator/commercial artist, but has always painted on weekends and vacations. During his interview, Shapiro spoke in a clear, melodic voice about painters he admires and his commitment to painting. He has never had a major illness and believes "art and music preserve life," as well as "a heart full of love." He "works with some urgency now," and would like another four or five good years of work to "do some good paintings to sum it up."

I know there is a God in some form.

I paint to make things whole.

—Harry Shapiro

You don't get better than that. Thank you, Harry.

With Our Best Wishes

We have both enjoyed researching and writing this book. Besides the fun we have had "our own selves," we've also found pleasure in developing the ideas for the book, trying out the exercises, and writing and honing the text and the directions. Watching it become a book was a pleasure.

Lauren has enticed her friends over to "draw for their dinner" to make some of the drawings for the book (she is a good cook), and worked with her mother's drawing group for some of the others. Still other drawings and responses come from her classes, and she found a few old treasured pieces, hidden away in her file drawers.

Lisa has enlisted her daughter to make a few drawings around her house so both sides of the country are represented. As her daughter was temporarily camped out with her during the writing of this book, it was only fair.

We hope you enjoy this book for a while and dip back into it whenever you want an idea, a tip, some encouragement, or some of our soon-to-be-world-famous wit.

We leave you with the best set of guidelines we know: Be well, be happy, encourage yourself. Try to follow them, and you'll soon be guiding others as well.

The Least You Need to Know

➤ The world is your oyster. Draw it.

➤ Time and tide wait for no man (or woman). Draw it now.

➤ A rose is a rose is a rose, until you start to draw it.

➤ Love the world in your drawing and in all your work, and the world will love you back.

Your Artist's Materials Checklist

For Your At-Home And Portable Drawing Kit

Paper, in a Variety of Types

➤ Newsprint
➤ General drawing paper in pads or sketchbooks
➤ Bristol board
➤ Watercolor paper

Drawing Utensils

➤ Mechanical pencils in various hardnesses and leads
➤ Drawing pencils in various hardnesses
➤ Charcoal pencils, and soft-charcoal sticks and paper stomps
➤ Spray fixative
➤ Conte crayons
➤ India inks, dipping pens, brushes
➤ Drawing and technical pens
➤ Dry-erase markers and permanent markers

For Exploring Color

➤ Colored pencils and water-soluble pencils
➤ Oil pastels and crayons
➤ Colored markers
➤ Pastel pencils and soft pastels
➤ Watercolors, gouache, and acrylic paints
➤ Water-based crayons

Nice Necessities

➤ Erasers
➤ Drawing board

➤ Artist's tape
➤ Ruler
➤ Clips
➤ Pencil sharpener(s): manual, electric, and battery-operated
➤ Viewfinder frame
➤ Plastic picture plane
➤ Your sketchbook journal

For Your Studio

➤ Adjustable drawing table
➤ Comfortable office-style chair
➤ Extendable goosenecked architectural lamp
➤ Small freestanding bookshelf
➤ Supply cart on wheels (a taboret)
➤ Tackboard
➤ Computer, printer, and scanner
➤ Filing box
➤ Portfolio
➤ Set of paper storage drawers

Resources for Learning to Draw

Bays, Jill. *Drawing Workbook*. Devon, England: David & Charles, 1998.

Box, Richard. *Drawing for the Terrified*. Devon, England: David & Charles, 1997.

Brookes, Mona. *Drawing with Children*. New York: Jeremy P. Tarcher/Putnam, 1996.

Calder, Alexander. *Animal Sketching*. New York: Dover Publishing Co., 1973.

Cameron, Julia. *The Artist's Way*. New York: Jeremy P. Tarcher/Putnam, 1992.

Codniat, Raymond. *Twentieth-Century Drawings and Watercolors*. New York: Crown Publishers, Inc., 1968.

Crispo, Andrew. *Pioneers of American Abstraction*. New York: The Andrew Crispo Gallery, 1973.

Crispo, Andrew. *Ten Americans—Masters of Watercolor*. New York: The Andrew Crispo Gallery, 1974.

Draper, J. Everett. *Putting People in Your Paintings*. Cincinnati, Ohio: North Light Publishers, 1985.

Edwards, Betty. *Drawing on the Right Side of the Brain*. New York: Jeremy P. Tarcher/Putnam, 1999.

Frank, Frederick. *The Zen of Seeing*. New York: Vintage/Random House, 1973.

Frank, Frederick. *The Awakened Eye*. New York: Vintage/Random House, 1979.

Gedhard, David and Phyllis Plous. *Charles Demuth*. Berkeley: University of California, 1971.

Harding, J.D. *Lessons on Art*. London: Frederick Warne & Co., 1915.

Hinchman, Hannah. *A Trail Through Leaves: The Journal as a Path to Place*. New York: W.W. Norton, 1999.

Hoagland, Clayton. *The Pleasures of Sketching Outdoors*. New York: Dover Publishing, Inc., 1969.

Hultgren, Ken. *The Art of Animal Drawing*. New York: Dover Publications, Inc., 1993.

Larkin, David. *The Paintings of Carl Larsson*. New York: Peacock Press/Bantam Books, 1976.

Levy, Mervyn. *The Artist and the Nude*. New York: Clarkson Potter, 1965.

Nice, Claudia. *Creating Textures in Pen & Ink with Watercolor*. Cincinnati, Ohio: North Light Books, 1995.

Parramon, Jose M. *Drawing in Pencil*. New York: Watson-Guphill, 1999.

Partington, Peter. *Collins Learn to Draw—Wildlife*. London: HarperCollins, 1995.

Perard, Victor. *Sketching Landscape*. New York: Pitman Publishing Corporation, 1957.

Petrie, Ferdinand. *Drawing Landscapes in Pencil*. New York: Watson Guphill, 1979.

Pincus-Witten, Robert. *Georgia O'Keeffe—Selected Paintings and Works on Paper*. New York: Hirschl & Adler Galleries, 1986.

Pisano, Ronald. *William Merritt Chase*. New York: M. Knoedler & Company, Inc., 1976.

Raynes, John. *Drawing the Figure*. Cincinnati: North Light Books, 1997.

Rines, Frank M. *Drawing in Lead Pencil*. New York: Bridgeman Publishing, 1943.

Robertson, Bruce. *Collins Learn to Draw—Countryside*. London: HarperCollins, 1999.

Selz, Jean. *Nineteenth-Century Drawings and Watercolors*. New York: Crown Publishers Inc., 1968.

Slatkin, Regina Shoolman. *Francois Boucher in North American Collections*. Washington D.C.: National Gallery of Art, 1973.

Sloane, Eric. *An Age of Barns*. New York: Dodd, Mead & Company, 1985.

Stebbins, Theodore E. *American Master Drawings and Watercolors*. New York: Harper & Row Publishers, 1976.

Sternberg, Harry. *Realistic, Abstract Art*. New York: Pitman Publishing Co., 1943.

Thoreau, Henry David. *Walden*. New York: Holt, Reinhart, and Winston, 1961.

Turner, Elizabeth Hutton. *Georgia O'Keeffe, The Poetry of Things*. Washington, D.C.: The Phillips Collection, 1999.

Tiner, Ron. *Figure Drawing Without a Model*. Devon, England: David & Charles, 1992.

Vallery-Radot, Jean and Maurice Serullaz. *Drawings of the French Masters*. New York: Bonanza Books/Crown Publishers, 1962-1964.

Van Gogh, V.W. *Vincent Van Gogh, Paintings and Drawings*. Amsterdam, Netherlands: NV't Lanthuys, 1970.

Wadley, Nicolas. *Michelangelo*. Middlesex, England: Spring Books, 1965.

Wadley, Nicolas. *The Drawings of Van Gogh*. London: Hamlyn Publishing Group Ltd., 1969.

Weiss, Harvey. *Pencil, Pen, and Brush*. New York: Scholastic Books, 1961.

Wiffen, Valerie. *Collins Learn to Draw—Still Life*. London: HarperCollins, 1999.

Woods, Michael. *Landscape Drawing*. New York: Dover Publications, Inc., 1989.

Drawing Glossary

al fresco Italian for "in the fresh air;" it is the term for doing things outside—including drawing, of course.

artists' studios range from converted closets to converted guest houses. Where you put your studio depends on where you have room, of course, but its individuality can be whatever you choose.

cairns man-made trail markings, most often piles of rocks that mark the trailside path. Adding these mini-structures to your drawing can lead the viewer onto the trail, too.

calligraphic handwriting in a particular style, or font, often with a wedge-tipped pen called a calligraphic pen.

chiaroscuro Italian for light and shadow. It refers here to a system of tonal shading to render an object so it appears three-dimensional.

color wheel a way of showing primary and secondary colors. The circle is divided into sixths, and the primary colors—red, yellow, and blue—are in every other wedge. In between each of them are the secondary colors—orange, green, and purple—which are made by mixing the primaries on either side of them.

contour drawing any drawing in which the lines represent the edge of a form, shape, or space; the edge between two forms, shapes, or spaces; or the shared edge between groups of forms, shapes, or spaces.

drawing a way of representing what we see by placing lines onto a surface.

dry-erase pens pens designed to mark on smooth surfaces and wipe off easily. Delis use them for writing the day's specials. Look for them in an art or stationery store.

en plein air a French term meaning "full of fresh air." It refers here to painting done out-of-doors. Because classic painting had been done in studios, painting outside was a radical move.

eye level (see also, *horizon line*) straight out from where you are, neither above nor below the level of your view. As you move up or down, your eye level and view change.

filters the process of noticing only what we need to in any given scene. *Frames* are a similar sensory device, where we ignore what's outside of what we want to look at.

fixative protects an unstable surface; it is sprayed on a finished drawing to protect it after you've completed it.

foreshortening the illusion of spatial depth. It is a way to portray a three-dimensional object on a two-dimensional plane (like piece of paper). The object appears to project beyond or recede behind the picture plane by visual distortion.

gesture drawings drawn from short poses, no more than four minutes and often as short as one minute.

graphic images any images on your computer that are not text-based. Different image formats have different extensions (the letters that appear after the dot on a filename, including .jpg, .ipg, .bmp, .gif, and many others).

hardnesses (for pencils) range from the very hard Hs, which you can use to make a faint line, to the very soft Bs, which are smudgier, ranging from 6H all the way to 6B. Regular pencils are numbered as to hardness on the end.

high, middle, and low horizons represent how eye level is perceived and rendered in a drawing.

horizon line (*or eye level*) your point of view relative to what you are looking at. It is the point at which all planes and lines vanish.

illumination decoration, such as a border around words or a picture.

illustration shows the information itself in picture form.

lateralization the way specific functions or tasks are handled by the brain, whether by one side or the other or both. The brain is comprised of two hemispheres, the analytical and logical *left brain* and the more intuitive and holistic *right brain*. While Westerners tend to use their left brains far more, drawing is largely a function of the right brain.

negative space the area around an object or objects that share edges with those objects or shapes.

paper stomp anything from paper to finger that can smudge a line, can make interesting tones and blurred areas. Harder lines can be drawn or redrawn on top of the initial rendering for more definition.

parallelogram a geometric shape having four sides. Each pair of opposite sides is parallel and equidistant to each other.

perspective the perception that objects farther away are smaller than objects that are closer to us.

picture plane a piece of plastic or Plexiglas through which you view a subject and on which you draw it.

primary colors the basic colors—red, yellow, and blue—which can't be mixed from other colors.

proportion the comparative relation between things; in a rectangle, the comparative ratio between the height and width. Rectangles of different sizes that are in proportion share the same ratio in their height and width.

range the distance between you and your objects—close-up (objects), mid-range (still life), or far away (landscape).

scale in drawing, the rendering of relative size. An object or person or tree, as it is seen farther away, seems smaller than another of the same size that is closer.

secondary colors colors mixed from pairs of primary colors. Red and yellow make orange, yellow and blue make green, and blue and red make purple.

square 90-degrees, at right angles, as in the sides of a rectangle. Measuring carefully off center lines helps keep your rectangle square.

still life called *nature mort* (which means "dead natural things" in French), a collection and arrangement of things in a composition.

tertiary colors made from mixing two secondary colors; include soft taupes, grays, and neutrals.

trompe l'oeil French for "trick of the eye." *Trompe l'oeil* techniques involve making the eye "see" something that is painted seem so three-dimensional you can't quite believe it isn't really there.

2-D an abbreviation for two-dimensional, having the dimensions of height and width, such as a flat surface, like a piece of paper. *3-D* is an abbreviation for three-dimensional, having the dimensions of height, width, and depth, an object in space.

vantage point the place from which you view something and just exactly what, of that whole picture, you are choosing to see and draw. It is the place from which you pick your view from the larger whole, rather like cropping a photograph. If you move, your exact vantage point changes.

vellum surface drawing paper that has a velvety soft finish that feels good as you draw; it can handle a fair amount of erasing.

viewfinder frame a "window" through which you see an image and can relate the angles, lines, shapes, and parts—to the measuring marks on the frame and to each other. It is as simple as using your two hands to frame a view or making a cardboard frame.

viewpoint similar to eye level, but think of it as specifically where your eyes are, whether you are looking up, across, or down at something. Eye level is where you look straight out from that particular viewpoint. Things in your view are above, at, or below eye level. If you move, your view and eye level move, too.

Zen more than a religious practice, it's a philosophy and way of life that comes from Japanese Zen Buddhism. At its most basic, Zen can be thought of as a holistic approach to being that takes for granted the interconnectedness of all things and encourages simplicity in living in order to live with the complex.

Index

exercises
 drawing your hand while looking, 38-39
 drawing your hand without looking, 37
 object arrangements, 96-97
contrast, 161
creativity, 8
 seeing as a child, 152
 viewing work from a distance, 158
Crick, Francis, 16
cubes, 108
Cubism, 106
cylinders, 109

D

David, 279
deep space, 94
details, 132
 animals, 267
 clothes, 294-295
 houses, 245-252
 landscapes, 225
 nature, 133-135
distance viewing, 158
distractions, 166
docks, 232
dolichocephalic faces, 289
Dove, Arthur, 339
drawing, 3
 10 Commandments of Drawing, 143
 al fresco, 180
 artistic liberty, 233
 as basis for painting on furniture, 321
 checklist, 157
 child development, 7
 developing techniques, 13

essential materials, 10
expanding skills, 322
expressive, 147
form, 157, 160
guides, 152
 plastic picture planes, 152-153
 viewfinder frames, 153-154
Learning to Draw Cheat Sheet, 158-159
learning to see, 8
materials. *See* materials
out-of-body experience, 13
personal touch, 172
practice, 161
prehistoric times, 4
preparation, 166
reviewing your work, 151
right-brain. *See* right-brain
secret of, 5
sketchbook journals. *See* journals
spontaneous, 148
therapeutic, 147
while traveling, 315
without-looking, 152
Zen approach, 148
drawing boards, 22
drawing classes, 83
drawing devices
 picture planes, 48-51
 building, 48
 drawing exercise, 52-53
 drawing with, 48-49
 grids, setting up, 50-52
 historical uses of, 49-50

transferring drawings to paper, 54-55
 visual concepts, 49-50
 viewfinder frames, 59-60
 drawing with, 63-65
 making, 60-62
Drawing on the Right Side of the Brain, 5
drawing state of mind, 36
drawings
 caring for, 330-331
 drawing from, 341
 writers' views, 142
dry-erase pens, 174
Dunlop, James M., 338

E

e-mailing images (computers), 332
ears, 289
earth tones, 329
ectomorphic, 276
Elements, 105
elephants, 258
ellipses, 107-108, 130
ellipsoids, 108, 277
en plein air, 213
endomorphic, 276
erasers, 22, 85
etching paper, 128
Euclid, 105
exercises
 animals, 258-259
 contour drawing, 36-41
 drawing an object while looking, 41
 drawing an object without looking, 40
 drawing your hand while looking, 38-39
 drawing your hand without looking, 37